LABYRINTHS: ROBERT MORRIS, MINIMALISM, AND THE 1960s

LABYRINTHS

ROBERT MORRIS, MINIMALISM, AND THE 1960s

MAURICE BERGER

ICON EDITIONS

1817

Harper & Row, Publishers, New York
Grand Rapids, Philadelphia, St. Louis, San Francisco
London, Singapore, Sydney, Tokyo

FIRST EDITION

Designed by Karen Savary

Library of Congress Cataloging-in-Publication Data

Berger, Maurice. Labyrinths : Robert Morris, minimalism, and the 1960s / by Maurice Berger.—1st ed.
 p. cm.—(Icon editions)
 Includes index.
 ISBN 0-06-430384-5
 1. Morris, Robert, 1931- —Criticism and interpretation.
 2. Minimal art—United States. 3. Arts and society—United States.
 I. Title.
 NX512.M67B47 1989
 700'.92'4—dc19 88-37606

89 90 91 92 93 CC/MPC 10 9 8 7 6 5 4 3 2 1

For my sister, Beverly

CONTENTS

LIST OF ILLUSTRATIONS

pencil on typewritten bond paper, 11 × 8½″. Collection of the artist. Photo: Courtesy of Robert Morris.

81. Robert Morris, poster for Castelli/Sonnabend Gallery exhibition, April 6–27, 1974. Offset on paper, 36⅞ × 23¾″. Edition of 250. Collection of Leo Castelli Gallery, New York. Photo: Bruce Jones, courtesy of Leo Castelli Gallery.

82. Robert Morris, *Sex Chamber*, 1975. Pencil on paper, 29½ 42½″. Collection of the artist. Photo: Courtesy of Robert Morris.

ACKNOWLEDGMENTS

The arguments presented in this book were first developed in my doctoral dissertation on Robert Morris, completed for the Graduate Center of the City University of New York in the Spring of 1988. The valuable insights of my dissertation co-advisers Distinguished Professor Linda Nochlin of the City University of New York and Professor Yve-Alain Bois of Johns Hopkins University resulted in a constant and lively discourse on the complex theoretical and historical issues surrounding Morris's work. I would also like to thank Professors Rose-Carol Washton Long of Queens College and the Graduate Center of the City University of New York and Donald Kuspit of the State University of New York, Stony Brook, for the important advice they offered as my dissertation readers.

I would like to express my gratitude to the following people for their support, advice, and encouragement: Patricia Falk, Ann Gibson, William Gilson, E. C. Goossen, Marianne Hall, Rosalind Krauss, Barbara Kruger, Maud Lavin, Sherrie Levine, Therese Lichtenstein, Vincent Longo, Lucy Morris, Kathy O'Dell, Howardena Pindell, Lucio Pozzi, Yvonne Rainer, Carolee Schneemann, Jeanne Siegel, Carol Squiers, Elisabet Thanner, and Pip Wurmfeld.

The following institutions and individuals offered generous assistance in areas of research and photographic documentation: James Acevedo, Patti Brundage, Leo Castelli, Leo Castelli Gallery, James Cohan, Paula Cooper Gallery, Timothy Hailand, Bertha and Karl Leubsdorf Art Gallery of Hunter College, Lisa Martizia, Barbara and Peter Moore, Michael Ortoleva, and Ileana Sonnabend

Gallery. Additionally, the outstanding work undertaken in the late 1970s by Thomas Krens in reorganizing Robert Morris's archives in Gardiner, New York, facilitated my own research as well as that of other scholars.

The support and guidance of Professor Sanford Wurmfeld, Chairman of the Department of Art at Hunter College of the City University of New York, as teacher, as colleague, and as friend, have been unfailing; his efforts went far in making this book possible. The support of my friend and colleague Mason Klein must be acknowledged on many counts: throughout all stages of this book he has offered important critical and editorial advice. It was through my many discussions with him that the central issues of my argument were first shaped. The demanding questions raised and intelligent commentary offered by my students at Hunter College and elsewhere continually helped to sharpen and clarify my own thoughts on the complex culture of the 1960s. To them I am most grateful.

Brian Wallis's astute conceptual reading of this text as well as his editorial assistance represent an important contribution to this book. The editorial advice generously offered by my friend and colleague Ruth Limmer was, as usual, incisive. I would also like to thank Linda Safran, formerly of Harper & Row, for her early support of my work, and Pamela Jelley and Keonaona Peterson for their assistance in the production of this book. My editor at Harper & Row, Cass Canfield, Jr., offered much-appreciated encouragement, advice, and criticism throughout all stages of this book's writing and production. His commitment to my project and his attention to its needs were unwavering.

And finally, I extend my deepest gratitude to Robert Morris. He generously opened his personal archives to me and spent hours discussing the art and politics of the 1960s. Without his vigilant attention to the intricate demands of my work, this project could not have been completed.

INTRODUCTION:
ROBERT MORRIS OUTSIDE ART HISTORY

The lecture had been announced weeks in advance. An art historian, conservatively attired in a gray suit, white shirt, and striped tie steps to the podium. He adjusts his glasses, he drops his left hand, he feels his chin momentarily, and then he begins his lecture. The words come haltingly, echoed by a tape recording of the speech, which moves in and out of synchronization. When the speaker fills his water glass the sound is heard moments later. The speech itself is curious and circular. It is a text taken directly from the writings of another art historian, Erwin Panofsky. Plagiarizing Panofsky's *Studies in Iconology,* the lecturer describes a single, everyday gesture: "When an acquaintance greets me on the street by removing his hat, what I see from a formal point of view is nothing but a change of certain details within a configuration that forms part of the general pattern of color, lines, and volumes which constitute my world of vision. When I identify, as I automatically do, this as an event (hat-removing), I have already overstepped the limits of purely formal perception and entered a first sphere of subject matter or meaning. . . ."

Oddly enough, this lecture took place not at a museum or at some august art historical symposium, but at the small Surplus Theater in New York City in 1964. The "lecturer" was Robert Morris, then a little-known artist and performer, and the lecture itself was a performance piece entitled *21.3* (Fig. 1). Each movement, each facial inflection, each gesture enacted by Morris was premeditated: "come in with glasses on," "drop left hand," "feel

1

chin," "look at ceiling," "bend over text" are some of the hundreds of cues entered into the script (Fig. 2). Ultimately, the clash of reduplicated voices and the intentional lapses in synchronization frustrate the spectator's ability to render meaning from the mannered gestures or from the now-garbled text. In this strange theater, where even the most benign instance of spontaneity is unacceptable, content yields to the histrionic patterns of Morris's movements. Lost in these articulations and gestures, the issue at hand—Panofsky's search for the cultural codes that define the tipping of a hat—is soon forgotten.

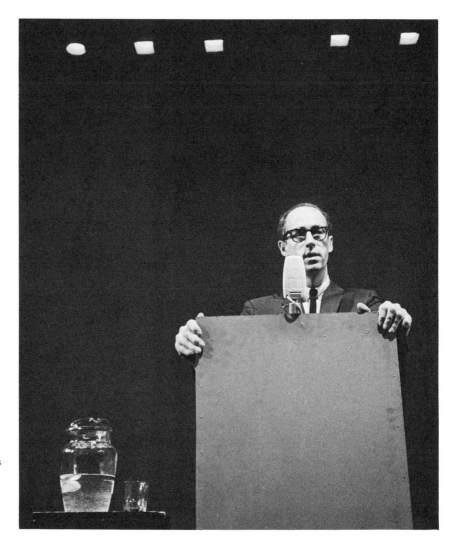

1
Robert Morris performing in Morris's *21.3*, Surplus Theater, New York, February 1964. Photo: © Peter Moore, 1964.

Robert Morris's work is fundamentally theatrical. Yet, as *21.3* demonstrates, his theater is one of negation: negation of the avant-gardist concept of originality; negation of logic and reason; negation of the desire to assign uniform cultural meanings to diverse phenomena; negation of a worldview that distrusts the unfamiliar and the unconventional. Morris's travesty suggests that the meaning of experience or even the understanding of the self is dependent as much on external as a priori situations. In direct contrast to the iconological thinking of Panofsky, Morris's critique of art historical method implies that we must turn not only to the private

2
Robert Morris, page from type-written script for *21.3*, 1964.

space of memory and knowledge but to the public space of experience to define our place in the world.

Morris's parody of the art historian can also be taken as prophecy, for in the past twenty-five years art historical and critical attempts to assess his work and the Minimalist movement with which he is most often associated have rarely advanced beyond conventional models and methodologies. Early critical attempts to name, to define, and frequently to condemn Minimalism were generally historicist in their methods. Under such terms as "Literal Art," "Primary Structures," "Minimal Art," "Systemic Painting," and "A B C Art," a wide range of critics sought to bring together a diverse and often incongruous group of artists working in reductivist, or "minimal," styles.[1] Important for having stimulated interest in the new art, such writing nevertheless was quick to notice formal, surface similarities, while it ignored the deeper philosophical or stylistic distinctions when these nuances threatened the unity of an argument.

From the first paintings, executed in the late 1950s, to the most recent monumental tableaus of death and destruction, Morris's oeuvre would seem to have little or no relationship to most of these by now canonical critical arguments. Critics and art historians for the most part have centered their attention on the relatively few large-scale, monolithic sculptures produced by Morris in the mid-1960s—those works that most conform to the critical canon of Minimalism—and have ignored or misinterpreted the astonishingly wide range of objects, dances, and films Morris executed during the same period. Such narrow readings have rushed to associate Morris with the Minimalist movement. But in an examination of the texts he read, the articles he wrote, the dances he choreographed, and the objects he made, a pattern of activities emerges that is not consistent with the established art historical perception of Morris or his work. From 1961 to about 1974—a period roughly commensurate with the upheavals of the 1960s from the blossoming of the New Left in the early 1960s to the oil crisis of 1973 that generated yet another, this time conservative, shift in the political economy of the United States—Morris's production reveals an intense commitment to social issues and to political and cultural activism. What I will argue in this book is that, rather than being part of a specific movement or canon Morris's work of the 1960s and early 1970s is decidedly independent and even marginal. By exposing this marginality, we can better under-

stand Morris's sensitivity to the greater social issues of the 1960s, problems that were themselves more or less peripheral to the mainstream art world.

Much art now ascribed by art historians to the Minimalist movement at the time merely sustained formalism's aestheticization of the object. In fact, early exhibitions devoted to the subject of "Minimalist" sculpture (free of the aggressive critical partisanship that later characterized the movement) took a surprisingly broad view of the new sculpture. Kynaston McShine's pivotal exhibition *Primary Structures* at the Jewish Museum, New York (April 27–June 12, 1966) is a case in point. In his catalogue essay, McShine argued that a new generation of sculptors had emerged who were critical of past modes of sculpture. Yet, McShine did not see this criticism as a complete rejection of late-formalist sculptural practice. On the contrary, he constantly employed such formalist jargon as "pictorial," "ambiguous," "mysterious," and "quiet lyricism" to describe the new art. Moreover, many of the important characteristics of this new sculpture—the elimination of pedestals, the reshaping of the relationship of the spectator to the sculptural space, and the use of new materials—McShine specifically attributed to formalist sources. "David Smith's challenge to the new generation" and the "painting that provided the new sculpture with clues to the solution of many of its problems" were seen as two important channels through which art "could attain a more direct and formal existence."[2] Indeed, in addition to more conventionally "Minimalist" artists, *Primary Structures* included a number of artists who maintained an uncritical formalist outlook. Among the forty-two participants were such artists as Anthony Caro, Ellsworth Kelly, Michael Todd, and Isaac Witkin, artists whose work employed the standard formalist conventions: illusionism, composition, expressive form, and an ambiguous relationship between the pictorial and the sculptural. On the other hand, the works that Morris exhibited, works that are conventionally thought of as his Minimalist pieces—the plinths, cubes, and beams of the mid-1960s—resisted the aesthetic refinements and compositional complexity of late formalism. Displaying simple geometric shapes, large size, and neutral gray surfaces, these pieces specifically worked against the part-to-part organization (Anthony Caro), the ascendant illusionism (Alexander Calder), and the anthropomorphic references (David Smith) typical of late-modernist sculpture.[3]

Significantly, Morris also resisted the theoretical constructs of other so-called Minimalists. In particular, he rejected Donald Judd's concept of the "specific object," saying that it had "come to mean a particular thing that my work [was] definitely not about."[4] Morris singled out for explicit repudiation Judd's continued support of the highly refined aesthetic object. In his essay "Specific Objects" (1965), Judd explored a distinctive direction in 1960s vanguard art: the desire to exist *between* painting and sculpture. By exceeding painting's two-dimensional limitations as laid down by Clement Greenberg and others, Judd reasoned that the new *objects* could explore the expanded range of creative possibilities inherent to three dimensions.[5] Yet the liberating features of the third dimension had to remain within the parameters of high art. Rather than rejecting the terms "painting" and "sculpture" altogether, Judd merely modified the concept of sculpture in relation to painting. His "specific objects" reformulated the experience of art while continuing to exist as self-contained, "emotive" objects; to be art at all, such objects would have to remain ambiguous, hovering somewhere between representation and literal experience.[6]

The intellectual and stylistic diversity of Morris's oeuvre represents another significant difference between Morris and the other "Minimalists." A listing of Morris's activities in the 1960s and early 1970s reveals the complexity of his production: the early paintings and dance improvisations, the Duchamp-inspired objects, the theatrical dance pieces, the reductivist structures, the large-scale installations and labyrinths, the earth and land reclamation projects, the anti-form pieces, the sound environments, the films and video works, and the political acts against the museum, the labor economy, and the Vietnam War constitute some of his activities in this period. Morris's philosophical sources are equally broad: Marcuse, Peirce, Merleau-Ponty, Chomsky, Foucault, Piaget, Kubler, Lévi-Strauss, and Wittgenstein represent some of the voices that echo throughout his development, influences that contradict the idea of a monotheistic Minimalism. The refusal by art historians to acknowledge these disparate attitudes ultimately perpetuates the avant-garde's obsession with establishing discrete and original stylistic movements. For example, the collapsing of the relatively conservative enterprise of Donald Judd (who, like Morris, rejected the concept of a "Minimalist movement") into the socially critical and stylistically diverse program of Robert Morris

suggests that such distortions lie not in the work of its practitioners but in the act and in the method of writing art history.

To trace the complex interrelation between form and idea, style and content in Morris's oeuvre requires an act of historical reclamation that both avoids art historical generalizations and refuses to set his production into a narrow formal context. By allowing this reclamation to hinge on a few objects organized according to the critical practices of late formalism, previous surveys of Morris's work, with the exception of Annette Michelson's catalogue essay for the Corcoran Gallery, Washington, D.C., in 1969, merely reiterate the official portrait of Minimalism as a coherent movement while underestimating the intellectual rigor and independence of its most philosophically oriented practitioner. Besides Michelson, the two other attempts at a comprehensive discussion of Morris's work of the 1960s—Michael Compton's and David Sylvester's extended catalogue entries for the artist's 1971 Tate Gallery retrospective and Marcia Tucker's essay for Morris's Whitney Museum show in 1970—relegate his production to narrow categories based on stylistic observations.[7] Compton and Sylvester, ignoring the artist's attempt at the Tate to overturn both the structure and the meaning of the retrospective, settle for a historical overview of some of the media and styles of his oeuvre (e.g., *Gray Polyhedrons, Lead Reliefs and Mixed Media, Permutations*). Tucker, similarly ignoring Morris's rejection of the historical retrospective, briefly described the various manifestions of Morris's work from the 1960s. Notably, the theater pieces, crucial to an understanding of the artist's politics, were omitted from both the Whitney and Tate discussions.

The need for a revisionist reading of Robert Morris in the context of the Minimalist movement has ramifications beyond the corrective. The point of this book is not that it presents a truer or more accurate history of Morris's career, but rather that it offers a means for rethinking a complex problem already suggested by the ambivalence of the new art toward the belief systems of formalism. Such a reconsideration of Morris's work allows us to reorient our conceptions of the art of the 1960s, suggesting a number of crucial questions about the nature of this period. Could the more radical aspects of art in the 1960s represent a critical "epistemological break" with the cultural practices of late modernism? And if the central purpose of advanced art and criticism since the early 1960s has been to question the monolithic myths of modernism

and its progression of great masters and masterpieces, then what role might more radical and activist art of the period have played in that change? Finally, was the emergence of new structures and forms for art in the 1960s independent of the political scene or must it have been influenced by the intense social climate of the period?[8]

In the past such questions have been neither posed nor answered because art historical analysis of avant-garde culture in the 1960s has discreetly distanced itself from the social issues of the period (and to a great extent from marginal art activities as well). This despite the abundance of evidence that might suggest a connection between art and politics.[9] The repression of social meaning through formalism's fetish of the object—where meaning is gleaned directly from the formal and stylistic nuances of the object rather than from its social or institutional context—is consistent with the general motives of criticism and history written specifically for consumers of high art. Thus, even the fairly tame criticality of Minimalism in the early 1960s resulted in a sharply critical response from the prevailing formalist circle. This "crisis" yielded a general and immediate proliferation of negative commentary coupled with a frustrating search for historical or stylistic precedents that might facilitate analysis of the new sculpture.

One methodological dilemma resulted from the fact that such reductivist and abstract sculpture, as McShine's essay suggested, was not entirely inconsistent with the formalist object. In contrast to the overtly political representations of Berlin Dada or American Pop Art, with their collision of high and popular culture, most Minimalist production remained comfortably removed from society, functioning best in the traditional art world setting of the gallery or the museum. But the clumsy proportions and everyday materials of these objects (which immediately distinguished them from the treasured museum object) were initially disconcerting to some critics and collectors. And their *theatrical* underpinnings— the aggressive way in which their large scale and direct engagement confronted the spectator—were anathema to formalist critics who championed contemplative, modest, and self-contained objects. Exhausting their stylistic and philosophical options, many critics conceded that existing methods and standards for evaluating art were rendered irrelevant by the resolute, industrial, and expressionless Minimalist object.[10]

According to Clement Greenberg, the preeminent formalist

critic of the 1950s, inherent distinctions between painting and sculpture are often blurred in order to deny the literalness of the third dimension—to distinguish the sculptural object from the nonaesthetic realm so that it does not read merely as physical matter bound to the pull of gravity. "Here the prohibition against one art entering into the domain of the other," Greenberg wrote in defense of formalist sculpture, "is suspended, thanks to the unique concreteness and literalness of sculpture's medium. Sculpture can confine itself to virtually two dimensions (as some of David Smith's pieces do) without being felt to violate the dimensions of its medium, because the eye recognizes that what offers itself in two dimensions is actually (not palpably) fashioned in three."[11] The anthropomorphic allusions and defiance of gravity (achieved by the balancing of welded form) evident in Smith's sculpture, Greenberg reasoned, allowed for the ultimate illusion: that "matter is incorporeal, weightless and exists only optically like a mirage."[12] Ultimately this formalist desire for illusionism predisposed critics like Greenberg against the new sculpture, where the use of simple geometric forms, the acceptance of gravity, and the employment of industrial materials generally negated the pictorial and optical aims of formalist painting and sculpture.

In his seminal essay "Art and Objecthood" (1967), the formalist critic Michael Fried argued against the "theatricality" of the new sculpture, claiming that it was "at war with . . . art."[13] Like Greenberg, Fried emphasized the pictorial and illusionistic possibilities of sculpture, stressing that sculpture's survival (like the survival of painting) depended on its ability to distinguish itself as art. For such modernist painting as Cubism, Constructivism, and Abstract Expressionism, work that was often utopian and spiritual in its associations, the problem was to transcend the literal shape of its support. For Fried, painting could be declared art a priori, because the field of the canvas was understood as separate from the real world. However, the literal condition of the canvas as *object* had to be overcome. To a very great extent, this formalist reasoning extended to sculpture, where the object sought to transcend its base material state (David Smith's anthropomorphic and ascendant sculptures provided an example for this argument). Because Minimal or "literalist" art relied on actual shape, Fried reasoned, it existed to "discover and project objecthood as such."[14] In other words, literal presence became the principal goal of many "literalist" objects, thus placing in question their "purity" as art.

Despite Fried's moralizing conclusions about the dangers of the new sculpture, his observations about the way such art functions in relationship to the spectator continue to read as astonishingly perceptive. In fact, Morris's understanding of his own sculpture, explained in a series of essays published in the mid-1960s, tends to corroborate Fried's observations. By liberating sculpture from representing objects in the world, Morris expressly wished to avoid psychological references and create an immediate sculptural experience (itself a metaphysical concept since no form can be entirely nonassociative or value free). Additionally, Morris sought to prolong and intensify this experience by frustrating the spectator's anticipation of a particular form, often through the distortion of three-dimensional gestalts. And so in contrast to previous art, as Fried notes, where "what is to be had from the work is located strictly within [it]," to experience Morris's sculptures is to experience an "object *in a situation*—one that, virtually by definition, *includes the beholder.*"[15]

Fried considered this complex interplay between viewer and object "theatrical"—and, consequently, inappropriate for sculpture. For him, the altered status of the spectator in the presence of such "literal" sculpture amounted to "nothing more than a plea for a new genre of theater; and theater is now the negation of art."[16] In a sense Fried was correct, for Morris's strategic disorientation of the spectator—through the use of altered gestalts, for example—was meant as a deliberate negation of traditional sculpture. In addition, the viewer was distanced by the objects themselves, objects inserted directly into the flow of their ambient space without the presence of mediating pedestals. "The beholder knows himself to stand in an indeterminate, open-ended—and unexacting—relation *as subject* to the impassive object on the wall or floor," Fried wrote. "In fact, being distanced by such objects is not, I suggest, entirely unlike being distanced or crowded by the silent presence of another *person;* the experience of coming upon literalist objects unexpectedly—for example, in somewhat darkened rooms—can be strongly if momentarily disquieting in just this way."[17] Because theater was for Fried the avowed enemy of art, he felt no need to answer an obvious question raised by his essay "Art and Objecthood": Why was "theatrical" space and time so important for artists in the 1960s?

Among critics, Annette Michelson was perhaps the first to comprehend the importance of the issue of theatricality. In her

essay on Morris in 1969, she argued that formalism, with its meta-
physical aspirations, could neither accept nor fully understand the
radical, "transgressive" character of Morris's theatricality.[18] This
was, in part, because a criticism based on a "modernist, post-
Symbolist allegiance to the primacy of the Imagination and the
apprehension-in-immediacy of its works" could not effectively
evaluate an art that employed everyday materials and literal space
and time.[19] Michelson, therefore, advocated a radical revision of
the critical vocabulary, one that would reject the flourishes of the
formalist metaphysician—"the language of our art criticism"—in
favor of the discourse of real experience. For Michelson the issue
was practical: the critical terms generally used for discussing art—
verbs such as "saying," "expressing," "embodying," "incarnat-
ing," "hypostasising," and "symbolizing"—were simply not rele-
vant to Morris's *critique* of formalist space. More appropriate, she
felt, were the phenomenological discussions of Maurice Merleau-
Ponty and the writings of the semiotician Charles Sanders Peirce,
whose concept of "epistemological firstness" directly influenced
Morris.[20] In his work, Michelson argued, the emphasis on the
reflective process, on the need for the experience of sculpture to
be public rather than intimate, was central. His exploration of the
external origins of cognition and self-definition sought to reaffirm
that the way meanings are established is wholly dependent on
other beings and things in the world and on the act establishing
connections to them. This philosophical premise, consistent with
the writings of Peirce and Merleau-Ponty, disavowed the illusion
of the self as a contained, independent whole, by acknowledging
that we must connect with other selves, other minds, and other
things to determine our existence.[21] As Fried had observed, Mor-
ris's large-scale, nonassociative plinths (Fig. 3) demanded a literal,
direct interaction between spectator and art object.[22] But inverting
Fried's logic, Michelson argued that "it is [Morris's] commitment
to the exact particularity of experience, to the experience of a
sculptural object as inextricably involved with the sense of self and
that of space which is their common dwelling, which characterizes
these strategies as radical."[23]

Yet, even Michelson's methodology, while not bound to a
literalist version of formalism, remained centered on the art object
and directed largely toward art world issues. Failing to transcend
the limitations of phenomenology despite her astute observations,
Michelson's critical method continued formalism's inherent resist-

ance to broader social issues.[24] In reappraising the culture of the 1960s from the vantage point of the 1980s, however, it is possible to recognize that it was specific political issues that prompted the otherwise unpredictable, *theatrical* relationship established between spectator and art object. The "Minimalist" desire for pure experience independent of memory or logic, for example, recalls the New Left's demand for liberation from society's oppressive conventions and standards. In Morris's case, his phenomenological imperative was actually tied to a specific political source, as his interest in Peirce and Merleau-Ponty was extended to Herbert Marcuse's radical concepts of freedom and desublimation.

Art historians today, by continuing to rely on institutionally validated readings of "Minimalism," consistently overlook the alternative resources that might reclaim the radical side of 1960s art. Yet this side of the 1960s is recuperable in the activist journals of the period,[25] in the writings of more socially aware art critics (e.g., Ursula Meyer, Lucy Lippard, Gregory Battcock, and Barbara Reise),[26] in the social theory of writers associated with the New Left (such as Herbert Marcuse, R. D. Laing, Paul Goodman, and Noam Chomsky), in the tracts and petitions of artists' protests against the museum and the Vietnam War, in the art worker con-

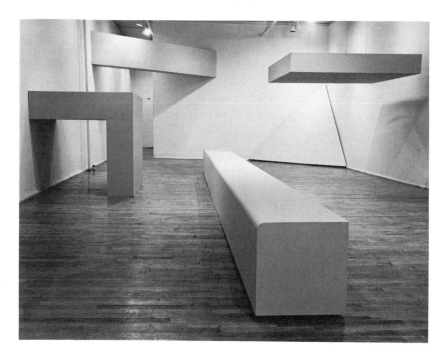

3
Installation view of Robert Morris's one-person exhibition at the Green Gallery, New York, 1964.

cept, and, finally, in the archives and work of the artists themselves. These materials remain available to those historians who wish to work outside a canonical view of the 1960s; through them we can begin to draw a vital link between the avant-garde and radical, even underground, culture. In this way, Fredric Jameson has argued that any attempt to see the 1960s as a distinct historical period encounters a need to transgress the limitations of traditional history through a restructuring of the very methodology of history. "What is at stake then," Jameson has written, "is not some proposition about the organic unity of the '60s on all its levels, but rather a hypothesis about the rhythm and dynamics of the fundamental situation in which those very different levels develop according to their own internal laws."[27]

In attempting to locate an appropriate methodology for understanding the relationship between the "internal laws" of Morris's art and ideas and the broader social space of the 1960s, I have found the work of the art historian T. J. Clark most useful. In his impressive reading of the role of Edouard Manet and his followers in the emergence of modernism, Clark places in political context paintings that have traditionally been read formalistically by art historians. By resuscitating the alternative archives of the nineteenth century—the political and social texts of critics, journalists, and artists generally ignored by art historians—he reinterprets Manet's complex ideological program in relation to the dictates of official French culture at mid-century.[28] The central thesis of Clark's *The Painting of Modern Life: Paris in the Art of Manet and His Followers* (1984) is that modern art developed from a desire to represent the uncertainty and class tensions of Paris's new urbanism. Centering on three figures of the late nineteenth century—Edouard Manet, Edgar Degas, and Georges Seurat—Clark explores the convergence of form and content in early modernism. He argues, for example, that Manet's *Olympia* (1863) signifies the subliminal connection between prostitution and class struggle, thus challenging the acceptability of the image of the courtesan as perpetuated by the Salon. In the work's ambiguities of surface detail and imagery, Clark sees broader political meaning; rather than providing a mere stylistic confrontation with the spectator, *Olympia* confronts us with the hypocrisy of public morality in nineteenth-century France. By referring to a range of archival sources (including newspaper accounts, cartoons, social history, and popular literature)—materials that originated not in the world of art but

in the greater social sphere of Paris after Haussmannization—Clark explores the connection between art, popular culture, and the social upheavals of the new Paris.[29] In the end, he ascribes a political aspect to the most advanced painting of the late nineteenth century. According to Clark, the principal motivation for Manet and his followers was to expose a vital truth: that the debased polarization of the classes was a direct consequence of Baron Haussmann's restructuring of Paris. Thus, Clark reveals that the radical spirit of early modernist painting, interpreted as stylistic revolution by a century of formalist art history, was entirely commensurate with the social revolution that characterized the class struggles of the nineteenth century.

Of course, the relationship of Robert Morris to the social context of the 1960s is concerned with a different type of archive and different art historical problems. For one thing, the unfamiliarity of Morris's oeuvre (particularly in contrast to Manet's) presents an immediate obstacle: the need to reconstitute Morris's diverse production in order to reclaim its political imperatives. And second, whereas Clark has excavated the social archives of France to build what is fundamentally a sociological argument, I have tended to look at the alternative philosophical and theoretical models that were available to the artistic avant-garde in the United States in the 1960s. Unlike Manet's realism, Morris's art rarely extended to the world of everyday activities and events; as an avid reader and debater of philosophical issues, he maintained an intellectual and politically radical—though somewhat distanced—approach to culture. Whereas Manet's painting projected meaning through the act of pictorial *representation* (hence Clark's blending of Marxist and iconographic readings with semiology), Morris's phenomenology generally demanded a more abstract consideration of the spectator and the ontological space of viewing.

Clark's attention to the social practices of the new Paris is firmly rooted in issues of class. "In a capitalist society, economic representations are the matrix around which all others are organized," he writes. "In particular, the class of the individual—his or her effective possession of or separation from the means of production—is the determinant fact of social life."[30] In contrast to the general class divisions that were reflected in the work of Manet and his followers, Morris's class interests were most often invested in one particular type of cultural situation: the social and economic status of the artist. And while such explorations of the artist's role

in society were correlated by Morris to broader social relation-ships, my own argument openly acknowledges that one of the most radical aspects of Morris's ideological program—the analogy be-tween artists and working-class people—was presented through symbolic or abstract means. Other areas of Morris's political think-ing, including the desublimation of sexuality and the antiwar pro-tests, were considerably more accessible to the spectator.

The revisionism I propose in relation to Morris's work is ulti-mately consistent with Clark's move toward the recontextualiza-tion of the art object in relation to dominant ideologies and beliefs. In brief, my methodology can be divided into four interconnected areas of inquiry: (1) an accounting of the more marginal aspects of Morris's production; (2) an analysis of his writings and philo-sophical and theoretical sources; (3) an examination of the rela-tionship of his art and ideas to the broader cultural and political issues of the 1960s; and (4) an evaluation of how this conflation of art and politics upsets bourgeois ideologies and forces both artist and spectator to reassess their relationship to art and its institu-tions.

If Clark's discussion centers on the social and cultural crisis that marked the beginning of modernism, my argument examines the crisis of belief that has haunted its end. Clark's conception of the artist as critical witness—a role categorically rejected by for-malists, who would argue that art should serve no political function at all—can logically be extended to Robert Morris. Like the "spec-tacle" of modernity portrayed a century before in the images of Manet, Morris's "spectacles" center on the decline of industrial society in the era of late capitalism. From his deliberate allusion to Manet's *Olympia* in his dance piece *Site* (1963) to his electrified interrogation room in *Hearing* (1972), Morris examines the work-ings of the industrial social order one hundred years after Manet. And like Manet's desire to confront the spectator with the debased reality of the new Paris, Morris's art functions ideologically as it attempts to re-create the decentering conditions of late-industrial society—the space of labor, commerce, and production—in an effort to engender in the spectator a sense of uncertainty and resistance.

NOTES

1. Michael Fried, "Art and Objecthood," *Artforum* 5 (June 1967); Kynaston McShine, *Primary Structures: Younger American and British Sculptors* (New York: The Jewish Museum, 1966); Richard Wollheim, "Minimal Art," *Arts Magazine* 39 (January 1965); Lawrence Alloway, *Systemic Painting* (New York: Solomon R. Guggenheim Foundation, 1966); and Barbara Rose, "A B C Art," *Art in America,* 54 (October 1965). The Fried, Wollheim, Alloway, and Rose essays are reprinted in Gregory Battcock, ed., *Minimal Art: A Critical Anthology* (New York: Dutton, 1968), pp. 116–47, 387–99, 37–60, and 274–97.

2. McShine, "Introduction," in *Primary Structures,* n. p.

3. For an important discussion of these sculptural principles see Rosalind Krauss, *Terminal Iron Works: The Sculpture of David Smith* (Cambridge, Mass., and London: M.I.T. Press, 1979), and Krauss, "Tanktotem: Welded Images," in *Passages in Modern Sculpture* (New York: Viking Press, 1977), pp. 147–200.

4. E. C. Goossen, "The Artist Speaks: Robert Morris," *Art in America* 58 (May 1970), p. 111.

5. Donald Judd, "Specific Objects," *Arts Yearbook,* 1965; reprinted in Judd, *Complete Writings, 1959–1975* (Halifax: Nova Scotia College of Art and Design, 1975), p. 184.

6. In his essay "Specific Objects," Judd illustrated allusive (abstractly representational) objects by Jasper Johns, John Anderson, Robert Watts, Robert Rauschenberg, Richard Artschwager, George Ortman, H. C. Westermann, Lucas Samaras, Yayoi Kusama, Philip King, Claes Oldenburg, Richard Smith, Tony DeLap, Dan Flavin, and Frank Stella, as well as works by Morris and Judd.

7. See Marcia Tucker, *Robert Morris* (New York: Whitney Museum of American Art, 1970), and Michael Compton and David Sylvester, *Robert Morris* (London: Tate Gallery, 1971).

8. This possibility has been suggested by some of the essays in Sohnya Sayres et al., eds., *The '60s Without Apology* (Minneapolis: University of Minnesota Press, 1984), and in the recently published anthology by Jonathan Arac, ed., *Postmodernism and Politics* (Minneapolis: University of Minnesota Press, 1986). Arac's collection, unlike *The '60s Without Apology,* continues to rely on the now-questionable category of "postmodernism," underplaying the most radical sectors of modernist culture in order to constitute a distortive opposition between "modernism" and "postmodernism."

9. For an outstanding corrective for this problem in the humanities, see Sayres et al., eds., *The '60s Without Apology.*

10. See, for example, Fried, pp. 116–47.

11. Clement Greenberg, "The New Sculpture," in *Art and Culture* (Boston: Beacon Press, 1961), p. 143.

12. Ibid., p. 144.

13. Fried, p. 139. For more on Fried and the theatricality of art, see Stephen Melville, "Notes on the Reemergence of Allegory, the Forgetting of Modernism, the Necessity of Rhetoric, and the Conditions of Publicity in Art and Criticism," *October,* no. 19 (Winter 1981), p. 65. On Fried's concepts of absorption and theatricality, see Michael Fried, *Absorption and Theatricality: Painting and Beholder in the Age of Diderot* (Berkeley and Los Angeles: University of California Press, 1980). And for an important critique of formalism, see T. J. Clark, "Clement Greenberg's Theory of Art," *Critical Inquiry* 9 (September 1982); reprinted in Francis Frascina, ed., *Pollock and After: The Critical Debate* (New York: Harper & Row, 1984), pp. 47–63.

14. Fried, "Art and Objecthood," p. 120.

15. Ibid., p. 125.

16. Ibid.

17. Ibid., p. 128.

18. Annette Michelson, "Robert Morris: An Aesthetics of Transgression," in *Robert Morris* (Washington, D. C.: Corcoran Gallery of Art, 1969), pp. 7–79.

19. Ibid., p. 9.

20. Rosalind Krauss has further elaborated on the relationship of these issues to Morris and his contemporaries: "When the minimalist generation first took up Merleau-Ponty [*Phenomenology of Perception*] in the early 1960s, they did so against the background of Pollock and Still, Newman and Rothko. They therefore had a very different understanding of what could be meant by Merleau-Ponty's notion of a 'preobjective experience' than did the artists of the 1940s working in France [under the influence of Jean-Paul Sartre]. . . . The *Phenomenolgy of Perception* became, in the hands of the Americans, a text that was consistently interpreted in light of their own ambitions toward meaning within an art that was abstract." See Krauss, "Richard Serra, A Translation," in *The Originality of the Avant-Garde and Other Modernist Myths* (Cambridge, Mass., and London: M.I.T. Press, 1985), pp. 260–74.

21. See ibid., pp. 260–62, for a discussion of this reorientation of meaning in Minimalist sculpture.

22. The literal directness of Morris's plinths, cubes, and beams was enhanced by the neutrality of their mat gray surfaces, a color used by Morris in an effort to avoid color-based associations.

23. Michelson, p. 43.

24. Michelson did make one allusion to the psychopolitical implications of form in a footnote on the prolonged debate over the shape of the table and seating arrangements that precluded the opening of the Paris "peace talks" in 1968. The point, which was both narrow and undeveloped, had no bearing at all on Morris's politics.

25. Examples of these publications include the journal *Avalanche,* the anthology *Conceptual Art* edited by Ursula Meyer, and such underground newspapers as *Black Mask* and the *New York Element. Studio International,* while not activist in the political sense of that word, nevertheless devoted space to reports on social protests in the art world.

26. See, for example, Ursula Meyer, "The Eruption of Anti-Art," in Gregory Battcock, ed., *Idea Art* (New York: Dutton, 1973), pp. 116–34; Lucy Lippard, "The Art Workers' Coalition: Not a History," *Studio International* 177 (November 1970), pp. 171–74 (reprinted as "The Art Workers' Coalition," in Battcock, ed., *Idea Art,* pp. 102–15); Gregory Battcock, "Marcuse and Anti-Art," *Arts Magazine* 43 (Summer 1969), pp. 47–50; and Barbara Reise, "A Tale of Two Exhibitions: The Aborted Haacke and Robert Morris Shows," *Studio International* 182 (July–August 1971), p. 30.

27. Fredric Jameson, "Periodizing the '60s," in Sayres et al., p. 179.

28. T. J. Clark, *The Painting of Modern Life: Paris in the Art of Manet and His Followers* (New York: Knopf, 1984).

29. For Clark's argument on *Olympia,* see "Olympia's Choice," in ibid., pp. 79–146.

30. Ibid., p. 7.

DUCHAMP AND I

I seem to speak, it is not I, about me, it is not about me.
—Samuel Beckett, *The Unnamable*

In 1963, Robert Morris constructed a work that consisted of a small lead-covered box with a ring of twenty-seven keys hanging from its lid. Each key was inscribed with one of the words from Marcel Duchamp's "Litanies of the Chariot," a section of his notes for the *Large Glass* (Fig. 4). One of Morris's early homages to Duchamp, this work, entitled *Litanies,* was subsequently exhibited at the Green Gallery as part of Morris's first solo exhibition in New York. There the work was purchased by the architect and art collector Philip Johnson. But after six months, Morris still had not received payment. Frustrated, he responded to the oversight with *Document* (1963, Fig. 5), a work designed to negate the aesthetic value of *Litanies.* In *Document,* Morris juxtaposed profile and frontal views of *Litanies* etched into lead with a typed "Statement of Esthetic Withdrawal." Bound in imitation leather and legally notarized, the statement asserted: "The undersigned, ROBERT MORRIS, being the maker of the metal construction entitled LITANIES, described in the annexed Exhibit A, hereby withdraws from said construction all esthetic quality and content."

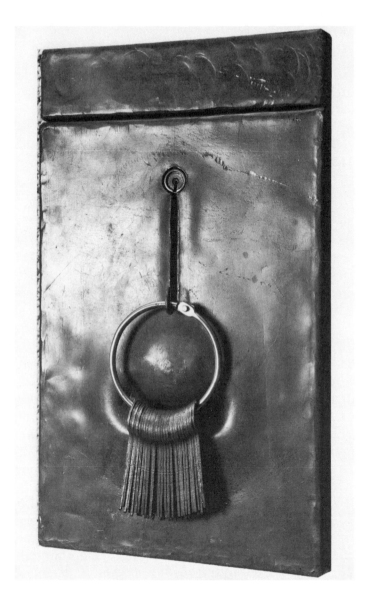

4
Robert Morris,
Litanies, 1963. Lead
over wood, steel
key ring, 27 keys,
and brass lock.
Museum of Mod-
ern Art, New York.

The official-sounding text plays humorously on formalism's obsession with the aesthetic object and recalls two related paradigms of the Dadaist readymade: the idea of individual creation as a bourgeois trap and the blurring of boundaries between art and the rest of production. As Peter Bürger argued in *Theory of the Avant-Garde,* the provocative and transformative nature of the readymade depended on the artist's signature. "When Duchamp

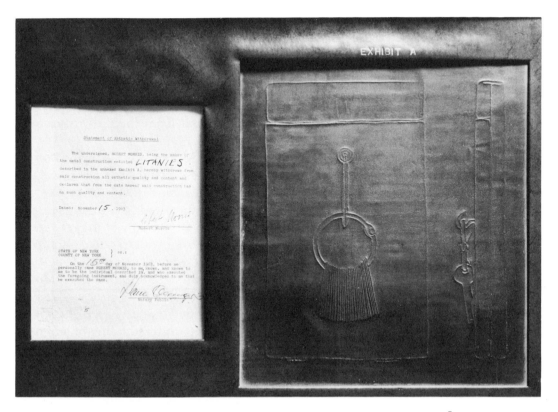

5
Robert Morris, *Document,* 1963. Typewritten and notarized document, imitation leather, lead. Museum of Modern Art, New York.

signs mass-produced objects (a urinal, a bottle drier) and sends them to art exhibitions," Bürger wrote, "he negates the category of individual production. The signature, whose very purpose it is to mark what is individual in the work, that it owes its existence to this particular artist, is inscribed on the arbitrarily chosen mass product, because all claims to creativity are to be mocked."[1] In *Document,* Morris's signature—inverting Duchamp's readymade strategy—represents a purely contractual negation of artistic value. Morris's work not only challenges conventional notions of ownership and authenticity but also affirms his waning belief in the artist's (and the art object's) magical powers.

But *Document* differs from Duchamp's more austere readymades. For one, it is not a mass-produced "found" object but an enigmatic construction that remains separate from bourgeois society. One would not expect to encounter it, as one might a bottle drier or urinal, in the course of everyday life. And while *Document* appropriates the ideologies of the readymade, it intentionally in-

verts its logic: while Duchamp sarcastically proclaimed arbitrarily chosen mass-produced objects "art" by virtue of a signature, Morris's signed statement insisted that an object that had previously been executed, exhibited, and sold as art was no longer aesthetically viable. Thus, Morris's signature was not meant to add value to an object but, in a parody of a certificate of authenticity, to devalue it—to symbolically withdraw it from the fetishistic order of aesthetic objects.[2]

From his beginning as an artist, Morris was suspicious of the fetishism attached to art objects. He believed that even Duchamp—whose readymades he felt were undeniably seductive and beautiful—was a fetishist. But at the same time, as Morris has freely admitted, Duchamp also liberated art from many of the repressive conditions of object making. "I was bored with the deaf and dumb objects of high modernism, objects which, more or less, have refused to accept their transitive and conditional status," Morris has said. "My fascination with and respect for Duchamp was related to his linguistic fixation, to the idea that all of his operations were ultimately built on a sophisticated understanding of language itself."[3] Duchamp was indeed fascinated with transitive and contingent states. The *Rotative Demisphere* (1925) or the spiraling puns of his film *Anémic Cinéma* (1926), for example, are works that demonstrate his interest in perceptual states that would allow art to enter into the realms of process, temporal experience, and, by extension, language. This arena of operations not only fascinated Morris, it shaped the aesthetic, theoretical, and political dynamic of his work of the 1960s and early 1970s.

During the mid-1950s, when many young artists continued to be interested in Abstract Expressionist painting, Morris was already skeptical of art based on formalist principles. While studying philosophy and psychology at Reed College in the early 1950s, Morris was captivated by the radical intellectual climate of the campus. Although he initially contemplated an academic career, he eventually decided against it. Instead he moved to San Francisco in 1956 and renewed his interest in making art. As early as grade school in Kansas City, Missouri, Morris had painted murals. After high school and a brief stint as a semiprofessional baseball player, he enrolled at the Kansas City Art Institute, where he studied painting and drawing. In San Francisco he produced dozens of paintings and over two hundred large drawings that both emulated and questioned the painting techniques of Jackson Pollock (Fig. 6).

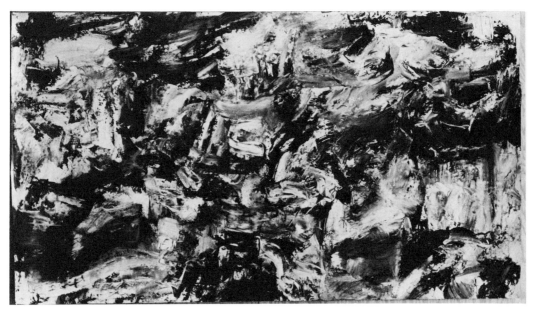

6
Robert Morris, *Untitled (No. 31)*, 1956–60. Oil on paper. Collection of the artist.

The paintings, the first of Morris's works to be exhibited, were shown in two solo exhibitions at the Dilexi Gallery in San Francisco in 1957 and 1958.

Building on Pollock's innovations in these early paintings, Morris began to explore the materiality of paint, varying the viscosity of the medium and continually changing the character of his gestures. Rather than working toward a predetermined image, he explored the dynamics of painting by making a priori decisions only about tools and application. While departing little from Pollock's painting technique, these works nevertheless suggest Morris's disenchantment with the static, precious art object. Morris had already oriented his technique principally toward the problems of process, and, thus, Pollock was an important source for rethinking the role of the artist in the production of art. As Hans Namuth's photographs and film of Pollock painting revealed, the artist's technique dismantled the hierarchies of easel painting as Pollock walked around and into floor-bound sections of canvas. Morris's first paintings were executed vertically: canvases were propped up against the wall in the fashion of easel paintings and paint was applied with a knife or trowel. Finding this process indirect and formal, he eventually painted directly on rolls of paper or canvas that were placed on the floor in the manner of Pollock.

His process was at once mechanical and choreographic as he dripped and splattered paint from a low scaffold, which he moved along the perimeters of the long canvases.

The expressive, controlled interaction of materials and action in the choreographic painting process of Pollock became for Morris a liberating model. Until Pollock, painting had been a relatively limited act as far as the human body was concerned; its gestural possibilities were mostly limited to movements of the hand, wrist, and arm. Eschewing the traditions of easel painting, Pollock used his entire body in the act of painting. Furthermore, by working directly on the floor, he was also able to investigate the properties of various materials in relationship to gravity. "[Pollock's] work turned back toward the natural world through accident and gravity and moved the activity of making into a direct engagement with certain natural conditions," wrote Morris years later. "Of any other artist working in two dimensions, it can be said that he, more than any others, acknowledged the conditions of accident and necessity open to the interaction of body and materials as they exist in a three-dimensional world."[4]

Thus for Morris, Pollock's working process prefigured his own task-oriented art of the 1960s.[5] Morris postulated that the balance between arbitrary and nonarbitrary actions characteristic of Pollock's process constituted a semiotic basis for process art. "There is a binary swing between the arbitrary and the non-arbitrary, or 'motivated,' Morris observed, "which is . . . an historical, evolutionary, or diachronic feature of language's development and change. Language is not plastic art but both are forms of human behavior and the structures of one can be compared to the structures of the other."[6] Morris reasoned that the bifurcated nature of speech—as it oscillates between arbitrariness and conventional systems and patterns (e.g., grammar, syntax)—parallels the special nature of a *transitive* art based on task, process, and duration rather than on aesthetic finish. As such, chance and automation play an integral role in the production of advanced art: the activity of making art is truly coherent only when accidents and predetermined mechanical processes replace traditional handwork. But what began as an exploration of Pollock's process ended in disillusionment for Morris. He found that he was more interested in the *act* of painting than in compositional harmony and refinement: "I either accepted [the painting] or threw it out," Morris said. "But I didn't go back and adjust it."[7]

Not surprisingly these paintings were created in a period when Morris was becoming increasingly involved in dance. In 1954, while at Reed College, he met, and shortly thereafter married, the dancer and choreographer Simone Forti. Along with several other dancers, artists, and musicians, the couple formed an improvisational theater and dance group in San Francisco in 1957. At that point, Morris's confidence in painting began to falter:

> I slowed down in painting. . . . I was involved in these theater things, more involved in doing some writing, just reading and not painting much. Painting ceased to interest me. There were certain things about it that seemed very problematic to me. I couldn't solve the problems. There was a big conflict between the fact of doing this thing, and what it looked like later. It just didn't seem to make much sense to me. Primarily because there was an activity I did in time, and there was a certain method to it. And that didn't seem to have any relationship to the thing at all. There is a certain resolution in the theater where there is real time, and what you do is what you do.[8]

The agenda of the improvisational group was influenced by the Dancer's Workshop Company, formed in 1955 in San Francisco, by Forti's teacher, Ann Halprin. In contrast to the illusionism of ballet and the histrionics of modern dance, Halprin explored movements associated with everyday activities such as walking, eating, bathing, and dressing. Her performances in collaboration with other dancers, such as Forti, Trisha Brown, Yvonne Rainer, and Steve Paxton,[9] and such musicians as Terry Riley, La Monte Young, and Warner Jepson—liberated dance movement from emotional expression and narrative, allowing simple and ordinary gestures to develop according to their inherent principles. While the members of the San Francisco improvisational group respected Halprin's innovations, they wanted to explore some of her concepts in a more disciplined and controlled setting. A small workshop was formed; meeting on Sundays, its members took turns teaching movement, sound, and lighting. Closed to the public, these sessions were highly experimental: members discussed all aspects of preparation and process and examined ways of dismantling narrative time in favor of real time. "The effect of the workshop," Morris has said, "was to blur the distinction between performance and those aspects of preparation and process (e.g., constructing props or practicing pedestrian

movements and gestures) that went into making up the dance."[10]

Morris's professional association with Simone Forti was central to his development of a performance sensibility that resisted the techniques of traditional dance.[11] In her early dances, Forti explored "rules" or gamelike situations. The complexity of these rules—often requiring the dancer to react "frantically" to a barrage of often contradictory cues—prevented the performers from locking into predictable patterns. In a duet performed at Yoko Ono's loft in New York by Morris and another male dancer, these cues resulted in intentional conflict:

> [Forti] told me one thing. She told him something else. She told neither one of us what she had told the other person. What she told me was to lie on the floor for the duration of the piece; what she told him was to tie me to the wall. So it created this incredible kind of conflict.[12]

Even after their divorce in early 1961, Morris continued to attend Forti's performances and was greatly influenced by them. In her 1961 performance *Slant Board,* first presented as part of a series of dance concerts organized by La Monte Young in New York, Forti instructed the dancers to climb inclined planes with the aid of ropes, a task that Morris would later assign to spectators at his Tate Gallery retrospective in 1971.[13]

After relocating permanently to New York in 1961, Morris was introduced to a number of influential figures in the now burgeoning world of avant-garde music, theater, and dance. John Cage, George Brecht, Yvonne Rainer, and Robert Whitman were among the people he met while first living in New York. By the early 1960s, the city had emerged as an important world center for performance and dance—from Happenings and Fluxus to the New Dance of the Judson Dance Theater. If the San Francisco improvisational group had provided Morris and Forti with a beginning for establishing a new and radical vocabulary of movements and forms, the radical innovations of New York dance and performance offered them a means for developing these ideas to their full potential.[14]

Fluxus was particularly important for the emergence of a radical performance sensibility in New York in the early 1960s. Their performances—called Events to distinguish them from Happenings—were cool and conceptual. As opposed to the assaultive, chaotic Happenings of Jim Dine, Allan Kaprow, and Claes Olden-

burg,[15] for example, the Events were much more involved in the deliberate, passive, and task-oriented situations characteristic of Halprin's Dancer's Workshop Company. The Events sensibility originated primarily from the courses in experimental music composition taught by John Cage at the New School for Social Research in New York. In these courses, begun in 1956, early proponents of the new performance, including George Brecht, Alison Knowles, Emmett Williams, and Jackson Mac Low, experimented with strategies based on chance situations and simple, unitary tasks. Deeply rooted in Cage's respect for everyday sounds and practices, these early Events explored ordinary phenomena (such as turning a lamp on and off or pouring water into a glass) in unadorned settings.

Morris was peripherally involved with these Events through the encouragement of his friend La Monte Young. Young, an avant-garde composer whose work in this period would later be associated with Fluxus, first met Morris in San Francisco, where they were both involved in improvisational performance. Young had already been introduced to Cage's ideas while a graduate student at the University of California at Berkeley. After arriving in New York in the fall of 1960, Young became an important catalyst for the new performance. He asked Morris to participate in several of his New York projects, including a performance series at Yoko Ono's loft in 1961 and an anthology of contemporary performance and literary works. *An Anthology* was initially planned in 1960 (while Young was still in San Francisco) as a special issue of the poetry magazine *Beatitude East.* A compilation of writings and performance ideas, including the work of Cage, Brecht, Forti, Dick Higgins, Walter de Maria, Dieter Rot, and Nam June Paik, the anthology was eventually published in 1963 by George Maciunas, a Lithuanian émigré and New York gallery owner. It was Maciunas who, in 1962, brought together the various American and European manifestations of Events under the title "Fluxus," eventually acting as the movement's chief spokesman and principal sponsor.

The Duchampian, task-oriented sensibility of these Events appealed to Morris. Significantly, figures like Young and Brecht waged a major challenge to the concept of artistic authorship as they reformulated the readymade strategies of Duchamp. Like his teacher Cage, Brecht believed that music was not simply a construction of refined sounds played on special musical instruments but an extension of ordinary sounds and events. In Brecht's *Time-*

table (1961), for instance, performers were instructed to go to a train station, select a number from the timetable, and commence a performance of the same duration as that number (i.e., 2:25 would translate into two minutes and twenty-five seconds). Brecht considered all the activities that occurred in the train station during this period to be part of the performance.

Shortly before the publication of *An Anthology* in 1963, Morris withdrew his contribution, a manifesto on "Blank Form" sculpture—essentially reductivist monoliths that prefigured his orthodox Minimalist pieces—and instructions for "an object to be lost."[16] He had grown uncomfortable with Maciunas's leadership of Fluxus despite the movement's continued orientation toward Duchamp and its interest in reevaluating the role of the artist and the art object. "The Fluxus performances under the direction of Maciunas were nothing more than vaudeville, shallow revivals of the Dadaist performances of Hugo Ball and Tristan Tzara," Morris recently remarked. "I could not abide by the notion of theater as entertainment played for laughs."[17] In 1964 he wrote to Maciunas to inform him that he wanted nothing more to do with Fluxus.

Despite his involvement in Fluxus and performance, during this period Morris still saw himself primarily as an artist and not as a performer. The Events were important to him principally as a conduit to Duchamp's ideas on process, an interest that was stimulated by his reading of Robert Lebel's authoritative monograph on Duchamp, first published in 1959.[18] The tendency of the early dance improvisations and paintings to fetishize simple movements and gestures at the expense of broader social or intellectual contexts had made Morris extremely ambivalent about art making. As he sought a theoretical basis for reconciling process and theatricality with his art, the work and ideas of Duchamp seemed to offer a solution.[19] In 1960, after briefly experimenting with film as a device for recording various phenomena such as smoke and fire, he produced his first small-scale objects and drawings that related to Duchamp's use of convoluted instructions and processes.

One of the earliest of Morris's Duchampian objects was *Performer Switch,* an oak box with a mechanism and mirror inside and inscribed with a frustrating set of instructions: "To Begin Turn On—Continue Doing What You Are Doing—Or Don't—Do Something Else. Later Switch May Be Turned Off—After A Second, Hour, Day, Year, Posthumously" (Fig. 7). Several months later, Morris introduced the actual performance of repetitive tasks into

his art. For his drawing *Litanies,* (1961, Fig. 8), he wrote repeatedly for two and a half hours the text of the "Litanies of the Chariot," copying it directly from the typographic version of Duchamp's *Green Box* (published in English in 1960). For *Litanies,* Duchamp became Morris's alter ego, as the latter diligently copied over his teacher's writings like a student condemned to writing words of penance on a blackboard.[20] The task of duplicating Duchamp's prose—a list of instructions for the building of a sleigh for the realm of the bachelors in the *Large Glass*—also reiterated the fact that these notes spelled out a specific process. Significantly, one of the words in Duchamp's list, onanism, was a reference to mastur-

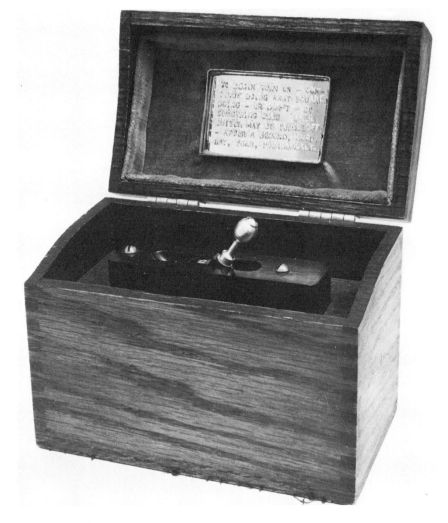

7
Robert Morris, *Performer Switch,* 1960. Oak file box, brass, velvet, and mechanism. Private collection.

bation, a self-contained and repetitive process. With this connection in mind, *Litanies* can be seen as a masturbatory performance piece where a useless task is repeated exhaustively in the manner of his early dance improvisations.

The *Box with the Sound of Its Own Making* (1961, Fig. 9), a nine-inch walnut cube containing a three-hour tape recording of its actual construction, was the first work by Morris to be fully involved with process. The *Box* literally interposed a temporal

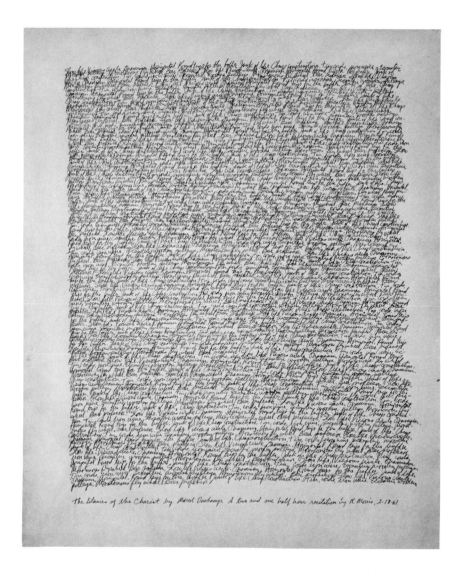

8
Robert Morris,
Litanies, 1961. Pen
and ink. Museum
of Modern Art,
New York.

record into the viewer's experience, a kind of nonverbal version of Duchamp's notes for the *Large Glass.* John Cage, who had been instrumental in introducing Morris to both the artist Jasper Johns and the influential art dealer Ileana Sonnabend, was the first person in New York whom Morris invited to see the piece. "When [Cage] came," Morris recalled, "I turned it on . . . and he wouldn't listen to me. He sat and listened to it for three hours and that was really impressive to me. He just sat there."[21] Cage's response was important to Morris, as he recognized the piece as a fully theatrical experience.

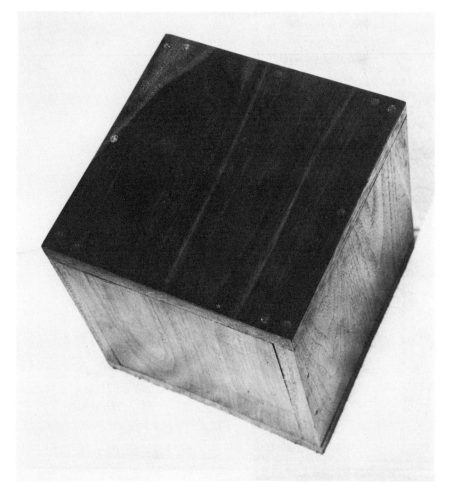

9
Robert Morris, *Box with the Sound of Its Own Making,* 1961. Walnut box, speaker, and tape recorder. Collection of Mr. and Mrs. Bagley Wright.

Another work of the period, *Card File* (1963, Fig. 10), was similarly process oriented. The work consists of a flat file mounted vertically on a wood panel. Notations inscribed on its cards enumerate, as in *Box with the Sound of Its Own Making,* the phases of its construction. The headings, clearly visible to the spectator even when the file's leaves are closed, offer a list of operations and transitions: the words "accidents," "alphabets," "categories," "changes" can be read along its plastic tabs.[22] In yet another kind of process piece, *Metered Bulb* (1963, Fig. 11)—a small wooden structure containing a light bulb and fixture attached to an electric meter—the expenditure of electricity is continuously recorded. In effect, the work traces the passage of energy and time in the context of capital, maintaining the kind of matter-of-factness one associates with a utility company demonstration.

10
Robert Morris, *Card File,* 1963. Flat file, wood, index cards. Collection of the Dwan Corporation, New York.

11
Robert Morris, *Metered Bulb,* 1963. Light bulb, ceramic socket, electric meter, wood. Collection of Jasper Johns.

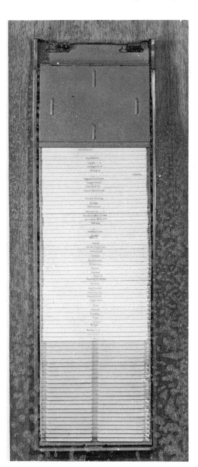

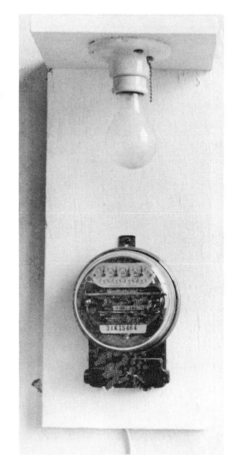

Morris's subversion of standard measure, an inversion rooted directly in the work of Duchamp, further confuses the normative conditions through which we attain our bearing in the world.[23] From 1961 until 1964, Morris produced more than two dozen objects and drawings of rulers, rods, and other devices for measurement that fundamentally challenged "objective" or "fixed" standards. In *Three Rulers (Yardsticks)* (1963, Fig. 12), the objectivity of measurement is confounded as each "yardstick," of a different actual length, "measures" thirty-six inches: standardized relations of scale are suddenly relegated to individual perception and subjectivity as the *concept* of measure becomes our *percept* of it. In *Enlarged and Reduced Inches* (1963), Morris shifts the action from

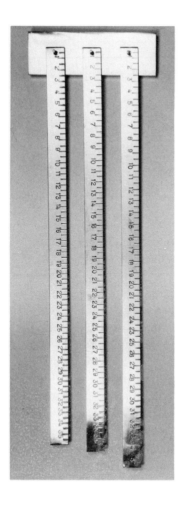

12
Robert Morris,
Three Rulers (Yardsticks), 1963/72.
Bronze.

predetermination to perception and contingency as the spectator is invited to view a ruler through two different lens apertures—one magnifying, the other reducing. In a painted construction from 1964 (Fig. 13), the "objective" ruler, which can now slide back and forth, is juxtaposed with the words "SWIFT NIGHT RULER." The relationship of the poetic (and erotic) non sequitur to the hard-edged object below it further undermines the ruler's pristine status as a vehicle for truth.

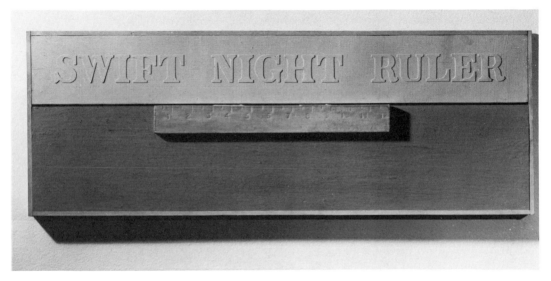

13
Robert Morris, *Swift Night Ruler,* 1963. Wood, wood ruler, oil paint. Collection of Leo Castelli.

In certain instances, Duchamp's objects provided a scenario for Morris's theatrical games. *Fountain* (1963, Fig. 14), a play on Duchamp's readymade of a urinal placed on its back, consists of an ordinary galvanized steel bucket hung above eye level. Unlike Duchamp's inverted urinal (Fig. 15), Morris's homage does not function as a static object; inside the bucket, and well above the viewer's line of vision, water noisily circulates through a pump.[24] What might have been a silent pun on modernist history instead becomes an endless performance piece, a kind of aural *ballet mécanique.* In contrast to Duchamp's readymade *Bicycle Wheel* (1913, Fig. 16), Morris's *Wheels* (1963, Fig. 17), made of fir and cast iron and measuring over four feet high, is vastly oversized. *Wheels* engages its ambient space in much the same way as large-scale props transform a proscenium in order to avoid an intimate, hence fetishistic, relationship with the spectator.

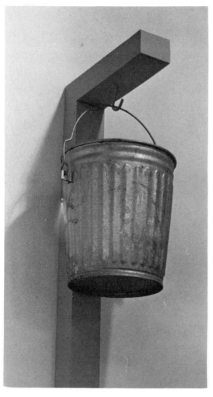

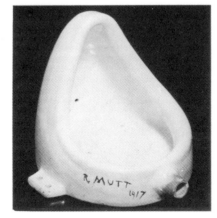

14
Robert Morris,
Fountain, 1963.
Wood painted
gray, galvanized
steel bucket, cir-
culating pump, and
water. Private col-
lection.

15
Marcel Duchamp,
Fountain, 1917.
Readymade: in-
verted porcelain
urinal. Original
lost, second ver-
sion. Collection of
Sidney Janis.

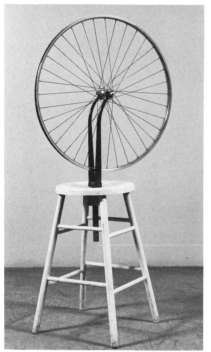

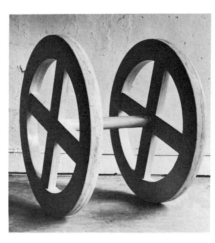

16
Marcel Duchamp,
Bicycle Wheel, 1913.
Bicycle wheel,
painted wooden
stool. Original lost,
third version
(1951). Museum of
Modern Art, New
York.

17
Robert Morris,
Wheels, 1963. Lami-
nated fir and cast
iron painted gray.
Art Gallery of On-
tario, Toronto.

To further distance his early objects from such a fetishistic relationship, Morris constantly projected enigmatic forms and confusing situations that denied the spectator a sense of complacency. This denial was effected through another Duchampian model, one that would become central to Morris's thinking: the idea of the self as perpetually divided and unstable. *I-Box* (1962, Fig. 18) represents one of Morris's earliest explorations of this shifted understanding of the self. The work—a box with a door in the shape of the letter "I" that conceals a photograph of Morris naked and grinning—cannot be read as a conventional self-por-

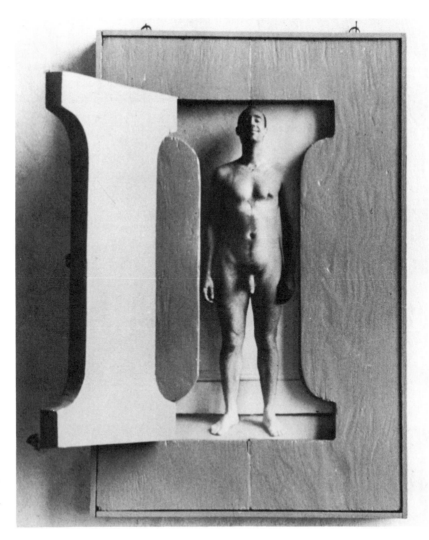

18
Robert Morris,
I-Box (open), 1962.
Plywood cabinet,
sculptmetal, photo-
graph. Collection
of Leo Castelli.

trait. The self is spelled out in *I-Box* not as centered but as an arbitrary function that hinges on an external action. While the act of opening the door exposes an improbable self-portrait that challenges art historical traditions of chastity and taste, the act of closing it (Fig. 19) denies representation of a specific self. "I" could now represent anything or nothing at all. As in *Document*—where an object's "value" depends on whether the patron or the artist is speaking—the oscillating meaning of the self in *I-Box* is contingent on outside factors.

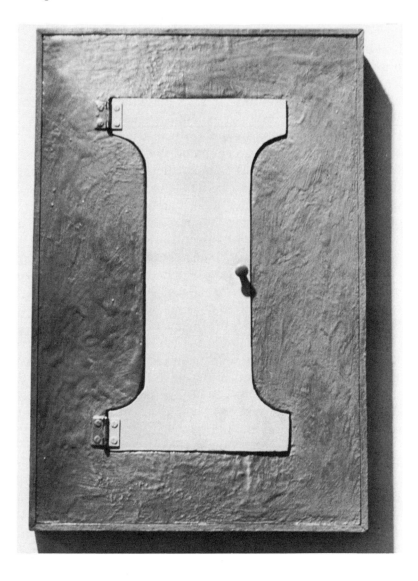

19
Robert Morris,
I-Box (closed),
1962.

The concept of a contingently identified self appeared earlier in this century in Duchamp's adoption of the female alter ego Rrose Sélavy, a significant fracturing of the psychological center into the bivalent sectors of sexual identity. (Another metaphor for this indeterminancy is Duchamp's *Door, 11 rue Larrey* [1927], an actual door designed by Duchamp to serve two doorways in his small Paris apartment. Paradoxically, the door could be opened and closed at the same time.) In order to understand the nature of such oscillating identifications of the self, we must turn to the concept of the shifter, an idea first explored by Annette Michelson in relationship to Duchamp.[25] The term "shifter" was initially employed by Roman Jakobson to describe "that category of linguistic sign which is 'filled with signification' only because it is empty."[26] Essentially, shifters are those features of speech that assign personal identity. The pronoun "this" is a shifter, its meaning fully dependent on its referent; it is only when we qualify such a shifter—"this pen" or "this cup," for example—that meaning can exist at all. In relation to this argument, the personal pronouns "I" and "you" are also shifters because their referents are entirely contextual, *shifting* in meaning as the conversation volleys back and forth between speakers. (The "I" belongs only to the person who is speaking; the "you" only to the person being addressed.) It is precisely a collapse of control over these qualifying factors of language that characterizes Duchamp's and Morris's transposition of the shifter into visual language. The sense of psychological centering inherent in the normal use of personal pronouns—the smoothly functioning shifters that demarcate the boundaries of a conversation—often collapses in their work.

In the development of speech in children, the ordering and application of personal pronouns is, in fact, difficult to master. In very young children, the conceptual distinction between "I" and "you" is one of the last things to be learned. In cases of aphasia, where the ability to orient speech correctly is entirely lost, personal pronouns are among the first things to break down. Bruno Bettelheim has observed that the problem of naming an individuated self is also central to the condition of autism in children. Bettelheim's observations on the autist's obsession with revolving disks (as in an oscillating fan), the fantasy of being a machine, and the withdrawal from coherent speech into a world of private allusions and riddles are, as Michelson has pointed out, analogous to Duchamp's interests. Michelson argues, "Duchamp's persistent interest in *Ro-*

tary Spheres, in the forms of rotation and motion, the insistence upon the usefulness of objects (exemplified in his joy at the possibility of *Anémic Cinéma* being considered as a therapeutic device to be used in the restoration of Vision), the elaborate linguistic play, the recasting of natural laws into highly artificial and controlled codes, the subversion of measure, the constant movement between alternatives which support his *esprit de contradiction,* the disdain of community, the extreme interest in scientific discovery, the enchantment with the pseudo-science of paraphysics, represents only a few strategies of the autistic economy so remarkably converted by him to uses of art and speculative thought."[27]

Influenced by Duchamp's *Rotative Demisphere* (1925, Fig. 20),[28] Morris's small construction *Pharmacy* (1962, Fig. 21) exemplifies the kind of autistic situation described by Michelson. The work

20
Marcel Duchamp, *Rotative Demisphere,* 1925. Painted wood demisphere, black velvet, copper, plexiglass dome, motor, pulley, and metal stand. Museum of Modern Art, New York.

interposes a glass plate between two circular mirrors. Two pharmacy bottles, one colored red, the other green, are depicted, one on each side of the glass plate.[29] The comparison to devices for rotation goes beyond the formal: by juxtaposing the images on a glass plate between the mirrors, Morris sets up an endless *mise en abyme,* an infinite repetition of red and green bottles. Such a compulsion to repeat would seem to suggest Morris's desire, like Duchamp's, to bring the art object more resolutely into the order of language and out of the realm of mute, magical objects.[30] But like Duchamp's linguistic imperative, the strategy of reduplication inherent in Morris's *Pharmacy* (as well as his later mirror pieces) resembles the running around in circles of the autistic child who never finds his elusive center, who is unable to connect with the linguistic order that would facilitate the search. Similarly, while Morris's mirrored reduplication of red and green forms reiterates their function as signifiers, the endless repetition offers no clarity for the viewer, who confronts instead a whirling, decentering riddle.

21
Robert Morris,
Pharmacy, 1962.
Painted wood, mirrors, glass. Collection of the artist.

Shortly after completing *Pharmacy,* Morris choreographed a dance solo that employed a similar use of disorienting, circular motion. *Arizona* (1963), one of the first dance pieces to be choreographed by Morris after he moved to New York, explored the simple movement of a dancer manipulating props (such as adjusting a horizontal rod mounted on a vertical rod or throwing a javelin at a target). A significant part of the piece involved swinging a small blue light at the end of a cord. As the cord was slowly let out, the lights in the room were dimmed until finally, in total darkness, only the moving point of light was visible as it revolved in the space above the heads of the audience. The establishment of a shifting focus "between the egocentric and exocentric"[31]— that is, between an internal and external connection with the world—reiterated Morris's concern with collapsed or fluctuating shifters, a concern with implications for the audience as well as the performer. In *Arizona,* the spectator was disoriented by the necessity of concentrating on the rotating point of light. This concentration served to suppress responses rooted in narrative or memory. The increasing prominence of the spiraling light gradually narrowed the spectator's field of vision. Vertigo eventually gave way to near blindness as the eye and mind fixed on the luminous speck navigating through total darkness.

Ironically, it is often Morris himself who is represented as decentered in these early works. Objects like *I-Box* or performances such as *Arizona* distort the boundaries defined by the normal use of the shifter, presenting the self—the "I"—through outer-directed, external references. *I-Box* neutralizes language by allowing the letter "I" to eclipse its referent. Once closed, the "I," independent of a subject to activate its role as shifter, "shifts" into another capacity: that of a coffin lid that enshrouds all personal references to the artist. In two other early works, *Self-Portrait* and *Portrait,* Morris suggested new ways of representing the self and of describing its relationship to a cultural process. The electroencephalogram of Morris's *Self-Portrait* (1963, Fig. 22), a registration of brain activity, stands as a mechanical trace of the artist's emotional center.[32] The work reiterates the way science often represents the human body and mind—as an external and mechanical record. In a slightly different way, *Portrait* (1963) names its subject with bottles of bodily fluids, permitting that which is excreted, literally left behind, to serve as a proxy for human existence.

22
Robert Morris, *Self-Portrait*, 1963. Electroencephalogram, lead labels, metal-and-glass frame. Collection of Max Protetch Gallery.

Driven by his opposition to formalism and encouraged by his association with dancers, artists, and musicians, Morris had begun in these early works to ask fundamental questions about the way art is made, exhibited, and received and the way in which the individual is situated and represented in social contexts. In this investigation, Morris frequently asserted his own presence in ways that sought to transcend his simultaneous desire to mock the cultism of the formalist artist. As the provocateur or protagonist in such works as the *Litanies* drawing, *I-Box,* and *Self-Portrait,* the "I" that he utters—in contrast to the machismo and temperament of the Abstract Expressionists—is neither biographical nor expressive. The viewer can never contact the man behind the persona, for his characters read as nothing more than bad actors whose gestures and articulations at every moment reaffirm the false and theatrical space around them. The "I" spoken in the early objects and dances is always rhetorical, always institutionally grounded, always deflected away from the private personality or history of the speaker. The "I" who is the pretentious art historian in *21.3,* the "I" who withdraws all aesthetic value in *Document,* the "I" who mocks the notion of the self-portrait in *I-Box* exist not as expressions of personality or ego but as constantly shifting surrogates who question the rules and standards that determine the particular and repressive order of our lives.

NOTES

1. Peter Bürger, *Theory of the Avant-Garde,* trans. Michael Shaw (Minneapolis: University of Minnesota Press, 1984), pp. 51–52.

2. Of course, Morris's position is impossible. Even the readymade itself could not escape from the museum's will to convert it into a valuable aesthetic object. Once established, as Peter Bürger has argued, the readymade paradigm quickly adapted to the status of art world commodity and was eventually absorbed by the museum (see Bürger, pp. 52–53). The fate of *Litanies* and *Document* is an exceptional example of this phenomenon. In reaction to Morris's response, Johnson purchased *Document,* later donating both works to the Museum of Modern Art in New York.

3. In conversation with the author, Gardiner, New York, June 21, 1986.

4. Robert Morris, "Some Notes on the Phenomenology of Making: The Search for the Motivated," *Artforum* 9 (April 1970), p. 63.

5. In 1969, Morris curated an "anti-form" exhibition at the Leo Castelli Warehouse in New York City that explored the issue of process in the art of the late 1960s. Artists in the show, in addition to Morris, were Alan Saret, Claes Oldenburg, Eva Hesse, Keith Sonnier, Bruce Nauman, Richard Serra, and Stephen Kaltenbach.

6. "Some Notes on the Phenomenology of Making," p. 64.

7. Transcript of a taped interview with Robert Morris by Paul Cummings for the Archives of American Art, March 10, 1968, pp. 17–19 (Morris archives, Gardiner, New York).

8. Robert Morris as quoted in an unpublished interview with Jack Burnham, November 21, 1975, p. 4 (Morris archives, Gardiner, New York).

9. It was these dancers who, in 1962, formed the core of the Judson Dance Group in New York.

10. This point was made by Robert Morris in a telephone conversation with the author on July 2, 1988.

11. Morris in Cummings, p. 29.

12. In conversation with the author, Gardiner, New York, June 11, 1985.

13. "Notes on Dance," *Tulane Drama Review* 6 (Winter 1965), p. 179.

14. Simone Forti was establishing an important dance career in New York in the early 1960s.

15. For more on the striking, decentering treatment of the audience in Happenings, see Susan Sontag, *Against Interpretation* (New York: Farrar, Straus & Giroux, 1967), p. 273. Sontag writes: "The performers may sprinkle water on the audience, or fling pennies or sneeze-producing detergent at it. . . . the audience may be made to stand uncomfortably in a crowded room, or fight for space to stand on boards laid in a few inches of water. . . . In Allan Kaprow's *A Spring Happening,* presented in March 1961, at the Reuben Gallery, the spectators were confined inside a long, boxlike structure resembling a cattle car; peepholes had been bored in the wooden wall of this enclosure through which the spectators could strain to see the events taking place outside; when the *Happening* was over, the walls collapsed and the spectators were driven out by someone operating a power lawnmower" (p. 265).

16. Morris's text for the latter—"put something inside that makes a noise and give it to a friend with the instructions' 'to be deposited in the street with a toss' "—was influenced by Duchamp's *A bruit secret* (With Hidden Noise) of 1916. Inside this work, a ball of twine between two brass plates, Duchamp had placed an unknown object that makes a noise when the sculpture is shaken. The information on Events and Fluxus in the above paragraphs is culled from Barbara Haskell, "Fluxus," in *Blam! The Explosion of Pop, Minimalism, and Performance, 1958–1964* (New York: Whitney Museum of American Art, 1984), pp. 48–59.

17. Robert Morris, in a telephone conversation with the author, July 17, 1988.

18. *Marcel Duchamp* (New York: Grove Press, 1959). Morris purchased the book in 1959.

19. For an early and important discussion of Morris's critical relationship to Duchamp, see Annette Michelson, "Robert Morris: An Aesthetics of Transgression," in *Robert Morris* (Washington, D.C.: Corcoran Gallery of Art, 1969), pp. 7–75. Duchampian strategies influenced a number of Morris's contemporaries, including Arakawa, Arman, Art & Language, Joseph Beuys, George Brecht, Marcel Broodthaers, John Cage, Allan Kaprow, Yves Klein, Jasper Johns, Robert Rauschenberg, Daniel Spoerri, and Andy Warhol. For a discussion of Duchamp's influence on post–World War II art, see John Tancock, "The Influence of Marcel Duchamp," in Anne d'Harnoncourt and Kynaston McShine, eds., *Marcel Duchamp* (New York: Museum of Modern Art, 1973), pp. 159–78.

20. Another work of this type consists of 1,347 pencil strokes drawn on bronze-paint-coated paper (*1,347 Strokes,* 1962). Such repetitive tasks can be seen as re-creations of the pathetic endgames of Samuel Beckett, a sensibility inherent to much of the artist's production. (Morris has acknowledged Beckett's influence in a transcript of an unpublished interview with Jack Burnham recorded on November 21, 1975.) For an important discussion of how these tactics invert such rationalist concepts as mathematical intelligibility, see Rosalind Krauss, "LeWitt in Progress," *October,* no. 6 (Fall 1978), pp. 46–60.

21. Burnham, p. 11.

22. *Card File* also parodies modernism's autonomist ambitions: in 1961, Morris was employed at the New York Public Library, often working in a veritable maze of card files filled with notations concerning the condition and location of the library's holdings. Since the internal dynamic of *Card File* is, in contrast, entirely self-referential (i.e., the operational information refers only to the making of the file itself), it is ultimately a "useless" object—a parody of the Baudelairean concept of *l'art pour l'art* on which so much modern art was built.

23. An important instance of this inversion occurs in Duchamp's *Trois Stoppages Etalon,* 1913–14. "*Etalon,*" or "standard," serves as *the* operative word as Duchamp's technique of measurement parodies our dependency on a priori systems. Essentially Duchamp dropped three one-meter threads on pieces of canvas, cutting out the resultant shapes defined by the curve of the threads: "they should be seen horizontally instead of vertically because each strip shows a curved line made of sewing thread, one meter long, after it had been dropped from a height of one meter, without controlling the distortion of the thread during the fall. The shape thus obtained was fixed onto the canvas by drops of varnish. . . . Three rules . . . reproduce the three different shapes obtained by the fall of the thread and can be used to trace those shapes with a pencil on paper. . . . One meter was changed from a straight line to a curved-line without losing its identity . . . and yet casting a pataphysical doubt on the concept of a straight-line as being the shortest route from one point to another."

24. The circulating pump in *Fountain* may be a theatrical allusion to the water mill in the realm of the bachelors in Duchamp's *Large Glass.*

25. "*Anémic Cinéma:* Reflections on an Emblematic Work," *Artforum* 12 (October 1973); reprinted in Amy Baker Sandback, ed., *Looking Critically: 21 Years of Artforum Magazine* (Ann Arbor: U.M.I. Research Press, 1984), pp. 143–48. For another important discussion of the shifter in re-

lationship to Duchamp, see Rosalind Krauss, "Notes on the Index: Part 1," in *The Originality of the Avant-Garde and Other Modernist Myths* (Cambridge, Mass., and London: M.I.T. Press, 1985), pp. 196–209.

26. Krauss, "Notes on the Index: Part 1," p. 197.

27. Michelson, p. 148. Michelson's categories of autistic behavior are taken from Bruno Bettelheim's description of Joey, a severely autistic child who lived for some years at the Orthogenic School in Chicago. At some time in his early childhood, Joey became so threatened by the human community that he transformed himself into a machine and invented an elaborate apparatus that he attached to his bed—a car machine that would run him or "live him" while he slept. For a detailed description of this aspect of Joey's case, see Bruno Bettelheim, *The Empty Fortress: Infantile Autism and the Birth of the Self* (New York: 1967), pp. 233–339.

28. When this work is in operation, the black concentric circles painted on a rotative demisphere appear to undulate, creating a mesmerizing illusion of space and depth.

29. These bottles allude to the red and green marks added by Duchamp to the print of a winter landscape in the rectified readymade *Pharmacie*, 1914, to suggest the bottles of colored liquid that were a common sight in pharmacy windows. According to Morris, he learned of this work in Lebel.

30. Behind the assertion that Morris's redu-

plicative strategies represent a kind of linguistic imperative stands Roman Jakobson's observation that the frequent occurrence of reduplication in infantile language suggests that it may be the sign of the subject's entry into the symbolic order. Significantly, the transition from babbling to linguistic performance—where the reduplication of sounds signals that "the uttered sounds do not represent a babble but a senseful semantic entity"—is coextensive with the mirror stage of childhood development, the stage just before entering into the symbolic order. For more on this issue, see "Why Mama and Papa?" *Selected Writings, I* (The Hague: Mouton, 1962), p. 542. For a discussion of this type of reduplication in relation to mirrors and photography, see Craig Owens, "Photography *en Abyme*," *October*, no. 5 (Summer 1978), pp. 73–88. For more on the concept of the "mirror stage" see Jane Gallop, *Reading Lacan* (Ithaca and London: Cornell University Press, 1982), pp. 74–94.

31. Robert Morris has discussed this relationship in "Notes on Dance," pp. 180–83.

32. Morris has elaborated on *Self-Portrait*'s shifted identification of the self: "I went to N.Y.U. Medical Center and . . . had an electroencephalogram made. I wanted to make a self-portrait. In one second the needle will travel so far so I calculated the time I would have to think about myself for the needle to travel the length of my height. That was considered a self-portrait. I thought about myself for this time and used that kind of output as a drawing." See Cummings, p. 27.

2

AGAINST REPRESSION:
MINIMALISM AND ANTI-FORM

Art remains alien to the revolutionary praxis by virtue of the artist's commitment to Form: Form as art's own reality, as *die Sache selbst.*
— Herbert Marcuse, *An Essay on Liberation*

A gray plywood column, two feet square and eight feet high, stands on an otherwise empty stage. For three and a half minutes the column remains erect. Suddenly the column falls to the floor. Another three and a half minutes pass without action. Finally, the stage lights black out, marking the end of the performance.

Significantly, Robert Morris's first Minimalist sculpture—*Column*—was not presented in a museum or gallery but in a theater. *Column* (Fig. 23) was the sole element in Morris's debut performance organized by La Monte Young at the Living Theater in New York in 1961 to raise money for the publication of *An Anthology.* Although a simple prop in a performance piece, *Column* presaged many of the major concerns of Morris's orthodox Minimalist sculptures of the mid-1960s. In its literal fall from illusionism, its rejection of formalist sculpture's defiance of gravity, *Column* reasserted the anti-illusionism that would become central to Morris's transgressive strategy. The action of the sculpture as a kind of confrontational *performer* created an explicit analogy between itself and the

47

artist's body. In fact, the original plan was for Morris to be inside the hollow column and for it to fall over while he was standing inside it, making the sculpture both literally and metaphorically a surrogate for the human body. (In the actual performance a string was used to topple the column because Morris was injured during a rehearsal on the day of the performance.) The notion of temporality and passage would contribute to the dissolution of formalism's romance with idealized form and time. In the end, Morris's metaphoric toppling of the pillars of late modernism announced an important shift within the American cultural scene as the art object appeared to be dissolving into a field of choreographic gestures.

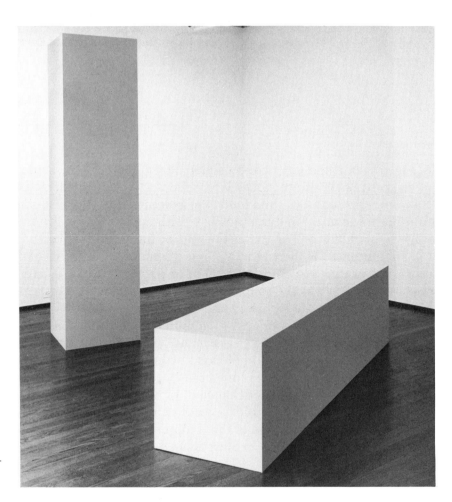

23
Robert Morris, *Columns*, 1961/73. Painted aluminum.

From the time he began painting in the 1950s, Morris's career as an artist was moving toward the theatrical. By 1964 he had stopped making small objects altogether, concentrating instead on dance pieces and on installations of the large gray polyhedrons that would come to characterize his Minimalist phase. Morris's earliest large-scale sculptures, executed in 1961 and influenced by the stage sets and props of Forti's early dances, often integrated the spectator into the temporal dynamic of the piece. Works like *Passageway, Pine Portal* (Fig. 24), and *Mirrored Portal*—sculptures predicated on the passage of the viewer's body through a channel or doorway—maintained a simplicity, literalness, and human scale that later would be extended to the Minimal sculptures. These theatrical explorations, by emphasizing the temporal experience over the art object's autonomy, contributed to Morris's reevaluation of the self-contained aesthetic object.

24
Robert Morris, *Pine Portal*, 1961.
Wood. Destroyed.

In "Art and Objecthood" Michael Fried wrote quite perceptively about the threatening, aggressive presence of Morris's Minimalist objects. He noted, in particular, that the disquieting experience of such sculpture was not unlike being "distanced, or crowded, by the silent presence of another *person.*"[1] This observation is especially interesting because on first glance Morris's works are so simple and unassuming. First constructed in plywood painted in a neutral gray and later fabricated in gray fiberglass, these sculptures are composed of simple, unitary geometric forms: rectangular plinths, cubes, beams, L-beams, and wedges. Fried's recognition of the confrontational stance of Morris's large-scale columns and L-beams raised important questions about the way these sculptures radicalized the heretofore passive relationship between art object and spectator, for in their large size and direct engagement of their ambient setting (i.e., pedestals were eliminated), Morris's Minimalist sculptures tended to create a *presence* parallel to that of the observer.

The scale relationships of Morris's Minimalist sculptures were significant, because the body was the ultimate target of their phenomenology. For Morris, the new sculpture was not so much a metaphor for the figure as it was a parallel existence, sharing the perceptual response a viewer would have toward the human body. "This is undoubtedly why subliminal, generalized kinesthetic responses are strong in confronting [the new sculpture]," he wrote. "Such responses are often denied or repressed since they seem so patently inappropriate in the face of non-anthropomorphic forms, yet they are there."[2] By assuming literal, human-scale relationships these objects create a direct analogy between themselves and the spectator's body.[3] Morris had proposed these sculptures as early as 1960 in a manifesto that was his unpublished contribution to La Monte Young's *An Anthology.* To be built in a scale that was roughly the same or slightly greater than that of the average man, Morris referred to these objects as Blank Form sculpture:

So long as the form (in the broadest possible sense: situation) is not reduced beyond perception, so long as it perpetuates and upholds itself as being [an] object in the subject's field of perception, the subject reacts to it in many particular ways when I call it art. He reacts in other ways when I do not call it art. Art is primarily a situation in which one assumes an attitude of reacting to some of one's awareness as art. . . .

Some examples of Blank Form sculpture:

1. A column with perfectly smooth, rectangular surfaces, 2 feet by 8 feet, painted gray.

2. A wall, perfectly smooth and painted gray, measuring 2 feet by 8 feet by 8 feet.

3. A cabinet with simple construction, painted gray and measuring 1 foot by 2 feet by 6 feet—that is, a cabinet just large enough to enter.[4]

Ultimately, the dimensions of the orthodox Minimalist sculptures began to conform to simple divisions or multiplications of the standard sizes of the materials used (e.g., 4 × 8′ sheets of plywood). Morris's acceptance of scale derived from such ready-made situations deprived these works of some of the mysteries of intuition, taste, and inspiration associated with late-modernist sculpture. The literalness of these sculptures was further enhanced by the neutrality of their mat gray color, paint chosen by Morris specifically to avoid color-based associations. In retrospect, contemporaneous works such as David Smith's elegantly burnished *Cubis* appear complex and expressive by contrast. Even Donald Judd's use of industrial materials and slickly colored surfaces (Fig. 25) seem precious when compared with Morris's more neutral and austere structures.

25
Donald Judd, *Untitled*, 1966–69. Stainless steel, plexiglass.

For Morris, whose ideas about perception and experience were rehearsed in a series of widely read writings, viewer behavior and interaction were far more important than traditional sculptural concerns with gravity, volume, and mass.[5] His preference for direct engagement, for example, called for a rejection of formalist sculpture's defiance of gravity: the illusionism of Brancusi's birds in flight, Calder's whimsical mobiles, or David Smith's balancing *Cubis* (Fig. 26). These were seen by Morris as seeking transcendence and thus were irrelevant to his interest in exploring process, the literal properties of materials, and the interaction of the viewer with the art object. By eliminating the base, for example, and placing his objects directly on the ground, Morris was able to realign the spectator's experience of sculpture. Rather than approaching allusive, rarefied forms, the viewer could now walk along, around, and even through the sculpture—a situation that emphasized the phenomenological implications of time and physical passage.

26
David Smith, *Cubi I*, 1963. Stainless steel. Detroit Institute of Art.

Morris sought to prolong and intensify the viewer's temporal experience of sculpture by frustrating the visualization of form through a disruption of its three-dimensional gestalts. For example, in *Untitled,* 1965 (Fig. 27), an arrangement of four identical cubic forms, two sides of each cube were sloped in order to question the strength of the known shape—the gestalt—while at the same time making that strength even more visible by affirming the impulse to see the shape as a cube (despite the displacement of one of its sides). In the simplest shapes, such as cubes and pyramids, "one sees and immediately 'believes' that the pattern within one's mind corresponds to the existential fact of the object."[6] The altered gestalt of *Untitled* prevents the spectator from immediately apprehending the individual shapes in the arrangement; one has to move around the piece *in time* to fully understand its nuances.[7]

27
Robert Morris, *Untitled,* 1965. Gray fiberglass.

Morris employed other devices for altering gestalts. In another untitled work of 1965 (Fig. 28), this time consisting of four identical three-foot mirror-laminated cubes, the artist allowed the form of the object to dissolve into its ambient setting—even as it was defined through reflection.[8] This use of altered gestalts became especially important to Morris as he extended the strategy to investigate the way objects are actually deployed in their settings. A dramatic instance is Morris's *Untitled (L-Beams)* (1965–67, Fig. 29), which juxtaposes three large L-shaped plywood beams.[9] The three identical forms, with their massive eight-foot extensions, were arranged in various positions relative to the floor: one lying on its side, one up-ended, one inverted. This displacement creates an optical illusion. While the logic of the forms' uniformity is understood, the visual inconsistency of their positioning precludes seeing them as the same. And because their similarity must be judged by standards that exist prior to actual experience, the *L-*

28
Robert Morris, *Untitled (Four Mirrored Cubes),* 1965. Installation at the Green Gallery, 1965. Glass mirrors on wood.

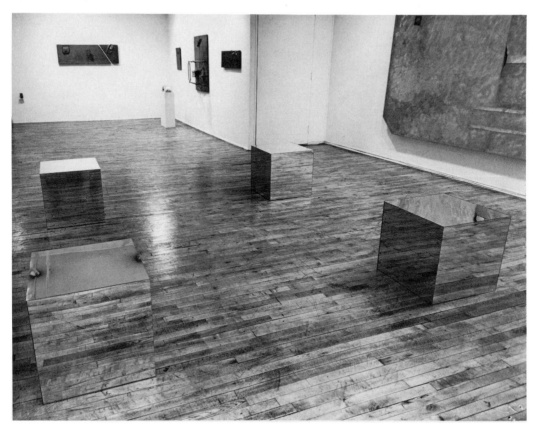

Beams—much like Morris's rulers of irregular lengths—are particularly challenging in their difference. The viewer's preconceptions must be set aside, for what is known mentally is rendered irrelevant by public experience. With such accumulations of memory and knowledge made inoperative, the viewer must start from the level of brute perception in order to grasp the reality of what he or she is seeing.

Morris's interest in systems and permutable structures offered another way of avoiding a consistent and easily definable gestalt. In the middle to late 1960s, Morris executed a series of large-scale sculptures that consisted of simple geometric units that could be rearranged into different structures.[10] In 1967, for example, he produced several untitled works consisting of wedge-shaped units accompanied by diagrams that offered numerous possibilities of manipulation and exchange (Figs. 30, 31). When these works were later exhibited at the Leo Castelli Gallery, Morris rearranged the

29
Robert Morris, *Untitled (L-Beams),* 1965–67. Gray fiberglass.

units each day to form new configurations. As Morris said later, by defying the "Cubist aesthetic of having reasonableness or logic for the relating parts, [the permutability of these pieces] takes the relationships out of the work and makes them a function of space, light, and the viewer's field of vision."[11] Instead of static gestalts, the spectator was confronted with a field of information that is continually subject to alteration and revision. Rather than representing the systems analysis that some critics have suggested (and that many artists were investigating at the time), Morris's work specifically contradicts the static, often predictable nature of systems. Instead of presenting logic or mathematics, his pieces are about the primacy of experience; they articulate meaning or understanding by filtering passage and vision through a constantly shifting set of temporal circumstances.

The provocative, aggressive relation of Morris's sculpture to the spectator's body suggests an even more complex level of confrontation—an erotically charged confrontation meant to overturn

30
Robert Morris, *Untitled (Wedges)*, 1967. Gray fiberglass. Panza Collection, Milan.

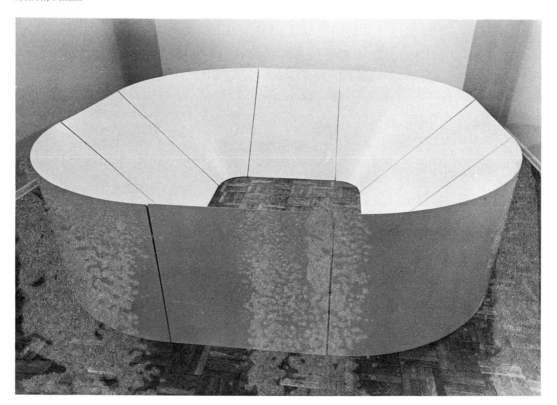

the purity and aloofness of much formalist sculpture.[12] For the most part, this psychosexual dimension of Morris's work eluded Minimalist criticism, where puritanical formalist methodologies continued to prevail. Indeed, the psychosexual possibilities of abstract art probably would have gone entirely unnoticed in the

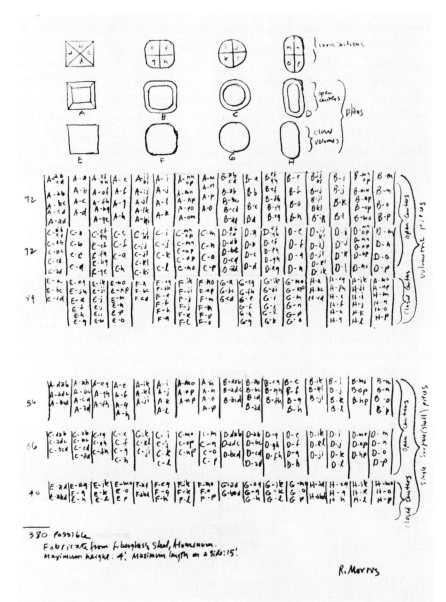

31
Robert Morris, *Untitled (Drawing for 380 Possible Fiberglass, Steel, and Aluminum Pieces)*, 1967. Pencil on paper. Collection of the artist.

1960s had it not been for the concurrent liberalization of sexual practices and mores in American society. In 1967, the art critic Lucy Lippard observed that a number of writers had speculated that the 1966–67 art season would be the "Erotic Season"—an answer to the Pop, Op, Primary Structures seasons past. "For at least two seasons," she wrote, "rumors have been rife of wickedness stored up in the studios waiting for the Trend to break."[13] It never did. Although Lippard believed that "an audience visually sophisticated enough to appreciate and at times prefer non-objective works of art as concrete objects in themselves, rather than associative look-alikes, [would] also prefer the heightened sensation that can be achieved by an abstractly sensuous object,"[14] abstract eroticism was a difficult concept for people to accept. As it was, Lippard was one of the few critics of the period to apply any kind of erotic reading to abstract art, and even she concluded that in Morris's case the lack of allusiveness in his orthodox Minimalist pieces amounted to a "deadpan anti-eroticism."[15]

Yet it was precisely the *repression* of eroticism that Morris's works attempted to dramatize: the viewer was aggressively *confronted* by imposing, unfamiliar forms inserted disconcertingly into the neutral space of the gallery or museum. In contrast to Morris's erotic work of the early 1960s—the allusions to sexual organs in the constructions, the nude photograph and swinging door of the *I-Box,* the overt sexual imagery in his dances *Site* and *Waterman Switch*—these large-scale geometric objects avoided explicit erotic content. Instead, their sensuality was predicated on the experience of encountering them. When the critic Jack Burnham asked Morris how he accounted for the sensuality of his large-scale plinths, cubes, and beams, Morris replied that the human scale and bulk of these sculptures emphasized their confrontational and anthropomorphic aspect. "Their sensuality has to do with their shape, how they stand in space," Morris said. "I just think that there are certain shapes that one . . . gets [a] charge from."[16] In particular, for Morris, such sculptural confrontation was transgressive because it defied the libidinal repressiveness of formalist sculpture.

An important record of Morris's reassessment of formalist practice during this period is his unpublished master's thesis, "Form-Classes in the Work of Constantin Brancusi." Written and researched under the direction of E. C. Goossen and William Rubin at Hunter College from 1963 to 1966, Morris's thesis was

based on George Kubler's *The Shape of Time* (1962).[17] Kubler's book, a popular theoretical text in the early 1960s, employed a methodology based on linguistics and anthropology in order to present a new approach to the problem of aesthetic historical change.[18] Kubler's analysis regarded historical sequence to be the result of continuous change rather than a succession of relatively static styles (the founding convention of art history).[19] Morris applied Kubler's ideas to an analysis of the various shifts and repetitions of abstract form throughout Brancusi's development; he eliminated both biographical information on the artist and organic metaphors of stylistic evolution. Rather than seeing Brancusi's development as continuous, and hence evolutionary, Morris discussed the various classes of forms that recur throughout his oeuvre.

One such "form-class," as Kubler called these areas of formal similarity, comprised the elaborately carved bases and pedestals that supported Brancusi's sculptures (Fig. 32). These bases became increasingly important for Morris as his thesis progressed, for he began to disdain Brancusi's sculpture, finding the works themselves compulsive, repressed, and transcendent. Morris felt that the bases were more important because they were less sexually constrained:

32
Constantin Brancusi, *Young Bird*, 1928. Museum of Modern Art, New York.

> I was really fascinated with the bases: they were stacked, per-
> muted. As [the art critic] Sidney Tillim had suggested, all the
> sexual energy, all the implications of violence, were below a
> neutral axis, repressed in the base. What lay above these
> pedestals was absurd—obsessive, repressive, puritanical.[20]

In an essay cited by Morris in his thesis, Tillim had described
Brancusi's compression of the totem into pedestals as a subordina-
tion of the artist's passions, a kind of puritanical repression of
sexuality and violence into the sculpture's base.[21] The threshold
of Brancusi's displacement of libidinal energy was, in Tillim's anal-
ysis, the top plane of the pedestal, the neutral axis that delineated
the horizontal base from the perpendicular vertical sculpture that
crossed it. The use of this crosslike organization, Tillim reasoned,
had unconscious meaning beyond the formal or aesthetic: "It pre-
vents the energy repressed into the pedestals from entering the
pure realm, that of the form it supports, and in this respect paral-
lels somewhat Modigliani's habit of employing sinuous elongated
necks in his portraits . . . to control his sexual appetites through
asceticism."[22]

For Tillim, Brancusi's "pietism" was rooted in self-protection;
his ambitions prevented him from exposing the shame of his libidi-
nal drives. Brancusi's fears demanded that he compress the totems
into pedestals in order to subordinate his passions or at least to
make them less prominent. In his sculptures as well, Brancusi
tended to deny the extremities of the body and to smooth his forms
to the bone so that they read as an essence, and only an essence,
of the real world. "Brancusi spoke of his expression as 'pure joy,' "
Tillim continued, "mistaking as essence what the anonymous peb-
ble form becomes when it is arrived at through intense stylization
of a particular form, like rocks by the shore smoothed by the
incessant tides until their surfaces offer no resistance."[23] Signifi-
cantly, Tillim went on to address the sociopolitical implications of
this repression, identifying its basis in ideology. As Tillim noted,
to relieve this repression Brancusi sought approval from authority
through quasi-aesthetic instruments—nature and piety. "Now,
when the great democracies are so anxiously engaged in promot-
ing what constitutes their ideologies," Tillim wrote, "we find a new
insight into this supposed essence. All told, this is sentimentality
dressed up as an idea."[24]

The idea of linking repression to social and political needs was

not uncommon in the theoretical writings of the late 1950s; it reflected an important shift in the analysis of Freudian theory. In *Eros and Civilization,* a philosophical critique of Freud, Herbert Marcuse argued for a recognition of the essentially political nature of this repression.[25] Marcuse's work, published in 1955 and widely read in both Europe and the United States, served as an influential manifesto of sexual liberation in the 1960s.[26] During this period, Morris was profoundly influenced by Marcuse's writings. He not only analyzed and debated *Eros and Civilization* at Reed College in 1955, but he continued to study Marcuse's writings well into the 1960s.[27] With *Eros and Civilization,* in particular, Morris was intrigued by Marcuse's vehement disputation of Freud's tendency to identify "civilization" with repression. Freud had reasoned that to function in an ordered society, the individual must yield to society's conscious and unconscious mechanisms of restraint and suppression; the base urges of "pleasure" must never overcome the pragmatic needs of "reality." For Marcuse it was precisely this acquired self-repression—so central to society that it is handed down from one generation to another like the tenets of law—that strengthens the forces that inhibit freedom and liberation. "What started as subjugation by force," wrote Marcuse, "soon became 'voluntary servitude,' collaboration in reproducing a society which made servitude increasingly rewarding and palatable."[28]

Freud saw the sacrifice of libido as necessary to stimulate a society oriented toward labor rather than leisure. In this sense, society's motive in enforcing the reality principle is "economic, since it has not means enough to support life for its members without work on their part, it must see to it that the number of these members is restricted and their energies directed away from sexual activities on to their work."[29] Rather than regarding repression as injurious, Freudian psychoanalysis to an extent invested in its virtues, validating its role in the formation of the symbolic order of language and ultimately of society. Yet, even Freud himself openly postulated that the very neuroses he sought to cure by psychoanalysis might be due to this repression.

So Marcuse's interpretation of the repressive role of sexual sublimation in an increasingly oppressive society was not entirely absent from Freudian discourse. Indeed, in his essay " 'Civilized' Sexual Morality and Modern Nervous Illness" (1908), Freud had argued that by prohibiting sexual intercourse except in monogamous marriage, "civilization" was contributing to the rapidly

spreading incidence of nervous illnesses in "present-day society."[30] For Freud, sexual repression was sanctioned in society in a number of ways, but especially by the church. There "the piece of instinctual satisfaction which each person had renounced was offered to the deity as sacrifice."[31] Freud felt the same was true in medicine, where proper "hygiene" insisted that sex be practiced only within the confines of monogamy. A perpetual insistence on sublimation—on the capacity to exchange specifically sexual aims for productive, civilized ones—might, according to Freud, result in an increasing degeneration into neurosis.[32] This "inverse relation holding between civilization and the free development of sexuality,"[33] Freud reasoned, should ultimately be modified in order to assure, rather than undermine, the furtherance of civilization.[34]

Fifty years later, a generation of thinkers emerged who radicalized the cause of liberating the sexual instincts in the service of social and cultural freedom. In the 1960s, it was often suggested, for example, that an end to political oppression was rooted in the discourse of sexual liberation (and the liberation of women from a gender-based power structure).[35] For Marcuse, the battle for liberation also would be fought on the turf of sexual freedom. In a revised "Political Preface" for *Eros and Civilization* written in 1966, at the moment of the great liberation struggles in Vietnam, the Congo, South Africa, and in the ghettos of America's "affluent society," Marcuse restated this connection: " 'Polymorphous sexuality' was the term I used to indicate that the new direction of progress would depend completely on the opportunity to activate repressed or arrested *organic,* biological needs: to make the human body an instrument of pleasure rather than labor. The old formula, the development of prevailing needs and faculties, seemed to be inadequate; the emergence of new, qualitatively different needs and faculties seemed to be the prerequisite, the content of liberation."[36]

The idea of desublimation was important to Morris, since art was for him a vehicle for unrepressed erotic expression. A self-portrait composed of bodily fluids, a work composed of rubber membranes and entitled "cocks and cunts," and the appearance of nude bodies from his *I-Box* to Carolee Schneemann's portrayal of Manet's *Olympia* in his dance *Site* are all representative of the psychosexual dynamic of his early work. His most controversial use of sexuality was—not surprisingly—a dance piece. In late Spring 1965, Morris shocked an audience in Buffalo with a dance that

became notorious for its supposedly scandalous use of nudity. *Waterman Switch,* which had first been performed at the Judson Memorial Church in New York on March 23, 1965, was a twenty-minute trio danced by Morris, Yvonne Rainer, and Lucinda Childs (Fig. 33). The stage was set with fake stones and four plywood sections of track. Morris and Rainer, nude and clutched in a tight, face-to-face embrace, carefully walked along the parallel plywood tracks. Childs, dressed as a man in a suit and tie, walked alongside the couple as she held a ball of twine, seemingly directed by the taut line that stretched over her shoulder to a point off stage. In a review in the *Village Voice,* the dance critic Jill Johnston described the action:

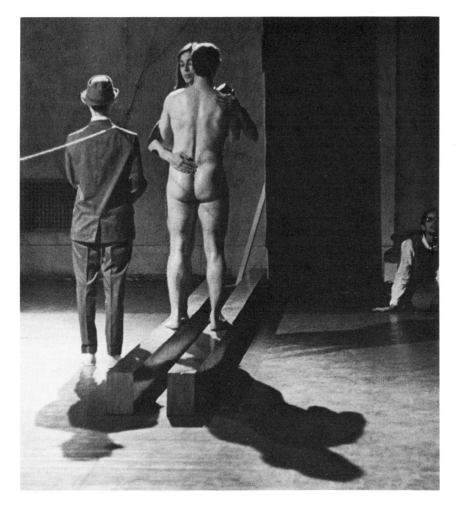

33
Robert Morris, Yvonne Rainer, and Lucinda Childs performing in Morris's *Waterman Switch,* Judson Memorial Church, New York, March 23, 1965. Photo: © Peter Moore, 1965.

The three of them walk to emphasize a horizontal journey that takes four minutes and suggests an eternity. The girl-boy image (Lucinda Childs) is entirely functional for set-up and support, but she is also a brilliant device as a neutral foil (familiar in various guises in Morris's sculpture) to the naked Morris and Rainer. Yet the two images seem scrupulously balanced. A girl obviously a girl dressed just as obviously as a boy can be an image no less striking than that public exposure which is immediately understood as vivid by any culture that undresses only in private.[37]

Unquestionably, the horizontal passage of Morris and Rainer was sexual. While never exposing their genitalia, the nude couple was emphatically erotic: their bodies, glistening in a sheath of mineral oil, remained pressed together in an embrace, their walk accompanied by "a very lush" love aria from Giuseppe Verdi's *Simon Boccanegra*. "It is an absurd love-duet," wrote David Antin, "and there is the sense that the artist is 'simulating' . . . being stripped bare."[38] As Antin suggested, the dance deliberately recalled Duchamp: the woman dressed as a man—a brilliant inversion of the transvestism of Rrose Sélavy—guiding the bride and the bachelor beyond the post-virginal point of no return. No wonder, then, that the final scene of *Waterman Switch*, essentially a duplication of the first, ended with Morris pouring the contents of a bottle of mercury down Rainer's nude, shimmering back. The slithering mass, rudely hitting the floor, serves as a metaphor for the deflowering—a transgressive, voyeuristic passage that implicates both spectator and performer.

Morris himself alluded to the Duchampian premises of the nude dance when, shortly after *Waterman Switch* was staged in 1965, he asked Duchamp about his nude appearance in Francis Picabia's *Ciné Sketch* in 1924. Between acts, during the brief run of the ballet *Relâche*, Duchamp and Brogna Perlmutter had performed Picabia's sketch, a *tableau vivant* of Adam and Eve—with the original costumes. Referring to a documentary photograph that indicated the discreet placement of a fig leaf over Adam's genitalia, Morris asked Duchamp if the camouflage was present in the actual performance. Duchamp answered that it was not, though it was.[39] Still, the exchange suggests that Morris's use of nudity in *Waterman Switch* was meant to attack the normalizing mechanisms of bourgeois repression—an intention that, besides the dances of

Morris, motivated such important manifestations of advanced art in the early 1960s as the influential performances of Carolee Schneemann (Fig. 34) and the films of Andy Warhol (Fig. 35).[40]

Morris's understanding of desublimation also underlay his very special conception of sculpture as a phenomenological experience. Despite art historical discussions that have attempted to locate Morris's understanding of phenomenology in his reading of Peirce and Merleau-Ponty in the early 1960s,[41] it was *Eros and Civilization* that first exposed Morris to the idea that the structure of art could be radically altered by reorienting it away from the

34
Carolee Schneemann and cast performing in Schneemann's *Meat Joy,* Judson Memorial Church, New York, November 1964. Photo: © Peter Moore, 1964.

predetermined institutional situations of the museum and gallery
and toward direct engagement with the spectator and the world at
large. Because the formalist concept of aesthetics based on Kant
inherently contradicts a reality principle based on utility rather

35
J. MacDermott, Ge-
rard Malanga, and
Edie Sedgwick in
Andy Warhol's
Vinyl, 1965. Six-
teen-millimeter,
sound, black-and-
white film. Museum
of Modern Art
Film Stills Archive.

than pleasure, it became a foil in Marcuse's battle for liberation. Marcuse's call for cognition liberated from the a priori conventions of culture went well beyond the relatively conservative imperatives of phenomenology. Marcuse wrote:

> Under the predominance of rationalism, the cognitive function of sensuousness has been constantly minimized. In line with the repressive concept of reason, cognition became the ultimate concern of the 'higher,' non-sensuous faculties of the mind; aesthetics were absorbed by logic and metaphysics. Sensuousness, as the 'lower' and even 'lowest' faculty, furnished at best the mere stuff, the raw material, for cognition, to be organized by the higher faculties of the intellect.[42]

If the phenomenology of Merleau-Ponty envisioned a world where "clear and articulate objects [are] abolished,"[43] where experience is pure and simple, it did so to apprehend the world free of the conditions of logic and reason established by a positivist, scientific, industrial social order. In a critique that was not inconsistent with the writings of Merleau-Ponty, Marcuse had cautioned against the Husserlian application of phenomenology as a kind of philosophical formalism that grasped the meanings of things "by abstracting their mere facticity, their mere belonging to the spatio-temporal world."[44] Such abstractions, he reasoned, deprived even phenomenology of an understanding of the greater social possibilities of validating existence over essence. For Marcuse, art could serve as a negating political force if its production and reception could be liberated from the repressive order of logic and reason.[45] In this way, it was Peirce's and Merleau-Ponty's questioning of rationalist principles, reinterpreted through Marcuse's political critique of the repressive logic of late capitalism, that constituted the social basis for Morris's brand of Minimalism.

In effect, Morris was interested in *desublimating* art—in producing aesthetic forms and conditions that challenged the repressive conditions of the museum or the gallery. Propelled by his own early desire to subject the art object to liberating conditions of process and performance, Morris came to believe that even his own orthodox Minimalist sculptures were formal and repressive, for their altered gestalts or mirrored surfaces did not negate their reality as unitary and closed forms. In the summer of 1967, Morris began the process of further reducing the repressive aspects of his art. This intensive process took the form of a series of sculptures

made of industrial-quality felt. The organization of the felts was relatively consistent: each piece was begun with one or more large rectangles of felt, sometimes slit into bands. The basic arrangement was geometric and regular; at other times it was irregular. Some pieces were hung on the wall, their parts cascading to the floor (Fig. 36); others were entirely floor bound (Fig. 37), organized in arrangements of folded or scattered rectangles. The softness and fragility of the felts resulted in a randomness subject to the temporal conditions of the environment.[46] The felt pieces allowed the sensual qualities of the earlier plinths to become more explicit. The formal, architectonic gray monoliths had dissolved into the random scatter of *anti-form*—a name coined by the editors of *Artforum* magazine in 1968 as the title of an influential and controversial essay by Morris.[47]

36
Robert Morris, *Untitled*, 1967–68.
Felt.

On one level, the felt pieces suggested Pollock's bifurcated process of accident and control.[48] The felts, however, were more radical in relation to traditional art than such historical allusions suggest. Morris himself cautioned against too literalist a reading of anti-form in relation to the past: "But to identify its resultant 'field' aspect very closely with Pollock's work is to focus on too narrow a formalistic reading. Similar claims were made when minimal art was identified with the forms found in . . . constructivism."[49] Fundamentally, anti-form overturned the conventions of connoisseurship, where the relative quality of sculpture was evaluated on the basis of the beauty and refinement of its form, offering instead an indeterminate object with an indefinite set of sculptural possibilities.

37
Robert Morris, *Untitled*, 1967–68. Felt.

Morris extended the anti-form concept to other areas of his production in this period. In a work of 1968, for instance, Morris gathered threads and fibers on a thirty-square-foot area of the floor, further dematerializing the work's objectness by dispersing several upright mirrors in the field of materials (Fig. 38). Other floor pieces involved the scattering of felt, rubber, and/or metal scraps, while *Earthwork* (1968, Fig. 39) consisted of a 20 × 25' low mound of soil and rocks. In his *Continuous Project Altered Daily* (1969,

38
Robert Morris, *Un-titled*, 1968.
Thread, mirrors, asphalt, aluminum, lead, felt, copper, steel.

39
Robert Morris, *Earthwork*, 1968.
Earth, grease, peat, steel, copper, aluminum, brass, zinc, felt. Destroyed.

Figs. 40, 41), Morris produced an environment with an almost inexhaustible set of variations as he scattered, shoveled, and displaced various materials on the floor of Leo Castelli's warehouse, changing the installation each day for a month. Rather than representing objects or forms, the anti-form works projected a direct and literal presence. In his essay on the anti-form sensibility, Morris argued that this negation could undermine the modernist fetishism of the object:

40
Robert Morris, *Continuous Project Altered Daily* (state 2), 1969. Earth, water, paper, grease, plastic, wood. Destroyed.

41
Robert Morris, *Continuous Project Altered Daily* (state 5), 1969.

Under attack is the rationalistic notion that art is a form of work that results in a finished product. Duchamp, of course, attacked the Marxist notion that labor was an index of value, but readymades are traditional iconic art objects. What art now has in its hands is mutable stuff which need not arrive at a point of being finalized with respect to either time or space. The notion that work is an irreversible process ending in a static icon-object no longer has much relevance.[50]

The modernist obsession with quality was also rejected by Morris as yet another condition of commodity fetishism. Calling the concern with quality in art another form of "consumer research," Morris saw it as a conservative concern involved with comparisons between static, similar objects within closed sets.[51] The anti-form concept—a notion derived from Morris's investigation of process and perception—posed a crucial question about the nature of advanced art: Could the form of the art object be desublimated in order to upset the fetishistic, repressive nature of its exhibition and display?

In 1969, Morris organized an *Anti-Form* exhibition at the Leo Castelli Warehouse that, in part, attempted to answer this question. Isolating the formal and intellectual problems associated with the anti-form concept, the exhibition—which included works by Alan Saret, Claes Oldenburg, Eva Hesse, Keith Sonnier, Bruce Nauman, Richard Serra, and Stephen Kaltenbach—refused the limitations of closed forms in favor of an exploration of formlessness and nontraditional materials. The Castelli Warehouse reverberated with piles of felt, rivers of spattered lead, electrochemical reactions, magnetic fields, sheets of rubber, latex, and plastic, neon and fluorescent light, and raw steel. And while the liberation of form through chance relationships alluded to the innovations of Surrealism, the critic Gregoire Müller credited the show with "broadening the horizon of minimal art in respect of both form and signification."[52]

Anti-form's assault on the conventions and pretensions of the modernist object dismantled the mechanisms of logic and idealism that governed formalist art. Materials—deployed as recognizable, unprecious, ordinary substances—no longer aspired to transcend gravity or represent values or things in the world. Wood did not suggest flesh, plastic did not embody modernity or technology, and steel did not mean brutality. Objects scattered on the floor

neither ascended to the sky nor transcended literal earthly conditions. They simply existed in their base material state as the physical residue of the transitive: Richard Serra's *splashed* molten lead (Fig. 42), Barry Le Va's *scattered* particles of gray felt, Robert Smithson's *displaced* mirrors, Eva Hesse's *spilled* latex, Raphael Ferrer's *melted* ice. The conceptual idealizations of modernist sculpture—the analytical expectations of the sculptural enterprise—were withdrawn in anti-form, an art that purposely rejected geometry as the basis of existence.

42
Richard Serra, *Casting,* 1969, detail. Lead. Destroyed. Photo: © Peter Moore, 1969.

Morris's involvement with anti-form was tied to that aspect of 1960s counterculture thinking concerned with liberation and freedom.[53] The anti-form concept parallels some of the ideas expressed by the art critic Ursula Meyer in her important text entitled "The Eruption of Anti-Art."[54] In addressing the issue of anti-art in the 1960s, Meyer suggested that the rediscovery of Dada had resulted in a new sensibility that called for the "desublimation" of cultural values in art. Building her argument on Marcuse's notion of a desublimated society, Meyer cited his influential *An Essay on Liberation* (1969), in which he suggested that "the radical character, the 'violence' of the reconstruction in contemporary art, seems to indicate that it does not rebel against one style or another, but against 'style' itself, against the art-form of art, against the traditional 'meaning' of art."[55] For Meyer (unlike Marcuse, who thought in terms of more conventional art forms), anti-art was most radical when it undermined the conventions and the form of the static art object—objects specifically created to meet the demands of the museum and its patrons. "If Anti-Art exists at all— not only in terms of an art historical (Duchampian) oddity, but in the context of a revolutionary present," Meyer concluded, "it has to be defined on the basis of its temporariness."[56]

While Morris's anti-form concept was developed concurrently with the writing and publication of *An Essay on Liberation,* Marcuse's ideas remained important to Morris's thinking.[57] The idea of stylelessness (so central to Morris's diverse oeuvre), of working outside the gallery or the museum, and of the rebellion against the "artform of art" is reflected in Marcuse's discourse on aesthetic liberation, which would have been available to Morris in *Eros and Civilization.* For Marcuse, it was ultimately the artist's commitment to rational form that prevented art from entering into a liberating or revolutionary praxis:

> Form is the achievement of the artistic perception which breaks the unconscious and "false" "automatism," the unquestioned familiarity which operates in every practice, including the revolutionary practice—an automatism of immediate experience, but a socially engineered experience which militates against the liberation of sensibility. The artistic perception is supposed to shatter this immediacy which, in truth, is a historical product: the medium of experience imposed by the established society but coagulated into a self-sufficient closed, "automatic" system.[58]

Calling for a "revolution in perception, a new sensorium"—a revolution committed to exposing the sham of formalism—Marcuse imagined a material and intellectual reconstruction of society rooted in a new aesthetic environment.[59]

For Morris, anti-form suggested one possibility, but by no means the only possibility, for desublimating the form of art and hence its repressiveness. In the end, the felts (and even the anti-form installations) were trapped by their own spare, formal beauty as museums and collectors validated them as significant aesthetic statements. In a rebuttal to Morris's essay on anti-form, the artist Allan Kaprow wondered whether anti-form could transgress the traditional art object while continuing to exist in relation—even negative relation—to the space of the gallery and museum. Kaprow wrote, "The [anti-form pieces] were made in a rectangular studio, to be shown in a rectangular gallery, reproduced in a rectangular magazine, in rectangular photographs, all aligned according to rectangular axes, for rectangular reading movements and rectangular thought patterns." Thus Morris's work, like Pollock's before him, functioned "strictly in contrast to, or now and then in conflict with, [its] enframing spaces."[60] Kaprow also questioned the extent to which such work was actually against form, observing that most anti-form pieces maintained a distinct shape and, like a Pollock painting, an internal rhythmic composition. Suggesting that the anti-form concept simply resisted hard-edged geometry, not form itself, Kaprow concluded that despite anti-form's dramatic promise, its stand against form was incomplete and thus unconvincing.[61] Inevitably, such criticism recalls Marcuse's own warning that the de-formation of form still results in *form*. "Anti-art has remained art," he concluded, "supplied, purchased, and contemplated as art."[62] While the concept of anti-form represented a significant contribution to advanced art in the 1960s, it would take other media and other venues for Morris to more fully meet his commitment to the idea of desublimating art in order to defy the repressive institutions of culture.

NOTES

1. Fried, "Art and Objecthood," *Artforum* 5 (June 1967); reprinted in Gregory Battcock, ed., *Minimal Art: A Critical Anthology* (New York: Dutton, 1968), p. 128. While the author's conclusions sustained the mythologies and illusions of formalism, his insights about the radical formal and stylistic devices of Minimalist sculpture (and how they differed from the canon of late modernism) were often brilliant and perceptive.

2. Robert Morris, "Notes on Sculpture, Part IV: Beyond Objects," *Artforum* 7 (April 1969), p. 51.

3. For more on Morris's concept of sculptural scale, see "Notes on Sculpture, Part II," *Artforum* 5 (October 1966); reprinted in Battcock, *Minimal Art,* p. 311.

4. For an illustration of Morris's "Blank Form" statement, see Barbara Haskell, *Blam! The Explosion of Pop, Minimalism, and Performance, 1958–1964* (New York: Whitney Museum of American Art, 1984), p. 101.

5. Morris's essays of the 1960s, 1970s, and 1980s appeared in such diverse publications as *Artforum, Village Voice, Perspecta, Avalanche, Tulane Drama Review, Art and Literature, October,* and *Art in America.* His collected essays will be published by M.I.T. Press in the spring of 1990.

6. This situational status for sculpture conversely affirms the visual strength of the gestalt. Despite the altered side of each polyhedron, the eye will continue to read its form as a cube, only later realizing its irregularity.

7. Fried, p. 125.

8. Annette Michelson, "Robert Morris: An Aesthetics of Transgression," in *Robert Morris* (Washington, D.C.: Corcoran Gallery of Art, 1969), p. 35.

9. The L-beam pieces were originally conceived as nine units allowing for nine positions and orientations. They were eventually reduced to seven and finally to three beams (though in some installations only two were actually shown).

10. The option to rearrange can be seen to disrupt the traditional hierarchical relationship between the art object and its patron. In contrast to the traditional art work—an object with fixed proportions and with a specific, preset relationship to the spectator—these permutation pieces enter into a dialogue with their environment, a dialogue in a limited way subject to the whims of the patron.

11. Morris, "Notes on Sculpture, Part II," p. 232.

12. The dance critic Jill Johnston has compared the provocative bisexual character played by Lucinda Childs in Morris's erotic dance piece *Waterman Switch* (1965) to the "neutral," yet confrontational, forms of his mature Minimalist style.

13. Lucy Lippard, "Eros Presumptive," *Hud-*

son Review (Spring 1967); reprinted in Battcock, *Minimal Art.* p. 210.

14. Ibid., pp. 209–10.

15. Ibid., p. 216. Lippard denied the erotic content of Morris's work: "Comparison of [Morris's sexual] works to Giacometti's *Disagreeable Object* of 1931 clarifies this change. *Object* is Surrealist, consciously [and] subconsciously inspired, bristling, literally, with erotic violence and hostility. There is nothing erotic about Morris's objects, nor was there about a still more radical gesture he made in a dance piece in which he and Yvonne Rainer, both nude, and in close but dispassionate embrace, were moved mechanistically across the stage, neutralizing nudity into a condition like any other condition, embrace into an act like any other act. . . . Any residue of sexual stimulus in Duchamp's or Morris's work evokes a cerebral rather than an emotional response" (p. 215). Lippard's position presumes that the mechanisms of sexual desire are purely emotional, a position discredited by the work of such figures as Sigmund Freud and Jacques Lacan. For an understanding of the function of eroticism in Morris's work of the mid-1960s, see David Antin, "Art & Information, 1: Gray Paint, Robert Morris," *Art News* 63 (April 1966), p. 58.

16. Unpublished interview by Jack Burnham, November 21, 1975, pp. 7–9 (Morris archives).

17. Robert Morris, "Form-Classes in the Work of Constantin Brancusi," M.A. thesis, Hunter College, New York, 1966. Morris began his studies at Hunter College in 1962.

18. See George Kubler, *The Shape of Time* (New Haven, Conn.: Yale University Press, 1962).

19. Kubler's deployment of a synchronic rather than a linear, diachronic analysis suggests the more fully developed structuralist methodology of Claude Lévi-Strauss.

20. Morris, in conversation with the author, Gardiner, New York, June 11, 1985.

21. Sidney Tillim, "The Pedestals of Brancusi," *Kenyon Review* 20 (Autumn 1958), pp. 617–27. References to Tillim's work in the present discussion are not meant as a validation of his rather awkward and unrigorous argument. In-stead, Tillim's position should be seen in relation to Morris's adaptation of it in relation to the issue of modernist repression.

22. Ibid., p. 623. The association of latent eroticism and violence with the horizontal axis, an axis Tillim equates with the "primitive," is not without precedent within the history of modernism. Rosalind Krauss has argued that the formal innovation of Alberto Giacometti's sculpture from 1930 to 1933—work that stylistically contradicts the elongated vertical figures of the artist's mature style—was their shift from a vertical to a horizontal axis, a shift based on the ideas of Georges Bataille. For more on these subjects, see Rosalind Krauss, "No More Play," in *The Originality of the Avant-Garde* (Cambridge, Mass., and London: M.I.T. Press, 1985), pp. 42–85.

23. Tillim, p. 620.

24. Ibid.

25. Herbert Marcuse, *Eros and Civilization* (Boston: Beacon Press, 1966).

26. See, for example, Elliot Linzer, "On Recurring Debates," in Sohnya Sayres et al., eds., *The '60s Without Apology* (Minneapolis: University of Minnesota Press, 1984), p. 302.

27. Morris followed Marcuse's publications through the late 1960s. His library includes heavily annotated copies of *Eros and Civilization* (1955), *One-Dimensional Man* (1964), *Negations* (1968), and *An Essay on Liberation* (1969), as well as Alasdair MacIntyre's *Herbert Marcuse: An Exposition and a Polemic* (1970).

28. Marcuse, *Eros and Civilization*, pp. xiii–xiv.

29. Sigmund Freud, *A General Introduction to Psychoanalysis* (New York: Garden City Publishing, 1943), p. 273.

30. Sigmund Freud, " 'Civilized' Sexual Morality and Modern Nervous Illness," in *The Complete Psychological Works of Sigmund Freud,* vol. 7, ed. James Strachey (London: Hogarth, 1959), p. 182.

31. Ibid., p. 187.

32. Ultimately, Freud understood that certain forms of sublimation could act as an enemy of mental health. "Experience teaches us that for

most people there is a limit beyond which their constitution cannot comply with the demands of civilization. All who wish to be more nobleminded than their constitution allows fall victims to neurosis; they would have been more healthy if it could have been possible for them to be less good." It is in this sense that Freud was willing to accept the need for a less repressive sexual environment—despite the necessity for true productivity—in order to improve the psychological constitution of society. See ibid., p. 191.

33. See ibid., pp. 185–91.

34. See ibid., p. 185.

35. Feminist discourse was, of course, a central catalyst for these changes. A number of important popular texts—including Betty Friedan's *The Feminine Mystique* (1964) and Kate Millett's *Sexual Politics* (1970)—as well as the formation of the National Organization for Women in 1967 contributed to the beginnings of a realignment of the gender-based boundaries of power. See, for example, Ellen Willis, "Radical Feminism and Feminist Radicalism"; Muriel Dimen, "The Strange Relation Between Sex and Reproduction"; Rachel Bowlby, " '60s Feminism"; and Silvia Federici, "Putting Feminism Back on Its Feet," in Sayres et al., pp. 91–118, 295–99, 326–27, and 338–46.

36. Marcuse, *Eros and Civilization,* p. xv. This is not to say that Marcuse's utopian position was not problematic within the context of 1960s radical politics.

37. Jill Johnston, "Dance: Morris/Childs," *The Village Voice,* February 13, 1965, p. 21. The title *Waterman Switch* came from the name of a road Morris surveyed in California when he was working as a surveyor. For additional discussion of *Waterman Switch,* see Robert Morris, "Notes on Dance," *Tulane Drama Review* 6 (Winter 1965), pp. 179–86.

38. Antin, p. 58.

39. Morris recalled this exchange in conversation with the author, Gardiner, New York, June 21, 1986. Duchamp's claim that he was completely nude must be questioned, since the *Ciné Sketch* was actually a *tableau vivant* of Lucas Cra-

nach the Elder's painting *Adam and Eve* (Duchamp saw the painting for the first time in 1912 during his stay in Munich while he was working on the *Large Glass*). In that work, Adam is shown covering his genitalia with a fig leaf and Eve covering hers with her hand. It is also important to add that Duchamp published a series of etchings representing the Adam and Eve scene from *Relâche.* The etchings also indicate the presence of a concealing fig leaf and hand. See also Arturo Schwarz, *The Complete Works of Marcel Duchamp* (New York: Abrams, 1969), pp. 565–66.

40. See John Hanhardt, "The Films of Andy Warhol: A Cultural Context," in *The Films of Andy Warhol: An Introduction* (New York: Whitney Museum of American Art, 1988), pp. 7–13.

41. Annette Michelson was the first to make this connection, in suggesting that Peirce's concept of "epistemological firstness" was most relevant to the thinking of Morris (and many of the new sculptors): Peirce proposed a quality of immediate, concrete, simple apprehension that served, according to Michelson, as "the first focus of an investigation of the most general conditions of experience, of knowing and perceiving." Peirce spoke to the condition of absolute presentness unencumbered by the restraints of psychological association or memory. "Imagine, if you please, a consciousness in which there is no comparison, no relation, no recognized multiplicity . . . no change, no imagination of any modification of what is positively there, no reflexion—nothing but a simple positive character. Such a consciousness might just be an odor, say a smell of attar; or it might be one infinite dead ache; it might be the hearing of a piercing internal whistle. In short, any simple and positive quality would be something which our description fits that it is such as it is quite regardless of anything else." "Firstness," then, is noncognitive, an experience fully dependent on literal feelings and perceptions and hence wholly incompatible with the collapsed, harmonic, and idealized time of modernist painting and sculpture. See Michelson, pp. 7–75. Rosalind Krauss extended Michelson's phenomenological argument in her *Passages in Modern Sculpture* (New York: Viking Press, 1977), considering other sources for the Minimalists'

phenomenology, including Maurice Merleau-Ponty (pp. 238–42) and Ludwig Wittgenstein (pp. 259–62).

42. Marcuse, *Eros and Civilization,* p. 180.

43. Maurice Merleau-Ponty, *Phenomenology of Perception* (London: Routledge and Kegan Paul, 1962), p. 283.

44. For more on Marcuse's critique of phenomenology, see Alasdair MacIntyre, *Herbert Marcuse: An Exposition and a Polemic* (New York: Viking Press, 1970), pp. 6–9. Marcuse did not critique the work of Merleau-Ponty.

45. Marcuse's aesthetic sensibility was remarkably traditional and conservative, a position that led him to reject work that deconstructed the forms and hierarchies of high art. He claimed, for example, that certain art forms of the 1960s— guerrilla theater, rock music, Conceptual Art, and film—were neither radical nor revolutionary because, unlike the art of the Romantic and Classical periods, they lacked the "negating power of art." In other words, such forms were incapable of producing a salutary counterpresence to the abusive realm of "real life." For a critique of Marcuse's aesthetic position, see Gregory Battcock, "Art in the Service of the Left?" in *Idea Art* (New York: Dutton, 1973), pp. 25–26.

46. For more on the felts, see Sylvester and Compton, *Robert Morris* (London: Tate Gallery, 1971), p. 105.

47. Robert Morris, "Anti-Form," *Artforum* 6 (April 1968), pp. 33–35.

48. For more on this connection, see ibid.

49. Morris, "Notes on Sculpture, Part IV: Beyond Objects," p. 54.

50. Ibid.

51. Ibid.

52. Gregoire Müller, "Robert Morris Presents Anti-Form," *Arts Magazine* 43 (February 1969), p. 30.

53. Stanley Aronowitz has organized the voices of counterculture in the 1960s into two distinct camps: the politics of direct democracy and the politics of the erotic revolution. "The second," he writes, "were the cultural radicals, the artists, the writers and, above all, the rock musicians and their audience, for whom the erotic revolution was a political movement." While Aronowitz goes on to say that it is important to recognize the difference between the two, it is clear that in certain instances, including Morris's art, some overlap exists. See Stanley Aronowitz, "When the New Left Was New," in Sayres et al., p. 24.

54. Ursula Meyer, "The Eruption of Anti-Art," in Battcock, *Idea Art,* pp. 116–34.

55. Herbert Marcuse, *An Essay on Liberation* (Boston: Beacon Press, 1969), p. 40. For an analysis of Marcuse's idea of anti-art in relation to the politics of the art world, see Gregory Battcock, "Marcuse and Anti-Art," *Arts Magazine* 43 (Summer 1969), pp. 47–50.

56. Meyer, p. 133.

57. Marcuse was important to other cultural and intellectual figures as well. Theodore Roszak reported that "Marcuse . . . had become 'hot feature material' for the American and European press in the wake of the 1968 student rebellions." Quoted in ibid., p. 130.

58. Marcuse, *An Essay on Liberation,* p. 39.

59. Marcuse had, in fact, called for counterrevolutionary "anti-forms" that continued to function in a high-art context. His category of anti-form centered on "poems which are simply ordinary prose cut up in verse lines" and "paintings which substitute a merely technical arrangement of parts and pieces for any meaningful whole." See Gregory Battcock, "Art in the Service of the Left?" pp. 25–26.

60. Allan Kaprow, "The Shape of the Art Environment: How Anti Form Is 'Anti-Form'?" *Artforum* 6 (Summer 1968), pp. 32–33.

61. Ibid. Kaprow suggested that a more successful stand against form occurred in his own Happenings (as well as those of Jim Dine, Claes Oldenburg, and Robert Whitman), where the performance space was often entirely filled with refuse in an attempt to avoid the delineation between object and pristine environment associated with the gallery or museum.

62. Marcuse, *An Essay on Liberation,* p. 42.

3

MORRIS DANCING:
THE AESTHETICS OF PRODUCTION

The artistic imagination shapes the "unconscious memory" of the
liberation that failed, of the promise that was betrayed.
 —Herbert Marcuse, *Eros and Civilization*

The action on stage is organized as a kind of *tableau vivant.* Down-
stage left, a white box conceals the hardware for the sound
track—a tape of construction workers drilling with jackhammers.
Upstage and right of center, Robert Morris stands with his back to
the audience. Several minutes later, he walks upstage center to a
large structure composed of whitewashed plywood boards and
slowly begins to take it apart. Dressed in work clothes, his hands
and feet protected by heavy work gloves and boots, he wears a
papier-mâché mask designed to reproduce, without expression,
his facial features. As Morris removes the heavy boards, relocating
them to other parts of the stage, he exposes Carolee Schneemann
reclining on a lounge of pillows and white fabric. Naked except for
a dusting of white powder and a ribbon around her neck, she is
posed in the manner of Edouard Manet's *Olympia* (1863). After
Schneemann is fully revealed, Morris walks downstage left, where
he moves one of the sheets of plywood into various positions (e.g.,

carrying it on his back, kneeling next to it). Several minutes later Morris walks back to Schneemann and covers her with the board. He then returns downstage left and turns his back to the audience as the house lights dim.

Morris and Schneemann, performing in Morris's dance duet *Site* at the Surplus Theater, New York, in 1964 (Fig. 43), portrayed characters almost never seen in the history of formalist art: workers. *Site* re-creates a symbolic world of manual labor and prostitution, where actors go through the motions of different types of labor. As early as his work with Simone Forti and La Monte Young, Morris had understood the potential of performance to explore simple processes such as moving props around a stage. But *Site* was even more self-conscious than these early projects in that it drove the formal problems of process into the ideological realm of labor and production. And while Morris's representation of labor remained symbolic (he did not, after all, re-create the conditions of the industrial worker), it drew an implicit analogy between the labor of workers and that of artists. In the end, *Site* addressed more than just art and dance world spectators; it communicated to other artists the need to recognize their labor as legitimate and productive—an issue that would enter into the consciousness of the avant-garde in the 1960s.

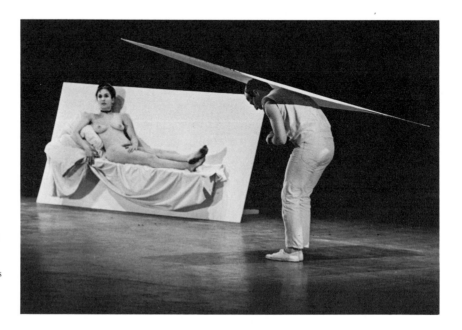

43
Robert Morris and Carolee Schneemann performing in Morris's *Site*, May 1965. Photo: © Peter Moore, 1965.

Ultimately, all of Morris's dances were centered on issues of process. But it was the flexibility of performance and the possibility of integrating props and narrative into his dances that Morris felt provided a credible forum for exploring deeper ideological issues. He choreographed six dance pieces from 1962 to 1965: *War* (1962–63), *Arizona* (1963), *21.3* (1964), *Site* (1964), *Check* (1964), and *Waterman Switch* (1965). With the exception of *Check,* which blended a room full of spectators into the actual performance,[1] his dances unfolded in a relatively traditional theatrical context: the audience was seated in front of a stage where dancers performed. Yet these performances, both in their form and content, were extremely provocative: *War* was a duel between Morris and the artist Robert Huot, both clad in armor; *Waterman Switch* broached the scandalous subjects of sexuality and liberation; *21.3* scathingly parodied the methodology and motivations of art history; and *Arizona* and *Site* explored the nature of the artist's labor. Although Morris did not continue as a dancer, these performances represent a critical part of his oeuvre. Moreover, these dances influenced a range of projects, from the orthodox Minimalist sculptures of the mid-1960s to the Conceptual Art pieces of the early 1970s.

Having participated in the San Francisco improvisational workshop and the projects of La Monte Young, Morris was naturally drawn to the passive, operational, and task-oriented maneuvers of the Judson Dance Theater in New York. The work of the Judson group built on innovations established in the late 1950s by such figures as Ann Halprin and John Cage. Four of its founding members—Trisha Brown, Ruth Emerson, Yvonne Rainer, and Simone Forti—had in fact worked with Halprin in San Francisco. Along with the dancers Steve Paxton, Deborah Hay, Fred Herko, and Elaine Summers, the group shared certain attitudes, such as the elimination of narrative and the employment of everyday movements and activities in their dances. Emphasis was placed on the *performers'* temporal actions and interrelationships. Reflecting Halprin's influence, Rainer observed that Judson performers never confronted the audience: "Either the gaze was averted or the head was engaged in movement. The desired effect was a worklike rather than exhibitionlike presentation."[2]

In addition to Halprin, a major influence on the Judson group was Merce Cunningham, whose New York studio set the pace in the late 1950s for the new American dance. In fact, the Judson Dance Theater had its origins in a dance class given in 1960 at the

Cunningham Studio by the composer Robert Dunn and his wife, the dancer Judith Dunn. This course brought together a range of new ideas in dance, from the ordinary found movements of Cunningham and Cage to the task improvisations of Halprin and her followers. Cunningham had wrenched dance away from the narrative associations and emotional expressiveness of modern dance as exemplified by the work of Martha Graham. Under Cage's influence, Cunningham employed ordinary "found movements" in his dances, a sensibility commensurate with the ideas of Halprin. After Dunn had disbanded his class in 1962, many of his students continued meeting together in the basement of the Judson Church in Manhattan. It was at these meetings that the Judson Dance Theater was officially formed.

The questioning initiated by the Judson Dance Theater led to the establishment of a radically new economy of movement removed from the idealized time of the balletic style. The revolutionary new dance demanded a "systematic critique of the rhetoric, conventions, the aesthetic hierarchies imposed by traditional or classical dance form."[3] The operational exercises choreographed by some members of the Judson group—and simultaneously explored in the dances of Robert Morris—were, to a degree, coextensive with the rise of the new sculpture. A chart by Yvonne Rainer lists the areas of commonality between the new sculpture and the new dance:

OBJECTS	DANCES
1. factory fabrication	energy equality and "found" movement
2. unitary forms, modules	equality of parts
3. uninterrupted surface	repetition and discrete events
4. nonreferential forms	neutral performance
5. literalness	task or tasklike activity
6. simplicity	singular action, event, or tone
7. human scale	human scale[4]

As an example, Rainer pointed out that her dance *The Mind Is a Muscle: Trio A* (1966, Fig. 44) was not mimetic but literal. Eliminating narrative references and the prescribed narrative time of modern dance, Rainer's choreography was "geared to the *actual* time it takes the *actual* weight of the body to go through the prescribed motions."[5] In the end, it was the task itself and the stresses sus-

tained by the body in expediting that task that determined the dance's structure. "The demands made on the body's (actual) energy resources," observed Rainer, *"appear* to be commensurate with the task—be it getting up from the floor, raising an arm, tilting the pelvis, etc.—much as one would get out of a chair, reach for a high shelf, or walk down stairs when one is not in a hurry. The movements are not mimetic . . . [for] in their manner of execution they have the factual qualities of such actions."[6] The pedestrian character of *Trio A* was reflected in the work's disavowal of traditional dance hierarchies: the notion of a "principal" dancer was dropped (Rainer, Steve Paxton, and David Gordon all held equivalent status on stage); the narcissism attached to the "beautiful" dancer's body was suppressed (ordinary clothes were worn); and all romantic, balletic gestures and flourishes were eliminated.

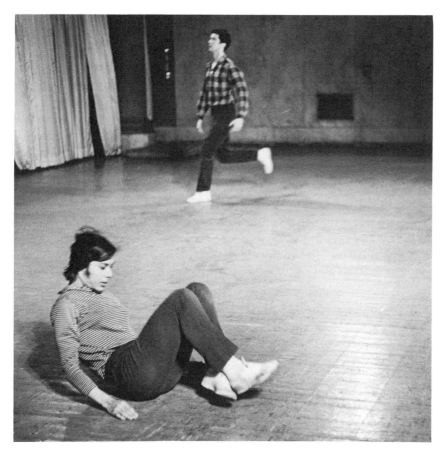

44
Yvonne Rainer and Bill Davis performing in Rainer's *The Mind Is a Muscle: Trio A*, Judson Memorial Church, New York, May 1966. Photo: © Peter Moore, 1966.

As was typical of the Judson group's approach, Rainer worked to redirect the emphasis of avant-garde dance away from the personality or personal expression of the dancer and onto the neutral performer. She encouraged her dancers to avoid the illusionistic gestures, movements, and expressions normally associated with ballet or modern dance. "The artifice of performance has been reevaluated," she wrote. "Action, or what one does, is [more] interesting and important than the exhibition of character and attitude, and that action can best be focused on through submerging of the personality; so ideally one is not even oneself, one is a neutral 'doer.' "[7] By masking his face in *Site,* Morris followed Rainer's dictum—all psychological nuances were concealed. Morris acted as a task-performing automaton, his mask covering any pain, tension, or frustration that registered in response to his intense labor. Later, in an unpublished notation for his dance *Waterman Switch,* Morris scrawled a list of things to be "avoided" in performance: "The self-indulgent, The personality, The perverse, The eccentric."[8]

In *Site,* Morris's representation of the artist/laborer eschewed the affectations of "artistic temperament" typical of most modernist art and dance. Modernism, always intent on establishing distance between the avant-garde and the grim realities of the industrial social order, often isolated the artist in a glorified, aesthetic realm. There, the artist's special role was best expressed through Baudelaire's concept of the dandy, an expressive figure who, through his elegant and studied dress and manner, embodied the special and rarefied features of "art" itself.[9] It was precisely this private and expressive role that Duchamp blasted with his ready-mades, works committed to invalidating notions of the master and the masterpiece. In turn, Duchamp's importance to Morris reflected a rejection in the late 1950s of the modernist belief in creative genius and self-expression. For Morris this meant a direct repudiation of the egotism of Abstract Expressionism's heroic generation. John Cage, as well, was unsympathetic to the Abstract Expressionist conviction that the true sources of art could be found in the artist's psychology, subjective expression, and creative process.[10] He questioned the Existentialist ideal of the artist who forges his or her own identity through the "anguished" act of creating. Cage's refusal to see the artist as master was intensified by his outright rejection of the static art object—a position that

spawned a great deal of the Performance Art of the 1960s, including Events, Happenings, and the new dance.[11]

By neutralizing the expression of personality, Morris's mask addressed another fundamental issue: the anonymity of labor. Neither wealthy nor impoverished, the Baudelairean dandy existed mostly outside the political boundaries of class, his marginality relegating him to the artificial and classless social category of artist. Specifically rejecting this historical model, Morris reoriented his art toward a consideration of labor and production. Through his obsession with process and task, Morris was able—symbolically at least—to extend the concerns of the artist into the realm of economics. Morris's world was a region of industrial materials, temporal operations, and direct interaction, a world where the mysteries of artistic creation yielded to the mundane sounds of saws and hammers (as in *Box with the Sound of Its Own Making*), where process was exposed rather than concealed, where the artist and the worker were (nearly) one and the same.

For Morris, the *process* of making art was a metaphor for industrial labor. "Whatever else art is, [it is] at a very simple level . . . a way of making," Morris wrote in an essay entitled "Some Notes on the Phenomenology of Making."[12] Written in response to an interest in process manifested in late Minimalist and Conceptual Art, Morris's essay explored the *systems* for the production of art developed since World War II. "What I wish to point out here," he continued, "is that the entire enterprise of art making provides the ground for finding the limits and possibilities of certain kinds of behavior and that this behavior of production itself is distinct and has become so expanded and visible that it has extended the entire profile of art."[13]

Morris's campaign to relate the ideologies of labor and production to the practices and processes of the artist often employed mundane, repetitive labor. At one point in his dance *Arizona,* for example, Morris faced the audience and twisted his upper torso so slowly that his movements were almost imperceptible. Significantly, his actions were accompanied by a rambling monologue of instructions, a "method for sorting cows":

> The first man continues with cows past the gate. The second man stops at the gate; he is the gate man. The other man is the head man and makes all the decisions. When sorting cows

the gate man's subordinate station should be well understood. He must, for the sake of efficiency and safety, never question the head man's decisions.[14]

In contrast to the useless and nonstrenuous task performed by Morris, the "sorting cows" text reiterates both the actual hierarchies of labor and production and their metaphorical implications. Workers follow instructions; they do not give them. In the context of a labor-based economy Morris's litany of instructions is not absurd at all; it offers a practical program for discharging a difficult job.[15] For Morris, labor is neither heroic nor unusual, but banal and pragmatic.

Sometimes the banality of Morris's more formal explorations of process, where the absence of a sound track or verbal narrative offered no outlet for ideological discourse, resulted in a kind of theatrical formalism. For example, in his project for the *Place and Process* exhibition at the Edmonton Art Gallery in Edmonton, Alberta, Canada (and executed at the nearby G Bar E Ranch on September 7, 1969), Morris simply rode several quarter horses

45
Robert Morris, *Pace and Progress,* 1969. Project for the *Place and Process* exhibition, Edmonton Art Gallery, Edmonton, Alberta, Canada.

along a line between two posts about two hundred yards apart (Fig. 45). His plan was to ride the horses hard, until either he or the horses became too tired to continue. The project was discontinued when the ranch owner noticed that a disfiguring track was being etched into the turf. Ultimately, the simple operation of riding a horse over a predetermined path amounted to little more than a theatrical cul-de-sac, a useless act committed for the sole purpose of demonstrating the net effect of repetitive labor—the exhaustion of its performers.

Nowhere did Morris walk a finer line between ideology and formalism than in a series of films that explored the body's manipulation of various objects. Morris produced six incomplete films during a three-year period, from 1969 to 1971: *Mirror* (1969), *Slow Motion* (1969), *Finch Project* (1969), *Gas Station* (1969), *Wisconsin* (1970), and *Neo-Classic* (1971). These films, which explored strategies of process and making, represent a codification of the most formal aspects of Morris's dance sensibility. Each film (which was also to have a sound track of everyday sounds) records people involved in simple tasks, exploring the "alignment between the properties of actions and the physical tendencies of a given media."[16] Such was the case with the simultaneous projections of *Gas Station* (33 minutes, silent, color; Fig. 46), where Morris set up two cameras in his apartment windows in Newport Beach, California, and directed them toward the gas station across the street. Another typical film, *Neo-Classic* (14 minutes silent, black and white, Fig. 47), represented the culmination of Morris's use of film

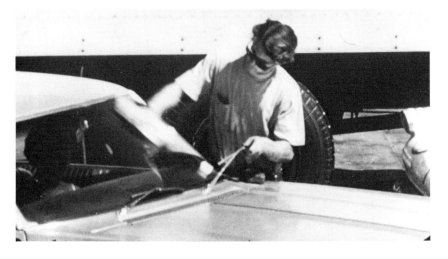

46
Still from Robert Morris, *Gas Station,* 1969. Sixteen-millimeter, silent, color film. Castelli/ Sonnabend Tapes and Films, New York.

as a temporal record of tasks and processes. *Neo-Classic* documented the actions of a nude female model as she interacted with a series of participatory sculptures created by Morris for his Tate Gallery retrospective in 1971.[17]

Morris himself realized the potential of these explorations into process to deteriorate into formal exercises. In the late 1960s, he acknowledged that the process-oriented films made by "plastic artists (excluding Warhol) over the past few years have amounted to a lot of boring formalism."[18] By this time Morris had also become disenchanted with the mundane exercises of the Judson Dance Theater. He regarded them as a mere repetition of simple tasks without regard for the ideological meaning of the artist's labor. (Rainer was so discouraged by the increasing formalism of the new dance that she stopped choreographing altogether and in the early 1970s turned her attention to directing politically oriented avant-garde films.) Of the Judson Dance Theater, Morris later said: "Although we shared certain common beliefs (e.g., the use of everyday movements, the removal of the performer's personality as an issue, the rejection of idealized time), I always felt somewhat removed from the thinking of the Judson group. Finally, their point of view became too formal and rigid."[19]

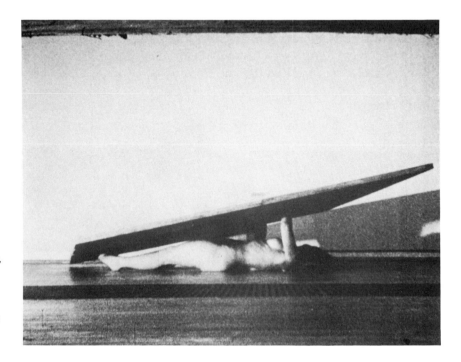

47
Still from Robert Morris, *Neo-Classic*, 1971. Sixteen-millimeter, silent, black-and-white film. Castelli/ Sonnabend Tapes and Films, New York.

The Judson group's explorations of process were so intent on overturning the conventions and practices of modern dance that they became inner-directed, obsessed with the formal conventions of dance itself. Morris himself was torn between the formal and ideological possibilities of his art: the early dances, films, and process pieces represented an important forum for working out this conflict. Ultimately, it was the employment of narrative and allusion that offered a way out, a means for contextualizing performance toward broader ideological issues. The text read aloud in *Arizona* or the historical allusions and sound track of *Site* helped to established a critical and social context for these dances, reminding the viewer that art was part of a greater social and political continuum.

Thus, despite the formalism of some of Morris's films and process pieces, much of his work in the middle to late 1960s reflected a growing interest among advanced artists in the 1960s in the ideological meaning of their labor and production. Populist manifestations of this questioning of the artist's role centered on the artist's right to control the sale and distribution of his or her work. For example, one group of disenfranchised artists in New York began to challenge their marginality in the economic life of the art world. On April 10, 1969, these artists established the Art Workers' Coalition at a public meeting of artists at the School of Visual Arts in New York.[20] Carl Andre, a generative force in the AWC and a key ally of Morris in organizing protests against the war in Vietnam, addressed the significance of the Coalition in overturning the elitist myth of the artist as being separate from the labor economy:

> The Art Workers' Coalition has nothing to do with what your art is like, but it has a great deal to do with keeping the springs and origins of art, which I think are essentially the same for everybody, open and fertile and productive as possible. And this is done by being able to get together, talk about the common social, economic, and political problems . . . [The term art worker does not designate] any kind of camp of Marxism, but it includes everybody who has a contribution to make in the art world. A collector can consider himself an art worker. In fact, anybody connected with art would be considered an art worker if he makes a productive contribution to art. I make art works by doing art work, but I think the work itself is never truly completed until somebody comes along

and does art work himself with that art work. In other words, the perceptive viewer or museum-goer who's got some kind of stimulus from the work is also doing art work. . . . I think [the term art work] should be as broad as possible because I never liked the idea of an art, political, economic, social organization which is limited to artists . . . that's just returning to another kind of elitism.[21]

Andre's art worker credo, in populist terms, embodied ideological issues that were important to advanced art. The bankruptcy of the museum—another important Art Worker battle cry—as well as the engagement of the spectator sanctioned by the phenomenology of the 1960s motivated the installations of Morris, Andre, Eva Hesse, Hans Haacke, Richard Serra, Robert Smithson, and others. Ultimately, the Coalition's will to expose the myth of artistic independence from political or economic reality reflected a dominant avant-gardist position of the period.

An intensive rethinking of the artist's economic condition, both in independent and group efforts, was coextensive with the greater social upheavals of the 1960s, a time when bourgeois dreams of controlled consumption and unproblematic production were violently disrupted. More than in any other period in American history, the struggles of the 1960s allowed for popular intervention as protesters crossed the boundaries of power: students raged against the Vietnam War; workers negotiated for fairer work practices; women, gay men, lesbians, racial minorities, and the elderly boycotted and marched in the streets for their civil rights. The interest of advanced art in process and task, as well as the concomitant realignment of the artist's and viewer's role in society, was, in part, predicated on this broader sociopolitical foundation.[22] Not surprisingly, the art critical and art historical community, slow to disengage from the apolitical, ahistorical, and fundamentally bourgeois pretensions of high modernism, tended to ignore the political context of the decade that produced the new sculpture; Pop, Op, and Conceptual Art; the new dance, Happenings, Fluxus, video art, and other performance options.

In all these cultural movements, process and experience were important. But these issues were also debated within the New Left, which was also committed to overturning the object- and commodity-based dynamic of modernist culture and late capitalism. Looking back on the 1960s cultural and political scene, Stanley Aronowitz has recalled:

The nature of the new left, summarized in a single word . . . [was] process. It signalled an almost religious return to *experience* and a converse retreat from the abstractions of the red politics of yesterday. . . . Rhetorical repetition, procedural debate, moral invocations to kindness and equality were all part of the process of community building, a psychopolitical experience in which duration played a purgative part in transforming traditional political interactions into what was described as "movement behavior."[23]

This New Leftist sensibility was a pervasive, though not always acknowledged, part of radical culture in the 1960s. Experience, duration, and repetition were regarded as necessary tools, for example, in the liberation of the visual and performing arts from the repressive, hierarchical conditions of modernist culture and production. In this way, Morris's phenomenological games hoped that the relationship between the art object and the viewer might be more or less democratic—free of the social and cultural hierarchies of art world institutions such as the museum. Thus, the psychopolitical experience in Morris's work of the late 1960s and early 1970s (works that re-created autistic states, labyrinths, mirror distortions, large-scale participatory installations) was not unrelated to Morris's radical political activity against the war in Vietnam, his assertion of the artist as worker, and his overt attack on the institutional sanctity of the museum. His involvement with task performance, both in dance and film, was also an extension of this reevaluation of the function of art and the place of the artist in society, a reappraisal that ironically mostly took place in the very institutions he deplored: the museum and the gallery.

Morris's most direct statement on the relation of the artist to the labor economy, however, was manifested outside the museum and gallery as part of an advertising campaign that appeared in a number of art magazines in November 1970 (Fig. 48). Morris introduced himself as a worker/artist who could be hired on an hourly basis to design and execute a range of nontraditional art projects. "Explosions," "Events for the Quarter Horse," "Speeches," "Alternate Political Systems," "Earthworks," and "Demonstrations" were among the possible selections. Morris's one-person employment agency—The Peripatetic Artists Guild—invited other artists to add their names to the PAG file of workers. The advertisement continued:

THE PERIPATETIC ARTISTS GUILD ANNOUNCES
ROBERT MORRIS

Available for Commissions Anywhere in the World

EXPLOSIONS—EVENTS FOR THE QUARTER HORSE—CHEMICAL SWAMPS—MONUMENTS—SPEECHES—OUTDOOR SOUNDS FOR THE VARYING SEASONS—ALTERNATE POLITICAL SYSTEMS—DELUGES—DESIGN AND ENCOURAGEMENT OF MUTATED FORMS OF LIFE AND OTHER VAGUELY AGRICULTURAL PHENOMENA, SUCH AS DISCIPLINED TREES—EARTHWORKS—DEMONSTRATIONS—PRESTIGEOUS OBJECTS FOR HOME, ESTATE, OR MUSEUM—THEATRICAL PROJECTS FOR THE MASSES—EPIC AND STATIC FILMS—FOUNTAINS IN LIQUID METALS—ENSEMBLES OF CURIOUS OBJECTS TO BE SEEN WHILE TRAVELING AT HIGH SPEEDS—NATIONAL PARKS AND HANGING GARDENS—ARTISTIC DIVERSIONS OF RIVERS—SCULPTURAL PROJECTS—

Collaborative Projects with Other Artists Invited

The above is but a partial listing of projects in which the artist is qualified to engage. No project is too small or too large. The artist will respond to all inquiries regarding commissions of whatever nature

Terms of Commissions

Sales or fees for any projects are not acceptable. A $25.00 per working hour wage plus all travel, materials, construction and other costs to be paid by the owner-sponsor. Subsequent sales of any project by the owner-sponsor will require a 50% return of funds to the Peripatetic Artists Guild (PAG) to be held in trust for the furtherance of saleless wage commissions between other artists and owner-sponsors. A contract will be issued for every commission.

Address all Inquiries to PAG, 186 Grand St.
NYC 10013

48
Robert Morris, advertisement for the Peripatetic Artists Guild, November 1970.

A $25.00 per working hour wage plus all travel, materials, construction and other costs to be paid by the owner-sponsor. Subsequent sales of any project by the owner-sponsor will require a 50% return of funds to the Peripatetic Artists Guild (PAG) to be held in trust for the furtherance of saleless wage commissions between other artists and owner-sponsors. A contract will be issued for every commission.[24]

The response to Morris's actually quite serious prospectus was less than enthusiastic. While a number of American and European artists—eager to secure work in a highly competitive field—sent formal requests to join the Peripatetic Artists Guild, few offers came from potential patrons.[25] Morris suspected that the PAG stipulations concerning resale of work proved undesirable for collectors. Although several inquiries were made, no projects were commissioned.

Successful or not, the Peripatetic Artists Guild brashly exposed the art world's economic imperative, since it was based on an explicit equation between labor and remuneration, between art and money. No longer was the artist presented as the reified creator of special aesthetic objects; the talents of the PAG artist extended into a range of activities most often associated with blue- and white-collar labor. More interested in the economic position of the artist than in the general world of art and business, the Peripatetic Artist's Guild nevertheless inverted modernist aesthetics: the fiction of peering into the human heart in search of passion or expressiveness was exchanged for the realities of a new art world economy where artists are workers and not dandies.

Still, within Morris's oeuvre, it was the dance *Site* that most rigorously explored this interchange among art, labor, and production. *Site* represented a complex commentary on the contemporaneous Marxist-oriented dialectic of work and play, a dialectic centered on a utopian, if not naïve, vision of nonrepressive labor. Marcuse, for example, dialectically divided the labor economy into two sectors of activity: "work" and "non-work." Work, in Marcusean thought, was an entirely desexualized phenomenon, a condition of enforced sublimation. Play, conversely, was entirely subject to the pleasure principle, as it served no other purpose than that of instinctual gratification. In contrast to Marcuse, post-Freudian theory diminished the importance of play within the economy of production, insisting that work done for the greater

society (and not the socially unproductive, autoerotic act of play) allowed humanity to thrive and survive. Post-Freudian theory in the 1930s and 1940s, in fact, exhibited a marked tendency to repress the imperative to play while favoring and glorifying labor as a means of self-realization. In Ives Hendrick's revision of Freud, in particular, it was the "mastery instinct"—the self-gratification and pleasure that were the result of a worker's efficient performance—that overcame the need for play and permitted the release of surplus libidinal tension.[26]

Marcuse himself observed that libidinal work—work based on pleasure and gratification—represented a nearly insurmountable contradiction in late-industrial society, where alienated labor was the rule rather than the exception: "In a reality governed by the performance principle," Marcuse wrote, "such libidinal work is a rare exception and can occur only at the margin of the work world—as 'hobby,' play, or in a directly erotic situation. The normal kind of work (socially useful occupational activity) in the prevailing division of labor is such that the individual, in working, does *not* satisfy *his* own impulses, needs, and faculties but performs a preestablished function."[27] In refusing the "mastery instinct," Marcuse went on to insist that the "pleasure [in doing a good job] has nothing to do with primary instinctual gratification. To link performances on assembly lines, in offices and shops with instinctual needs is to glorify dehumanization as pleasure."[28] If Marxism (not to mention modernism), in its most vulgar form, wished to see labor as transcendent, Marcuse preached the liberation of production through an acknowledgment of the *negativity* of labor.

Hendrick's gospel of labor, cloaked in the rhetoric of a "mastery instinct," suggested blind idealism, but Marcuse's validation of pleasure over the negative repression of labor constituted a removed, aristocratic idealism, a utopianism that called for a virtually impossible realignment of the labor economy. "Play . . . as [a] principle . . . of civilization," wrote Marcuse, "impl[ies] not the transformation of labor but its complete subordination to the freely evolving potentialities of man and nature. The idea . . . of play . . . now [reveals its] full distance from the values of productiveness and performance: play is *unproductive* and *useless* precisely because it cancels the repressive and exploitative traits of labor and leisure."[29] To completely cancel such "exploitative traits" is, of course, to obliterate the usefulness of work itself. To define play, nonalienated labor, or nonwork as finalities without end is to

aestheticize them "with all the bourgeois ideological connotations which that implies."[30]

Jean Baudrillard's critique of Marcuse reasons that such a fascination with nonwork—a kind of mirage of free time—ultimately continues the mechanisms of labor exploitation by holding out hope for workers that such desublimated labor is possible. For Baudrillard, the concept of nonwork is substantially a fiction, the repressive desublimation of labor power, an antithesis that acts as an alternative. "Exactly as the pure institutional form of painting, art, and theater shines forth in anti-painting, anti-art, and anti-theater, which are emptied of their contents, the pure form of labor shines forth in non-labor," he writes. "Although the concept of non-labor can thus be fantasized as the abolition of the political economy, it is bound to fall back into the sphere of political economy as the sign, and only the sign, of its abolition."[31]

Site also questioned these progressivist mythologies of labor and production, principally by challenging the problematic liberal tradition that treats the body as capital.[32] Since the living human body has no material value, the worker must physically *work* in order to survive. As a consequence, the laborer is continually subjected to the repressive hierarchies of the class structure. In the performance, the characters played by Morris and Schneemann were symbolic of two different types of labor. Morris represented the more traditional manual laborer who lifts heavy objects and engages in repetitive tasks, the worker who, despite distinct facial features and physical mannerisms, remains anonymous and unexpressive. Schneemann's portrayal of Manet's reclining Olympia, on the other hand, suggests the kind of "work" that conflates the dynamics of leisure and production—the libidinal labor advocated by Marcuse. But Schneemann's character merely feigns leisure. Her facial expression remains fixed and rigid; the reality of the labor that *Olympia* represents is that it necessarily exchanges the fulfillment of libidinal pleasure for the more debased terms of economic exchange.

As T. J. Clark has suggested, many nineteenth-century critics were content to use the term *courtisane* as a comfortable and archaic euphemism for Olympia's unspeakable profession. Like Baudelaire's artist-dandy, "the *courtisane* was supposed not to belong at all to the world of class and money; she floated above or below it, playing with its categories, untouched by its everyday needs."[33] Manet's Olympia, however, was different: she lacked the safety and

comfort of the chaste, porcelain Venuses of the salon. Her feet were dirty. A line of hair that extended from her navel to her breasts marred perfection as it accentuated sensuousness. Her eyes stared directly and solicitously at the spectator. Her skin was cast in the bluish tones usually reserved for corpses (Fig. 49).[34] To more than one critic, Olympia belonged not to the indeterminate class of the *courtisane* but to the world of the *faubourgs* and the working class. Jean Ravenel imagined her haunting the tables of Paul Niquet's—an establishment on the Rue aux Fers that stayed open all night and catered to a rowdy clientele of ragpickers, idlers, and drunkards.[35] As a radical inversion of its major historical source—Titian's *Venus of Urbino* (1538)—*Olympia* went far beyond the Renaissance realm of "unchaste chastity" to the grim specter of working-class sexual commerce, where, in the nineteenth century, women were most often the victims of abject poverty and disease. According to Clark, *class* is the essence of *Olympia*'s modernity: Manet's hardened prostitute serves as an emblem of an alienated and class-conscious Paris, the legacy of a brutal modernization scheme undertaken by Napoleon III and his city planner, Baron Georges-Eugène Haussmann.[36]

"Prostitution is a sensitive subject for bourgeois society," writes Clark, "because sexuality and money are mixed up in it. There are obstacles in the way of representing either, and when the two intersect there is an uneasy feeling that something in the

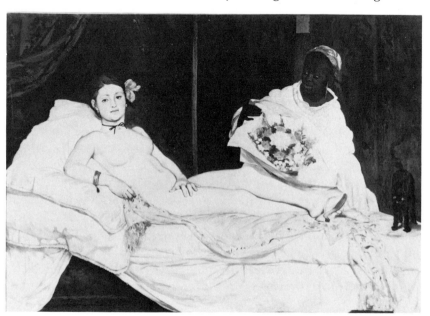

49
Edouard Manet, *Olympia*, 1863. Oil on canvas. Musée d'Orsay, Paris.

nature of capitalism is at stake, or at least not properly hidden.''[37] But has it not been equally embarrassing in the history of modernism to admit the status of art as commodity, the extent to which art and ideas are inexorably bound to money? This is a question that Morris entertained as early as his *Document* of 1961 or his *Brain* pieces of 1962 (Fig. 50)—plaster models of the human brain covered in silver leaf or dollar bills. With these objects Morris acknowledged the complex status of the art object as commodity in an *art world* situation, a context that implicates the artist as well as the patron. As Yve-Alain Bois writes:

> Works of art—as much as oyster pearls or great wines (other examples given by Marx)—are not exchanged according to the common law of the market, but according to a monopoly system maintained by the entire art network, whose keystone is the artist himself. This does not mean that the exchange of works of art is beyond competition or any other manifestation of the law of the market, but that their sometimes infinite price is a function of their lack of measurable value. Value in the art world is determined by the "psychological" mechanisms which are at the core of any monopoly system: rarity, authenticity, uniqueness and the law of supply and demand. In other words, art objects are absolute fetishes without a use value but

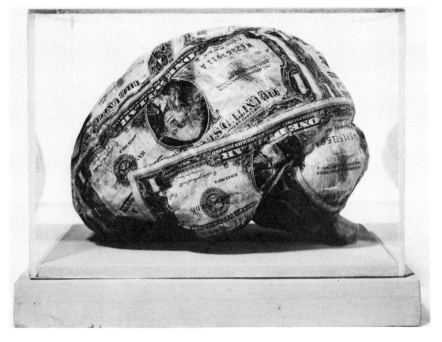

50
Robert Morris, *Untitled (Brain)*, 1962. U.S. currency, plaster, plexiglass, wood. Private collection.

also without an exchange value, fulfilling absolutely the collector's fantasy of a purely symbolic or ideal value, a supplement to his soul.[38]

If *Olympia* exposed the connection between sexuality and commerce, *Site* challenged an even longer-lived mythology: the artist's removal from the economy of labor. Schneemann's prostitute and Morris's manual laborer, in their unidealized task performance, implicated the artist in the class struggle because neither artist nor worker was seen as heroic or special. No place existed in Morris's anonymous realm of plywood, work clothes, and solicitous prostitutes for the young, elegantly attired dandy who turns his nose up at the rest of society. *Site*, like the Peripatetic Artists Guild that represented its logical extension, waged war against diehard convictions about the role of the artist in society, a battle accompanied not by the perfumed air and frenetic din of a Parisian café-concert but rather by the mundane drone of jackhammers breaking up a New York City street.

In the end, Morris's public explorations of production and performance were, in their conscious appeal to the issues of labor and class, political acts. One is reminded of Walter Benjamin's admonishment of the modern intellectual's ambiguous politics. Western intellectuals, he observed, did not see themselves as "members of certain professions" but as representatives of a "certain characterological type," a type located somewhere between the classes.[39] Advocating a more activist role for the intellectual, Benjamin called "for the transformation of the forms and instruments of production in the way desired by a progressive intelligentsia—that is, one interested in freeing the means of production and serving the class struggle."[40] Morris himself had advocated a greater involvement for the artist in controlling the commerce of his production. Morris's *Money* (Fig. 51), displayed at the Whitney Museum's *Anti-Illusion: Procedures/Materials* exhibition in 1969, for example, was essentially a business contract: a typed and signed agreement, related correspondence, and a canceled check—evidence of a transaction between Morris and the museum's directors. In lieu of a traditional art work, Morris proposed to the museum an investment plan. In effect, he wanted to buy blue-chip art and profit by reselling to European collectors and dealers. This venture into speculation was substantially modified by the museum. Although the trustees accepted Morris's proposal, they insisted on screening all his purchases.

It was precisely the possibility of transforming modernist cul-

ture—and the institutions on which it was based—that motivated the more radical artists of the 1960s. With his performance and conceptual pieces, Morris attempted to establish a materialist dialectic for his art, a dialectic that rejected even Duchamp's transgressive fetish of the object. Morris represented himself as a producer, acknowledging his real, if theoretically contradictory, place in the class structure. Morris was later to state his political position emphatically:

> All art is political and in the taking of it and the making of it . . . you cannot avoid the fact that it's . . . involved in a class situation. . . . Most of modern art itself is a very bourgeois undertaking, and we may have very . . . strong critical feelings about how this whole enterprise proceeds along[;] nevertheless we have a good deal of allegiance to the kinds of structures and intentions and investigations and changes that have happened within this class structure. There are a lot of oppressive . . . factors built into the way the art world moves along, irrespective of the sensibility or the invention going on.[41]

Naïve as such 1960s-style social awareness might sound today, Morris's concern for the conditions of class contrasted sharply with the cynicism and selfishness that evolved in post-1960s America. By the Reagan era, the discourse of the class struggle and issues regarding the economy of production had, for many intellectuals and artists, become unfashionable and even embarrassing. In the hermetic, formalist space of modern art, such biases, of course, have always existed. But for the most advanced artists of the 1960s—for a multitude of social, cultural, and political reasons— the magic, the ambiguity, and the metaphysics of formalism would yield, at least at that moment, to a radical reevaluation of social and cultural institutions.

51
Robert Morris, *Money*, 1969. Eight sheets of typed office stationery and one bank check. Photo: © Peter Moore, 1969.

NOTES

1. *Check* (1964, Fig. 52) was the least typical dance choreographed by Morris. The work intensified the spectator/performer relationship by employing "forty people . . . to coalesce and disperse into the audience," a theatrical event that "located [the forty] in [the] zone between performers and audience." *Check,* in its lack of internal organization, was "purposely antithetical" to Morris's previous dances. In a room 100 × 300′ (the central gallery at the Moderna Museet, Stockholm), 700–800 chairs were placed at random in the center area, with aisles around the perimeter. Individual performers executed various actions in these aisles. Forty other performers—men, women, and children—"wandered" through the entire space. At a given signal, the forty assembled into two groups for simple, simultaneously rendered actions. Repeatedly dispersing upon a signal to resume their wandering, the performers formed what Morris has termed a "proto-audience." Since the approximately 700 spectators were free to sit or stand as they wished, the "performed" actions were mostly invisible to them.

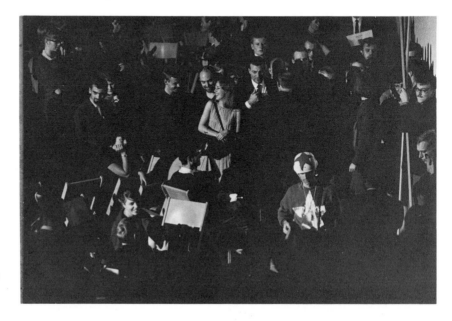

52
Robert Morris performing in Morris's *Check,* Stockholm, 1964.

2. Yvonne Rainer, "A Quasi Survey of Some 'Minimalist' Tendencies in the Quantitatively Minimal Dance Activity Midst the Plethora, or an Analysis of Trio A," in Gregory Battcock, ed., *Minimal Art: A Critical Anthology* (New York: E. P. Dutton, 1968), p. 271.

3. Rosalind Krauss, *Passages in Modern Sculpture* (New York: Viking Press, 1977), p. 233. For a detailed history of the Judson Dance Theater, see Sally Banes, *Democracy's Body: Judson Dance Theater, 1962-64* (Ann Arbor: U.M.I. Research Press, 1983).

4. Rainer, pp. 263-73. For a collection of Rainer's writings, see Yvonne Rainer, *Work, 1961-73* (New York: New York University Press, 1974).

5. Rainer, "A Quasi Survey," p. 270.

6. Ibid.

7. Ibid, p. 267.

8. Unpublished notation in Morris's dance notebook (1963), Morris archives, Gardiner, New York. In eschewing the self-indulgent, Morris asked Jasper Johns—an important figure in the Duchamp/Cage aesthetic—to help him execute the mask for *Site.*

9. Baudelaire wrote: "Whether these men are nicknamed exquisites, *incroyables,* beaux, lions or dandies, they all spring from the same womb; they all partake of the same characteristic quality of opposition and revolt; they are all representative of what is finest in human pride, of that compelling need, alas only too rare today, of combating and destroying triviality. It is from this that the dandies obtain haughty exclusiveness, provocative in its very coldness. Dandyism appears above all in periods of transition, when democracy is not yet all powerful, and aristocracy is only just beginning to totter and fall. In the disorder of these times, certain men who are socially, politically and financially ill at ease, but are all rich in native energy, may conceive of the idea of establishing a new kind of aristocracy, all the more difficult to shatter as it will be based on the most precious, the most enduring faculties, and on the divine gifts which work and money are unable to bestow. Dandyism is the last spark of heroism and decadence." Charles Baudelaire, "The Painting of Modern Life," in *The Painting of Modern Life and Other Essays,* trans. and ed. Jonathan Mayne (New York: Da Capo Press, 1964), p. 28.

10. Morris himself was unsympathetic to the modernist obsession with temperament. In 1971, in an essay entitled "The Art of Existence—Three Extra-Visual Artists: Works in Process," Morris parodied the critical fixation on creative and personal expression by devising an elaborated field of "biographical" information about a group of fictitious artists. See Robert Morris, "The Art of Existence—Three Extra-Visual Artists: Works in Process," *Artforum* 10 (January 1971), pp. 28–33.

11. "I was promoting the notion of an impermanent art," Cage said, "something that no sooner had it been used, was so to speak discarded. I was fighting at that point the notion of art itself as something which we preserve." See Irving Sandler, unpublished interview with John Cage (May 6, 1966); as quoted in Sandler, *The New York School: The Painters and Sculptors of the Fifties* (New York: Harper & Row, 1978), p. 164.

12. Robert Morris, "Some Notes on the Phenomenology of Making: The Search for the Motivated," *Artforum* 9 (April 1970), p. 62.

13. Ibid, p. 63.

14. Robert Morris, "A Method for Sorting Cows," *Art and Literature* 11 (Winter 1967); reprinted in Michael Compton and David Sylvester, *Robert Morris* (London: Tate Gallery, 1971), p. 8.

15. In fact, "A Method for Sorting Cows" describes the actual method used for sorting cows by Morris's father, who was in the livestock business. As a child, Morris would act as gate man, his father as head man.

16. Robert Morris, "Films," unpublished manuscript, undated, n.p. (Morris archives, Gardiner, New York).

17. Of the film *Neo-Classic,* Morris says: "I knew those things would be destroyed and I wanted a visual record of those objects: big balls, round things that rolled. And rather than just photographing them I wanted to see them in motion. Not necessarily the kind of motion they might've had while the show was on. The nude

gave the objects a sense of scale." Morris's other films were fairly consistent in their formalism. In *Mirror* (8½ minutes, silent, black and white), the phenomenological implications of passage and vision were explored as Morris walked in a circle around a Wisconsin landscape, holding up to the camera a large mirror that reflected the surrounding trees, snow, and the shifts in the camera's line of sight. *Slow Motion* (16½ minutes, silent, black and white), made from instructions given by Morris over the telephone, was his contribution to the *Art by Telephone* exhibition held at Chicago's Museum of Contemporary Art in 1969. In the manner of the photographer Eadweard Muybridge, a high-speed camera was focused on a shirtless, muscular male model as he ran into and finally pushed open a heavy glass door. Seen in superslow motion and framed from neck to waist following Morris's telephoned instructions, the figure contacted the door with various body parts, including the hands, shoulders, forearm, and back. *Finch Project* (silent, black and white), executed for the *Art and Process IV* exhibition at the Finch College Art Gallery, recorded simple activities—Morris hanging mirrors at one end of the gallery as a person at the other end tacked up life-size photographs of faces—through a camera placed on a turntable revolving at two revolutions per minute. Projected onto the same gallery walls with a film projector that revolved on the same turntable, the presentation of the film replicated the decentering point of view of the rotating camera and the circular path of the worker's labor. *Wisconsin* (14 minutes, silent, black and white), based on the dispersed choreography of Morris's *Check* (1964) and Yvonne Rainer's *North East Passing* (1968), captured the collective actions of a group of ninety-five people as they fell, ran, walked, and milled in a large field. Filming the scene from three cameras, Morris later intercut the three tracks in order to examine the individual events simultaneously from various angles and distances.

18. Morris, "Films," n.p.

19. Robert Morris, in a telephone conversation with the author, July 16, 1988.

20. The Art Workers' Coalition was actually conceived on January 3, 1969, at a meeting of several artists and critics (including Takis, Tsa'i, Hans Haacke, Willoughby Sharp, John Perreault, and Carl Andre) held at the Chelsea Hotel in New York. The meeting was called to discuss ways in which the art community could become more responsive to social and political matters and at the same time remain true to its respective artistic visions. For a short history and evaluation of the AWC, see Lucy Lippard, "The Art Workers' Coalition: Not a History," *Studio International* 177 (November 1970); reprinted as "The Art Workers' Coalition," in Gregory Battcock, ed., *Idea Art* (New York: E. P. Dutton, 1973), pp. 102–15.

21. In Jeanne Siegel, "Carl Andre: Art Worker" (interview), *Studio International* 177 (November 1970); reprinted in Jeanne Siegel, *Artwords: Discourse on the '60s and '70s* (Ann Arbor: U.M.I. Research Press, 1985), p. 130.

22. Morris's involvement in the activities of the Art Workers' Coalition was marginal. Except for the Coalition's active participation in the various artists' strikes and protests against the Vietnam War, Morris tended to reject its populist campaign and the tendency of its leaders (including Andre) to separate the art object from the political activism of its maker, a position that perpetuated modernist notions of the separateness of art.

23. Stanley Aronowitz, "When the New Left Was New," in Sohnya Sayres et al., eds., *The '60s Without Apology* (Minneapolis: University of Minnesota Press, 1984), p. 20.

24. The advertisement is reprinted in Sylvester and Compton, p. 9.

25. Morris's personal archives contain a number of requests for work. Since the advertisement appeared in *Studio International,* several requests came from Europe, including a letter from a Czechoslovakian artist who wanted to "dam up the upper flow of a brook" and ignite the contents of a drum of gasoline on the surface of the water.

26. Ives Hendrick, "Work and the Pleasure Principle," *Psychoanalytic Quarterly,* no. 12 (1943), pp. 314–18.

27. Herbert Marcuse, *Eros and Civilization*

(Boston: Beacon Press, 1966), p. 220.

28. Ibid., p. 221. Yet Marcuse's intellectual position—in its blending of Marxian and psychoanalytical devices—does not entirely rest on the issue of class. Unlike Marx, Marcuse's writing, in its utopianism, avoids the cold reality of labor as a constant feature of industrial society. Neither classically Marxist nor Frankfurt school, Marcuse's ideas represent a unique hybrid of late-modernist thought, thinking that is not always convincing in its understanding of the *reality* of labor and production. "For Marcuse, Marxism was rather a theory of the 'universal individual,' but one which surpasses simple humanism because it speaks both to the material forces which obstruct its realization and to the existing emancipatory forces that may yet achieve it," writes Barry Kåtz. "Thus he consistently rejected the distinction between the young, allegedly 'humanistic' Marx and the author of the mature critique of political economy, for the concepts of exploitation, surplus-value, profit, and abstract labor reveal the fragmentation of human life in capitalist society and thus contain—in negative form—the substance of a genuine humanism." See Barry Kåtz, *Herbert Marcuse and the Art of Liberation* (London: Verso, 1982), pp. 218–19.

29. Marcuse, p. 195.

30. Jean Baudrillard, *The Mirror of Production,* trans. Mark Poster (Saint Louis: Telos Press, 1975), p. 39.

31. Ibid., pp. 40–41.

32. Morris was fully aware of the political implications of his work and the extent to which the art world economy reflects the greater world of labor and production. On the issue of process, for example, he writes: "Process has its political and economic basis as well, for all theories of art's recent histories are also theories of scarcity in which a given 'line' of works and people [is] posited as the significant one." See Robert Morris, "Some Splashes in the Ebb Tide," *Artforum* 12 (February 1973), p. 44.

33. T. J. Clark, *The Painting of Modern Life: Paris in the Art of Manet and His Followers* (New York: Knopf, 1984), p. 87.

34. The critic Félix Deriège was one of the first to liken *Olympia* to a corpse. See ibid., pp. 97–98. Of course, Morris's depiction of the *Olympia* pointed to his own power relationship to the female subject. In effect, Schneemann was physically constrained by Morris's repressive instructions. "I was reduced to an historical anomaly," Schneemann has said of her role. "Only my body signified." In conversation with Schneemann, September 15, 1988.

35. Ibid., p. 88.

36. Norman Bryson draws a less definitive conclusion about *Olympia*'s relation to the working classes. For Bryson, Olympia remains intentionally suspended between the worlds of the *courtisane* and the prostitute. See *Vision and Painting: The Logic of the Gaze* (New Haven, Conn., and London: Yale University Press, 1983), p. 147. For an important defense of Clark's position see Klaus Herding, "Manet's Imagery Reconstructed," *October,* no. 37 (Summer 1986), pp. 113–24.

37. Clark, p. 102.

38. Yve-Alain Bois, "Painting: The Task of Mourning," in *Endgame: Reference and Simulation in Recent Painting and Sculpture* (Cambridge, Mass., and London: M.I.T. Press, 1986), p. 37.

39. Walter Benjamin, "The Author as Producer," in *Reflections,* ed. Peter Demetz, trans. Edmund Jephcott (New York and London: Harcourt Brace Jovanovich, 1978), p. 226. Within these quotation marks, Benjamin is quoting from the writing of Kurt Hiller, the German theoretician of Activism.

40. Ibid., p. 228.

41. "Robert Morris [New York 1972]," (interview) in Achille Bonito Oliva, *Dialoghi d'artista: Incontri con l'arte contemporanea, 1970–1984* (Milan: Electa, 1984), p. 83.

4

THE IRON TRIANGLE: CHALLENGING THE INSTITUTION

On Friday, May 22, 1970, Robert Morris led a group of demonstrators to the steps of the Metropolitan Museum of Art, New York, one half hour before the museum's scheduled opening (Fig. 53). The protesters were demanding that the Metropolitan close for the day in solidarity with their stand against the American involvement in the Vietnam War, the recent bombing of Cambodia, and the shooting of four student protesters at Kent State University. As was typical of such protests in New York during the Vietnam War era, the dissidents were confronted by a battalion of helmeted policemen. As visitors patiently waited to enter the museum, the strikers handed them pink leaflets that reiterated a set of demands directed at the Metropolitan's board of trustees. Newly arriving demonstrators were given placards emblazoned with the words "Art Strike Against Racism War Repression."

Responding to the strikers, the museum distributed its own leaflet, which stated the Metropolitan's sympathies with "the needs and wishes of the artistic community" but affirmed its refusal to close because "its responsibility to the people of New York is best served by remaining open and allowing art to work its salutary effect on the minds and spirits of all of us."[1] Later, as patrons sympathetic to the demonstrators turned away from the Metropoli-

tan, the museum issued a proposal to Morris and the group of artists he represented: the Met would close for one hour if the protesters would agree to disperse immediately after the closing. The group voted unanimously to reject the compromise.

Throughout the day the artists preached to potential visitors, maneuvered to block museum entrances, haggled with police, and debated with museum officials. For about an hour in the early afternoon, the second-floor European paintings galleries were indeed closed, presumably to preclude any acts of vandalism. Outside, a group of policemen flanked the growing band of protesters (sympathetic museum staffers and bystanders had increased its ranks to an estimated five hundred people).[2] By late afternoon the group had overwhelmingly approved a proposal to continue the strike until 10 P.M., the museum's extended closing time for that day. The police eventually retreated. Late in the evening, brooms were distributed to the demonstrators and debris was swept up,

53
Robert Morris and Art Strike protesters on the steps of the Metropolitan Museum of Art, New York, May 22, 1970.

erasing all evidence of protest and returning the Metropolitan steps to their sober dignity. Just before the group disbanded Morris called for a minute of silence: "I think we have been heard today," he proclaimed.

Morris's actions against the Metropolitan Museum of Art represented the convergence of two types of political positions inherent to his thinking. On one level, the Art Strike evolved out of Morris's own theoretical argument about the museum as an instrument of repression. As the protesters' placards suggested, the strike was against war and racism, but it also intended to dramatize and oppose a more general political condition: repression.[3] On another level, the Art Strike questioned the extent to which the voice of the artist could serve as a vehicle for change. In effect, the protesters were testing the limits of their own political power, both as cultural and political figures. As such, the American involvement in the Vietnam War and its tragic consequences served as a crucial catalyst. For Morris, the Vietnam conflict represented a desperate extreme of colonialism and oppression—an oppression that served to accentuate the underlying conditions of many of the institutions of late capitalism. Mirroring these conditions, the central forces of the art world—museums, galleries, and the media—were in his mind equally repressive. Together they formed a fortress of repression and seclusion, what he called an "iron triangle." In an unpublished statement on art and politics, Morris wrote,

> Artists' lives are bound within the repressive structure of the art world: The iron triangle is made up of museums, galleries, and the media. All three . . . wield power over artists while maintaining a symbiotic dependence on them. In most every case status quo economic interests support this iron triangle and effect policies coming from each corner of it. The repressive structures within the art world parallel those outside it. But while this should generate protest action on a broad front it has not done so until recently. . . . Primarily artists want to be left alone to do their work and consequently they do not develop political consciousness but prefer instead a paternalistic patronage and support.[4]

This statement was part of a proposal written by Morris in 1970 for a book (to be co-authored with the artist Poppy Johnson) that would examine "the modes of radical thought" in twentieth-

century art. Proposing a comprehensive discussion of the "relationships between radical art of the last half-century and radical political action of . . . the same period,"[5] Morris's outline linked various then underestimated movements in oppositional culture: the "roots of modernist mainstream art within the bourgeois classes"; Constructivism; the "people's" art of the W.P.A., 1930s regionalism, and 1960s black art; and the "reduction of the economic base within 'high' art to make it available to large numbers of people;" and the extent to which the aims of this art are contradicted by the demands of the gallery system.[6] Morris and Johnson wanted to analyze the underlying ideological and formal structures for such radical cultural action. Their methodologies would draw on certain philosophical and psychological works (such as Piaget and Merleau-Ponty) in order to go beyond the context of either art or politics as such. Moreover, "concepts of freedom, necessity, power and history" would be discussed in relationship to such figures as "Duchamp, Lenin, Trotsky, and Pollock and how these individuals relate to their respective groups, how such groups provide a context for their actions."[7]

Although this ambitious project was never completed, Morris's notes and proposals for the book offer insight into his ideas on the necessity for artists to challenge the institutions of art through social and cultural activism. Most importantly, these notes indicate Morris's antipathy toward art world institutions and his frustration with artists who tended to distance themselves from efforts to change the system. Such complacency, he felt, served to disguise the reality that many artists live in poverty or that those fortunate enough to sell their work serve a commodity system that brokers their art and robs them of a voice in the distribution and exhibition of their work. It was this complacency that Morris challenged:

> Art is always suffused with political meanings. One such meaning has to do with the class interests any particular art serves. All art serves some class interest since such interests provide the very ground upon which art is sustained. If there is a political context for the emergence of any art there is also one for its entombment in history. . . . The so-called modernist mainstream is a political document which registers certain class interests besides being a collection of physical objects.[8]

By acknowledging their place in the class structure, Morris felt that

artists could overcome the repressive myth of marginality that has been deemed appropriate for them since the rise of modernism. Ultimately, events like the Art Strike were seen by Morris as liberating, for when artists confronted oppressive institutions, they asserted their power as political figures.

It was the frustration of artists with the repressive and cloistered institutions of art—fueled by the atrocities of the Vietnam conflict—that motivated the Art Strike Against War, Repression, and Racism. The Art Strike was conceived on May 18, 1970, at New York University's Loeb Student Center. More than 1,500 artists, dealers, museum officials, and other members of the art community assembled to plan protests against the United States involvement in the Vietnam War and to "reassess the art world's priorities."[9] The idea for the meeting came originally from the faculty of the School of Visual Arts, who wanted to protest the recent bombing of Cambodia, the killings at Kent State University, and harsh police action at other campuses across the country.[10] After speeches by Morris, Johnson, Carl Andre, Irving Petlin, and representatives of the Art Students' Coalition, Women Artists in Revolution, the Art Workers' Coalition, Artists and Writers in Protest, and the Student Committee of Artists United, the Loeb conference elected Morris and Johnson as its co-chairpersons. Following a brief debate the following resolutions were approved:

□ That a one-day strike be declared [that] Friday to close museums and galleries as a protest against the war; with optional continuance for two weeks.

□ That an "emergency cultural government" be formed to sever all collaboration with the Federal Government on artistic activities.

□ That artists take over the ground floor of galleries and museums to help politicize visitors.

□ That a tithe—10 percent—be imposed on the sale of every work of art to go into a fund for peace activities.[11]

Representing about forty of New York's leading art galleries, Klaus Kertess, director of the Bykert Gallery, affirmed the dealers' support of a one-day closing "as an indication of solidarity within the art community."[12] Furthermore, Kertess added that the dealers would agree to use their galleries as information centers for peace activities.

The following evening, at a meeting in Yvonne Rainer's loft to organize the strike action, a group of thirty-five artists voted to demand the closing of five museums on the day of the strike—the New York Cultural Center, the Guggenheim Museum, the Whitney Museum, the Museum of Modern Art, and the Metropolitan Museum of Art. Later they decided to close down the Metropolitan first and to proceed to the others if they refused to participate in the strike. The committee was split in some areas. The two black artists present, for example, attempted without success to reconstitute the steering committee to include equal numbers of blacks, Hispanics, and whites.[13] Women—shamefully ignored by much of the New Left in the 1960s—were characteristically underrepresented at the meeting (one of the few women present was invited to serve as the recording secretary), eliciting another unsuccessful proposal to establish gender as well as racial quotas.[14]

On the day of the Art Strike, the Metropolitan attempted to downplay or ignore the protest, but other New York museums had a mixed response. The Jewish Museum and the Whitney closed in sympathy with the protesters. The Guggenheim suspended its admission charge and removed all paintings from its walls for the day to prevent vandalism. The Museum of Modern Art suspended its $1.50 admission charge for the day and staged a special "pro-youth" photography exhibition and an antiwar film festival, although MoMA's actions were not entirely sympathetic to the spirit of the boycott. The director, John Hightower, charged that the artists' demands for closing the museums put them in "the same position of Hitler in the thirties and forties, Stalin in the fifties—and more recently, the Soviet repression of free expression in Czechoslovakia. I cannot help but think those people in the United States who are most responsible for repression would be delighted by the action you are taking for them."[15]

The Art Strike events offered artists an important and relatively rare opportunity to publicly voice their political concerns. Although the issues of the artist protesters were marginal in relation to the greater political concerns of a country in turmoil, the strike was not unsuccessful in getting the participants' concerns across to the general public and to the art world hierarchy. Such political actions were widely covered by the national and local media—an important arm in Morris's triad of art world oppressors. Perhaps as important, curators, museum trustees, and gallery owners were forced to acknowledge and, as the May 22 Art Strike

suggested, to respond to the demands of the protesters.

The May 22 action, in fact, inspired a number of other protest activities, some more successful than others. On June 1, the New York Art Strike "confronted" the 65th Annual Meeting of the American Association of Museums with a set of demands for greater artist involvement in museum policy decisions. These were virtually ignored. Although the dissident artists were able to capture the speaker's rostrum and temporarily disrupt the proceedings, they later retreated to small, private meetings with sympathetic delegates. The Emergency Cultural Government Committee (a subgroup of the New York Art Strike that included Morris, Petlin, Frank Stella, and the art critic Max Kozloff) waged the Art Strike's most successful boycott: the withdrawal of twenty-six artists from the American Pavilion at the Venice Biennale in protest "against the U.S. government's policies of racism, sexism, repression and war."[16]

To compensate for the Biennale withdrawal, the Emergency Cultural Government Committee sponsored an open exhibition of graphic work (at an alternative space in New York called the Museum, ironically enough). The show's egalitarian format was the result of a challenge by the group Women, Students, and Artists for Black Art Liberation (WSABAL) to an earlier proposal that limited the exhibition to the predominantly white and male artists who had withdrawn from the Biennale. "It is hoped," stated WSABAL's press release, "that this new liberated show will go a step beyond the mere renunciation of government sponsorship by a few known artists in an international show."[17] Shortly after the announcement of the Biennale action, a group of artists and dealers headed by Robert Morris mobilized for a Washington journey in order to brief members of the Senate Subcommittee on the Arts and Humanities.[18] The voice of the artist-protester had become important enough in the eyes of the establishment that artists were now invited into such political forums, a significant breakthrough for cultural activists.

Yet, the Art Strike Against War, Repression, and Racism was quickly losing its ideological center. By the end of 1970, the movement—with neither an intellectual nor a political program to unify its disparate factions—had collapsed under the weight of dissension and disagreement. "[The Art Strike] concept began to come apart in terms of other interest groups within . . . the organization," observed Morris a decade later. "The consensus weakened.

. . . There were no common actions that could be agreed upon. It just began to dissipate very quickly."[19] Most of the Art Strikers did not consider their art intrinsically political or social, a problem that resulted in a divisive split between the purity of their artistic vision and the activism resulting from their frustration with the Vietnam War.

Morris, who had come to the artists' antiwar movement relatively late, was not reticent about reconciling his art with such political activities.[20] On one level, the American involvement in the Vietnam conflict revived Morris's ongoing interest in the devastation of war as a theme for his art. As early as October 1962, for example, he had executed thirteen drawings titled *Crisis* in response to the harrowing events of the Cuban missile crisis (Fig. 54).[21] The drawings—gray-washed pages from three New York tabloids bearing anxious and inflammatory banner headlines—created ironic juxtapositions between artfully subdued surfaces and the harsh, manipulative language lurking beneath them. Dur-

54
Robert Morris, *Crisis (New York Post, Monday, October 22, 1962)*, 1962. Newspaper page painted gray. Collection of the artist.

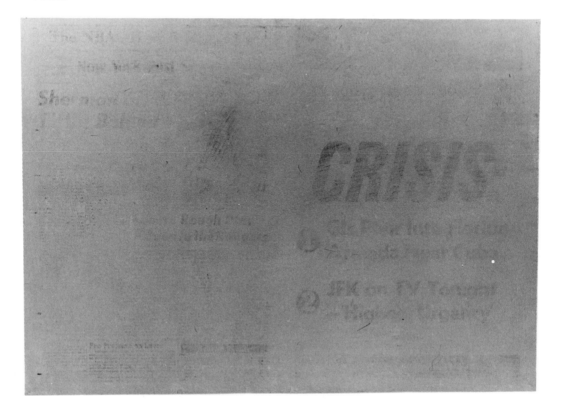

ing the same period, Morris and the artist Robert Huot began discussing urban violence and theories about its origins in class and race. As a possible outlet for the frustrations and tensions that resulted in these violent acts, Huot suggested a festive jousting tournament. This was the basis of a dance duet, *War,* that premiered at the Judson Memorial Church on January 30, 1963 (Fig. 55).[22] Finally, in direct response to the United States' bombing of Cambodia in 1970, Morris produced a series of drawings and a suite of five lithographs depicting visionary war memorials such as *Trench with Chlorine Gas, One-Half Mile Concrete Star with Names,* and *Scattered Atomic Waste* (Fig. 56).[23]

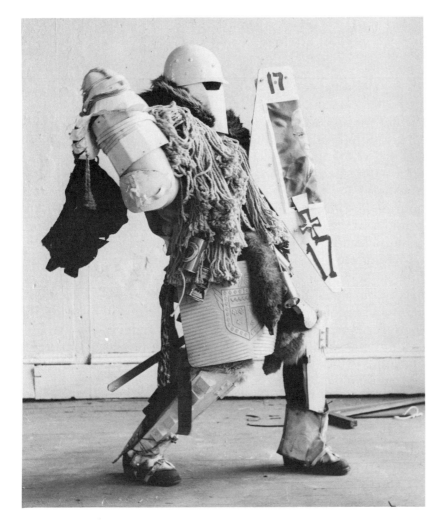

55
Robert Morris in costume for his dance *War,* performed at the Judson Memorial Church, New York, January 1963.

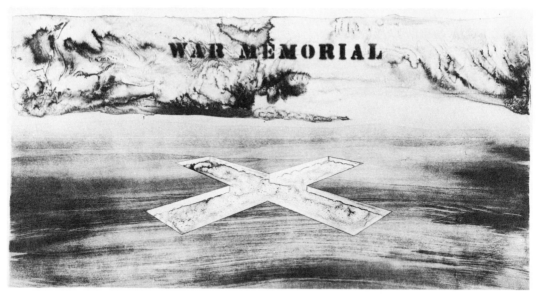

56
Robert Morris, *War Memorial: Trench with Chlorine Gas,* 1970. Lithograph. Leo Castelli Gallery, New York.

Beyond the issues of war, Morris's political activism against the institutions of art stemmed from his long-standing frustration with the traditional space of exhibition. Such protests and actions followed the desublimating impulses of the dances, gray polyhedrons, and anti-form pieces of the mid-1960s—innovative works motivated by underlying political concerns with the repressive institutions of late capitalism. So when Marcia Tucker, an associate curator at the Whitney Museum, offered Morris a retrospective at the Whitney to open in late Spring 1970, he agreed to exhibit only if the monetary value of the exhibited works was no greater than the cost of materials and labor. Essentially, Morris rejected the underlying economic motives of the traditional retrospective, where the veneration of historical objects tended to make them even more desirable to the art market. He offered the Whitney an ultimatum: either he would construct a site-specific installation or he would not participate. "I want to make . . . a redefinition of the possibilities for one-man shows in contemporary museums of art," he wrote to Tucker. "My hope is that the museum can support a showing situation which allows the artist an engagement rather than a regurgitation: a situation of challenge for the public and risk for the artist."[24]

Morris's view prevailed, and on April 9, 1970, his sprawling participatory exhibition opened at the Whitney Museum.[25] The

centerpiece of the show, a giant, primitive track system made of timbers and steel pipes, necessitated the clearing away of all partitions from the Whitney's third-floor gallery. Workers pushed massive concrete blocks down the tracks with pipe rollers until, at the end of the tracks, the huge blocks crashed to the floor. The large number of these blocks accumulating at one end of the track eventually caused the entire structure to collapse (Fig. 57). Rejecting the tradition of finished aesthetic objects, the installation juxtaposed the dynamic of construction and process with that of destruction. "As workmen moved in with gantries, forklifts and hydraulic jacks to help Morris do his thing," wrote *Time* magazine, "the museum took on the look of a midtown construction site."[26] Morris even dispensed with a formal opening, instead allowing interested museumgoers to observe him and his crew at work—a valorization of actual labor only symbolically represented in his dance *Site*.[27] With this installation, Morris attempted to undermine the concept of the exhibition as a cloistered and repressive display of precious objects. By opening up the installation of the work to the spectators, he demystified the process of "artistic creation," converting it into a theater of operations.

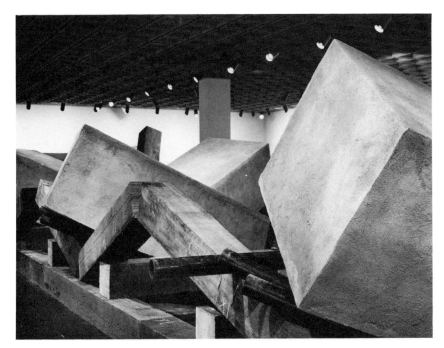

57
Robert Morris, *Untitled*, 1970. Installation for Morris solo exhibition, Whitney Museum of American Art, April 9–May 17, 1970. Timbers, concrete, steel. Destroyed. Photo: © Peter Moore, 1970.

Beyond the installation and the circumstances of its creation, another strategy of subversion was advanced three weeks before the exhibition's scheduled closing. Without warning, Morris released a statement simultaneously to the museum's trustees and to the press demanding that the museum close his one-man show, in order to underscore the need to shift priorities from "art making and viewing to unified action within the art community against the intensifying conditions of repression, war, and racism in this country." In addition, Morris asked the trustees to issue a statement of position, suspend all normal cultural functions during the closing, make available staff and space for meetings open to every level of the art community, and initiate discussions with other major museum staffs concerning the complicitous role of art institutions in the repression of artists and spectators. He warned that unwillingness to comply with these demands would be interpreted as "condoning . . . militarist and repressive policies."[28] Even though his proposals for realigning the Whitney's priorities were ignored, Morris's exhibition was closed three weeks early, on May 17.

Morris's actions, motivated by the continuing escalation of the Vietnam War, were in response to the tragic killing of four student protesters at Kent State University in Ohio on May 4, 1970, by National Guardsmen. Nine days after the Kent shootings, a group of artists participating in the *Using Walls* exhibition at the Jewish Museum had also voted to demand the closing of that show as a means of forcing the museum to respond to the atrocities at hand.[29] Artists are "not used to organizing and they prefer to be uninvolved in politics," Morris remarked. "The catalyst was the deaths of the students. A lot of us had strong feelings about Vietnam and Cambodia, but Kent State galvanized us into action. We identified with the students. Museums are our campuses."[30] Just as university campuses were places of learning for students, so museums were places where artists were educated. At the same time, Morris reasoned, just as students were oppressed on campuses across the country, artists were oppressed by museums. Thus, both places were seen as legitimate battlegrounds for liberation. (Student organizations such as the Students for a Democratic Society and the Free Speech Movement at Berkeley were important to the New Left. Morris's solidarity with the student protesters reflected a popular conviction in the late 1960s that students were major agents for social change.)[31]

Less than a year after the Whitney closing, a group of artists

participating in the sixth Guggenheim International Exhibition at the Guggenheim Museum strongly objected to a large striped cotton banner by Daniel Buren that obstructed the view across the building's impressive atrium.[32] Buren's desire to intentionally subvert the conventions of museum exhibitions did not convince many of the artists in the Guggenheim International, whose territorial rights were violated by the work's intrusive presence.[33] Under intense pressure from this small but vocal group of artists (led by the sculptor Dan Flavin), the museum removed the blue and white banner from the exhibition without prior agreement from Buren.[34] Robert Morris deplored the fact that no attempt was made to arrive at a consensus of participating artists. "This is insulting to Mr. Buren," he wrote to Guggenheim curator Diane Waldman, "and once again shows evidence of the cavalier, oppressive, and fascistic type of control exercised by museums."[35]

The 1960s and early 1970s witnessed a number of important challenges to the social order of the museum.[36] Many of the early protests of the Art Workers' Coalition and the Guerrilla Art Action Group, for example, were specifically waged against the museum. Individual artists were no less outspoken. Hans Haacke's direct social commentaries—on the real estate market's disenfranchisement of the poor, on the racism and classism that result in oppression, on the art world's complicity in such establishment ventures as the Vietnam War—spoke directly to political issues of patronage and art world money, eschewing the polite games of perception and individual reception prized by Minimalism's relatively purist aesthetic.[37] Haacke's position was so controversial that the director of the Guggenheim Museum, Thomas Messer, canceled his 1971 one-person exhibition in response to several offending works, including a piece that detailed the New York property holdings of slumlord Harry Shapolsky and his real estate group. Edward Fry, the curator of the exhibition, was fired after he defended Haacke. A group of artists, including Morris, held a protest demonstration at the museum: one hundred of them signed a pledge not to exhibit at the Guggenheim "until the policy of art censorship and its advocates are changed."[38]

"Art is not above ideologies," Buren had stated at the time of his own Guggenheim incident, "but a part of them. In the case of the 'avant-garde' art is a reflection of a dominant ideology—in our society, that of the bourgeoisie."[39] Yet it was important to Haacke's strategy and Buren's that most of their major installa-

tions were exhibited in museums and galleries, functioning within the system to undermine its oppressive conventions and hierarchies.[40] Rather than remaining marginal to the art world, they argued that artists could gain enpowerment through a subversive relation to these institutional connections. In the end, and as a result of the pressure from such organizations as the Art Workers' Coalition *and* the willingness of artists like Morris, Haacke, and Buren to exhibit in the museum, curators began to respond to the idea of reorienting the role of the exhibition. Consequently shows like *Anti-Illusion: Procedures/Materials* at the Whitney Museum (1969) and *Information* at the Museum of Modern Art (1970, Fig. 58) attempted to overturn the museum's dependence on rarefied aesthetic objects, as they allowed for the inclusion of politically oriented and nontraditional art forms.

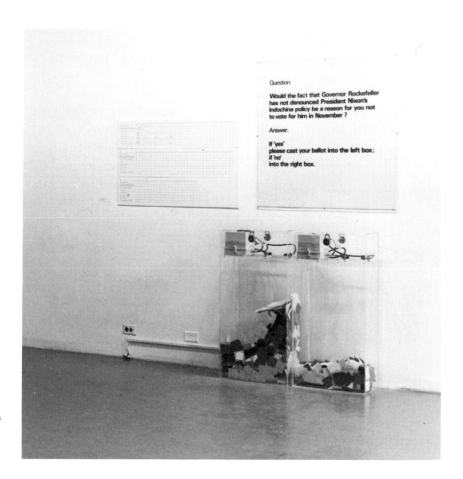

58
Hans Haacke, *MoMA Poll,* 1970. Installation view, *Information* exhibition, Museum of Modern Art, New York, June 20–September 20, 1970. Text, two acrylic ballot boxes fitted with photoelectrical counting devices.

Morris's challenge to the repressive hierarchies of the museum reached its culmination in May 1971 during the attempt by the Tate Gallery in London to mount an "authoritative" retrospective of his work. Again, Morris had refused the idea of a traditional retrospective. And, after reaching a compromise with the museum's trustees, Morris reduced the "authoritative" part of the Tate exhibition to photographic reproductions, several refabricated sculptures, and a slide show of his work of the 1960s. The "non-authoritative" part of the exhibition consisted of three architectonic theaters of viewer participation, rooms where all traditional notions of the autonomy of art and the reified nature of the exhibition space were overturned. In the first room was a large granite roller to walk around on. Nearby were two sets of steel ramps with large heavy forms to haul up and down on a rope. The second room—a monumental, Neoclassical rotunda—housed a large wooden ball that was to be kicked around a circular track. A low tightrope and a walking beam spanned the third (and final) room alongside a steel ledge to balance on, broad steel ramps, assorted slots and tunnels, and a set of vertical "chimneys" for climbing. In each room, instructions were posted on the walls indicating the various ways in which the spectator could interact with the structures.

These environments constituted a kind of aesthetic playground. But things got out of hand as traditionally passive museumgoers were thrust into the role of full participants (Figs. 59, 60). "The public got into . . . a somewhat overzealous participation," observed one spectator. "They were jumping and screaming . . . the middle-aged in particular. The children were the most sensible." The directors of the institution were not prepared for the public's response. The environment "produced an electric social atmosphere; individual exhilaration [became] group exhilaration, people wanted to do things together." Within a few days, the rooms "were a shambles." Objects still standing were in danger of collapsing. Five days after the show opened it was closed "to protect the public." Morris's resistance to the historicism of the "retrospective" was difficult for the commissioners of the Tate Gallery to accept; several days after the show was closed and Morris had returned to the United States, the exhibition was reopened as a hastily organized retrospective of the artist's work, assembled from the permanent collection and from objects loaned by local collectors and museums.[41]

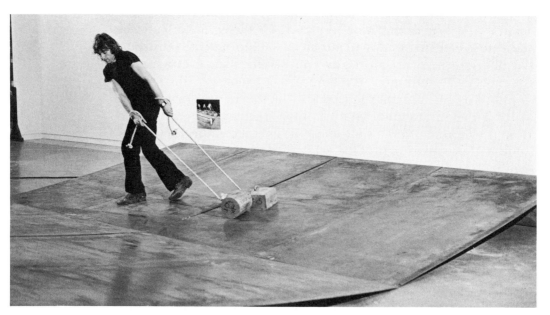

59
Robert Morris, *Untitled* ("participation" object). Installation view, Tate Gallery, London, April 28–June 6, 1971. Destroyed.

Critical response to Morris's Tate Gallery installation was generally cynical and suspicious. Many critics found Morris's antics shocking and destructive—a needless attack on the respectability of one of England's great institutions.[42] There were also critics who believed that Morris's willingness to work within the museum's institutional frame ultimately undercut the effectiveness of his protests. Peter Fuller sarcastically concluded that the Tate installation resembled a "Fun Fair": "If . . . [Morris] really meant half of what he says he would be down in Harlem somewhere, trying his experiments in a real life situation."[43] Yet it was the fun-fair ambience of the Tate installation that represented its most radical challenge to the institutional demands of the museum. More than any of Morris's projects up to that point, the Tate "retrospective" succeeded in shattering the repressive, cathedrallike silence of the museum. Remarkably, Morris introduced into the experience of the exhibition a heretofore alien concept: play. As such, these playful participation pieces—the ramps to be climbed or the objects to be moved and pushed around—offered a means for desublimating both the art object and the viewer's experience of the exhibition. The viewer—instead of interacting with cloistered, precious art objects—was thrust into a sensual and active experience, one that offered relief from the repressive world outside.

"Perhaps the artists should be integrated into society," Morris has observed, "and in some way improve the quality of life . . . [as] Marcuse has [advocated]."[44] In the end, Morris's rethinking of art's institutional frame at the Tate reconciled Marcusean notions of desublimating the repressiveness of society through art and its institutions. Such radicalism was driven by the will to overturn shopworn notions of the art object's autonomy, its existence outside the actual temporal experience of the spectator.[45] In rejecting these autonomist notions, Morris's art participated in a reevaluation both of the art object's deployment and display as well as its reception by the viewer. Morris often pushed individual contact to its extreme, forcing the art object and viewer into a complex, intrinsically phenomenological relationship: the altered gestalts of the Minimalist monoliths, the scatterings of anti-form, the psychosexual narrative of *Waterman Switch,* the ramps and tunnels of the Tate Gallery installation all speak to a direct and provocative *engagement* of the spectator. As calls for the "desublimation" of Western society and the liberation of human sexuality resounded in the 1960s, Morris sought to liberate the art object from the repressive control of galleries, museums, and the media—the imprisoning iron triangle of the art world.

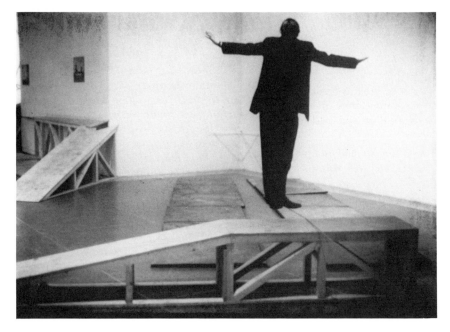

60
Robert Morris, *Untitled* ("participation" objects). Installation view, Tate Gallery, London, 1971.

NOTES

1. As quoted in Therese Schwartz and Bill Amidon, "on the steps of the met," *New York Element* 2 (June–July 1970), p. 4.

2. In an interview conducted in 1981, Morris recalled that, given the power of the Metropolitan Museum, the strikers expected to be arrested. Sean Elwood, unpublished interview with Robert Morris, New York City, October 29, 1981, p. 5. The chronology of events of the Metropolitan Strike is culled from conversations with Robert Morris and the following published sources: Schwartz and Amidon, pp. 3–4 and 19–20; Elwood, pp. 1–11; Grace Glueck, "500 in Art Strike Sit on Steps of Metropolitan," *New York Times,* May 23, 1970, p. 12; Lawrence Alloway, "Art," *Nation* 19 (October 1970), pp. 381–82; Elizabeth C. Baker, "Pickets on Parnassus," *Art News* 70 (September 1970), pp. 31–33.

3. This word had gained great currency in the political left since the publication of Marcuse's *Eros and Civilization* in 1955 and its 1969 sequel, *An Essay on Liberation.*

4. Unpublished essay on art and politics, undated (1970?), p. 1 (Morris archives, Gardiner, New York).

5. Handwritten abstract for a book on art and politics, undated, n.p. (Morris archives, Gardiner, New York).

6. Ibid. Morris's historical methodology for the book was influenced by Donald Drew Egbert's comprehensive study *Social Radicalism and the Arts: Western Europe—A Cultural History from the French Revolution to the Present* (New York: Knopf, 1970).

7. Preliminary proposal.

8. Morris, unpublished essay on art and politics, p. 1.

9. Grace Glueck, "Art Community Here Agrees on a Plan to Fight War, Racism, and Oppression," *New York Times,* May 19, 1970, p. 30.

10. Undated press release, May 1970 (Morris archives, Gardiner, New York).

11. Glueck, "Art Community Agrees," p. 30.

12. Ibid.

13. Black artists united under Women Students and Artists for Black Art Liberation (WSABAL), a student organization. Claiming that the art world existed to protect the interests of "superstar anti-human artists," WSABAL released a statement to the press on June 24, 1970 (written by the critic and writer Michele Wallace), that denounced the Artists' Strike as racist. Calling for a quota system of race and gender, the press release stated that black artists had united under WSABAL "to finally bring to an end the complex system of THE BIGOTED ART ESTABLISHMENT OF ANTI-HUMAN WHITES AND TOKEN NIGGAS." Original press release in Morris archives, Gardiner, New York.

14. For a discussion of the problematic relationship between feminism and the New Left, see Ellen Willis, "Radical Feminism and Feminist

Radicalism," in Sohnya Sayers et al., eds., *The '60s Without Apology* (Minneapolis: University of Minnesota Press, 1984), pp. 91–118.

15. For this quote and more on the response of New York museums, see Glueck, "500 in Art Strike," p. 12.

16. Statement from press release issued on July 14, 1970. The 26 boycotting artists were Richard Anuskiewicz, Leonard Baskin, Herbert Bayer, Robert Birmelin, John Cage, Raymond Deshais, Jim Dine, Sam Francis, Ron Kitaj, Nick Krushenick, Roy Lichtenstein, Vincent Longo, Sven Lukin, Michael Mazur, Deen Meeker, Robert Morris, Robert Motherwell, Claes Oldenburg, Robert Rauschenberg, Lucas Samaras, Frank Stella, Carol Summers, Ernest Trova, Andy Warhol, Jack Youngerman, and Adja Yunkers.

17. Press release for *Open Show,* issued on July 14, 1970.

18. The briefing occurred on June 16, 1970. For more on the Senate appearance, see Grace Glueck, "Strike Front Keeps Its Cool," *New York Times,* July 5, 1970, p. 17D.

19. As quoted in Elwood, p. 6. Elizabeth Baker wrote: "As art factions fought each other about tactics, concern turned inward and refocused around a number of points involving museum reform which art-world radicals, mainly the Art Workers' Coalition, had been working towards for over a year. All at once, strike leaders were openly stating that the war was no longer the issue, although at this juncture the continually elusive nature of the Strike constituency underwent a particularly major shift. Even by the time the Strike reached the steps of the Met, many of its first promoters had returned disillusioned to their studios, leaving a loose mixture of groups with different axes to grind." See Baker, p. 32.

20. Artists such as Nancy Spero, Carolee Schneemann, Robert Huot, Jon Hendricks, Rudolf Baranik, George Maciunas, and Leon Golub responded to the war as early as 1965. For an analysis of the representational strategies employed against the war in Vietnam, see Maurice Berger, "Broken Bodies, Dead Babies, and Other Weapons of War," in *Representing Vietnam, 1965–*

1973 (New York: Bertha and Karl Leubsdorf Art Gallery, Hunter College, 1988).

21. The title of the series, *Crisis,* was taken from one of the newspaper headlines. For more on this series, see Thomas Krens, *The Drawings of Robert Morris* (Williamstown, Mass.: Williams College Art Gallery, 1982), n.p.

22. For the performance, Morris and Huot individually, and in secret, crafted armor and weapons (Morris's shield was adorned with a large photograph of Dwight Eisenhower), agreeing only to make them breakable and harmless. Taunting each other with voodoo dolls, the two began their dance in total darkness as the composer La Monte Young played a large gong for three minutes: "Suddenly light flooded the space," recounted Huot. "Morris and I were at the far end of the [Judson] gym. We hesitated for a few seconds, turned and charged at each other. We collided and at the moment of impact released a pair of white doves. We battled as the doves flapped overhead. When we ran out of weapons we battled hand to hand, rolling toward the audience. As we reached them, the lights went out and La Monte played again for three minutes." While lacking the ideological complexity of *Waterman Switch* and *Site,* the Huot/Morris collaboration nevertheless served both as a disturbing reminder of the cold war ideologies that resounded in America and a parody of the machismo of Abstract Expressionism.

23. Two of Morris's war memorials, *Steel Ball in Trench* (1970) and *Large Cross-Shaped Trench with Steam* (1970), were actually proposed but were never built. For the 1969 *Art and Technology* exhibition curated by Maurice Tuchman at the Los Angeles County Museum of Art, Morris proposed that the massive air conditioners and heaters of the type used in the ground-support phase of intercontinental ballistic missile technology be buried in a square mile of ranch land in Irvine, California. The machine-generated hot and cold air would be vented in the ground, an effect designed to denaturalize and distort the pastoral experience. "One could wander around and come upon these local changes of temperature—a cold wind blowing out of an otherwise still tree or stones

radiating heat. . . ." The antiwar message of *Los Angeles Project II*, however, overstepped the boundaries of an exhibition designed to bring artists into contact with the "resources of modern industry and its related technologies." Tuchman eventually abandoned the controversial ICBM project when the corporation (Litton Industries) matched with Morris—a major producer of aeronautics technology—withdrew its support.

24. Letter from Morris to Marcia Tucker, December 28, 1969 (Morris archives, Gardiner, New York).

25. Morris took a cynical view of the museum's belated acceptance of his proposal: "It was too late. . . . They were obliged to install. They were scheduled and it was pretty late by then. My feeling is that they couldn't change things around." Unpublished interview with Jack Burnham, November 21, 1975, pp. 13–14 (Morris archives, Gardiner, New York).

26. "Maximizing the Minimal," *Time*, April 20, 1970, p. 54.

27. Other pieces in the show (there were six in all) included a large arrangement of massive timbers and a series of structures made of steel plates held together with brackets.

28. Press release signed and dated "Robert Morris, May 15, 1970" (Morris archives, Gardiner, New York).

29. This decision was made at a meeting held at the Jewish Museum on May 13, 1970.

30. Ralph Blumenfeld, "Daily Closeup: Show Mustn't Go On," *New York Post*, June 4, 1970, p. 37.

31. In this regard, Marcuse was an important catalyst in bringing students into the leftist fold. See Barry Kåtz, "Years of Cheerful Pessimism," in *Herbert Marcuse and the Art of Liberation* (London: Verso, 1982), pp. 162–92.

32. For more on the piece, see Daniel Buren in "Gurgles Around the Guggenheim," *Studio International* 182 (June 1971), p. 246.

33. For more on Buren's critical relationship to the institutional spaces of exhibition, see Daniel Buren, "The Function of the Museum," *Artforum* 12 (September 1973); reprinted in Amy Baker Sandback, ed., *Looking Critically: 21 Years of Artforum' Magazine* (Ann Arbor: U.M.I. Research Press, 1984), p. 142. For a discussion of the political implications of Buren's work, see Douglas Crimp, "The End of Painting," *October*, no. 16 (Spring 1981), pp. 69–86.

34. Diane Waldman, the curator of the exhibition, offered Buren a one-person show to follow immediately on the Guggenheim International if he agreed to withdraw the interior painting. Buren recounted, "There could clearly be no question of exhibiting Painting 2 without Painting 1; this would have been a mutilation of the project as originally conceived. As for the one-man show, which certainly would have interested me in other circumstances, it was no more than a skillful means of taking some of the odium from the censorship that was being exercised by certain artists, thus obviating a confrontation from which they could hardly have emerged with credit; by shifting my piece out of its initial context, it would be possible to diffuse the issue which it raised by its presence." See "Gurgles Around the Guggenheim," p. 246.

35. Robert Morris, "Statement of Position with Regard to the Removal of Daniel Buren's Work," enclosed with letter to Diane Waldman, February 15, 1971 (Morris archives, Gardiner, New York). Only Carl Andre withdrew his work from the Guggenheim International in protest at the removal of Buren's work.

36. For a series of interviews on the reordering of the economic and social structure of the art world in the midst of the political upheavals of the 1960s, see Jeanne Siegel, *Artwords: Discourse on the '60s and '70s* (Ann Arbor: U.M.I. Research Press, 1985), pp. 85–140.

37. Morris usually resisted direct political statements. Also, in keeping with most avant-garde practice in the 1960s, he avoided the world of popular culture. His attachment to the concept of art as removed from the absolutist state of social politics recalls the aesthetics of Marcuse, for whom even political art relegated to the streets (a condition advocated by Marcuse in the *Essay on Liberation*) must somehow appeal to the emotional

and aesthetic interests of *art.* See Kåtz, "Art and Politics in the Totalitarian Era (1942–1951)," in *Herbert Marcuse and the Art of Liberation,* p. 128.

38. For more on the Guggenheim incident, see Hans Haacke, "Shapolsky et al., Manhattan Real Estate Holdings, a Real Time Social System, as of May 1, 1971," in Brian Wallis, ed., *Hans Haacke: Unfinished Business* (New York: New Museum of Contemporary Art, 1986), pp. 92–97.

39. Buren, "Gurgles Around the Guggenheim," p. 246.

40. For more on this subject, see Yve-Alain Bois, Douglas Crimp, and Rosalind Krauss, "A Conversation with Hans Haacke," *October,* no. 30 (Fall 1984), pp. 23–48.

41. For journalistic accounts of the Tate exhibition and its subsequent closing, see Guy Brett, "Heavy Weights," *The Times* (London), April 28, 1971; Caroline Tisdall, "Sculpture for Performing On," *Guardian Weekly* (London), May 8, 1971; Nigel Gosling, "The 'Have-a-go' Show," *Observer Review* (London), May 2, 1971. For an appraisal of the Tate incident see Barbara Reise, "A Tale of Two Exhibitions: The Aborted Haacke and Robert Morris Shows," *Studio International* 182 (July 1971), p. 30. It should also be added that participation art was not uncommon in Europe at this time. The work of the Paris-based Groupe de Récherche d'Art Visuel was well established in Europe by the time of Morris's Tate exhibition.

42. See, for example, Reyner Banham, "Art in London: It Was SRO—and a Disaster," *New York Times,* May 23, 1971, p. 31.

43. "Morris Dances," *Ink* (London), May 29, 1971, p. 10.

44. Unpublished statement by Robert Morris dated June 3, 1971 (Morris archives, Gardiner, New York).

45. My use of the word *autonomy* and its avant-gardist implications is consistent with that of Peter Bürger. See Jochen Schulte-Sasse's analysis of Bürger's position in "Theory of Modernism versus Theory of the Avant-Garde," in *Theory of the Avant-Garde,* trans. Michael Shaw (Minneapolis: University of Minnesota Press, 1984), pp. vii–xlvii.

LABYRINTHS:
A SEARCH FOR THE SELF

A faded mimeographed invitation and a few photographs are all that survive from Robert Morris's *Passageway* (Figs. 61, 62). For a period of two weeks in June 1961, as part of a performance series arranged by La Monte Young in Yoko Ono's Lower Manhattan loft, guests were invited to experience "an environment." At first glance, Morris's first large-scale installation appeared just as drab and unrevealing as its announcement. Starting at the loft's front door, Morris had erected a fifty-foot-long semicircular channel that graduated to a point so sharp that it was impossible to enter the last quarter of its length. The starkness of the dead end, coupled with the recorded sounds of a clock ticking and a heart beating, contrasted with the passive experience of the viewer's passage.

Starting with *Passageway,* Morris's work has most often duplicated the experiential conditions of the labyrinth.[1] While some works were structures or proposals for mazes that the spectator entered and traversed (Fig. 63), others appropriated the decentering psychological conditions of the labyrinth. Because the ultimate organization of its numerous passages is unknown to the uninitiated, exiting the labyrinth is predicated on an accumulation of information in time. As the viewer walks around and through works like the *L-beams* or the four sloped cubes, each shift in

perspective renders new information about the objects and their setting. Thus, the phenomenological, temporal passage that defined the experience of Morris's gray polyhedrons, anti-form pieces, and large-scale installations originated with the spectator entering a situation without prior awareness of the absolute structure or design of the installation.

Morris's labyrinthine spaces take a dialectical view of their potential to *control* the viewer. While the experience of a labyrinth is somewhat claustrophobic and disturbing, its exploratory situation grants the individual a degree of independence from the traditional relationship between viewer and reverential art object. The Tate installation, for example, undercut the museum's ordering of the spectator; visitors were encouraged to climb, walk on, and touch objects without regard for the decorum of the institution. Once inside a labyrinth, the participant is freed from the immedi-

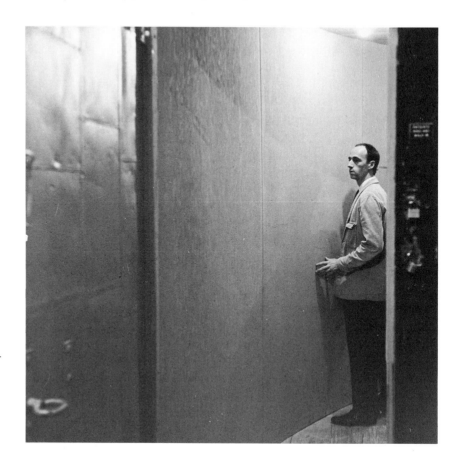

61
Robert Morris standing at the entrance to his *Passageway*, Yoko Ono's Chambers Street Loft, New York, June 1961. Plywood. Destroyed.

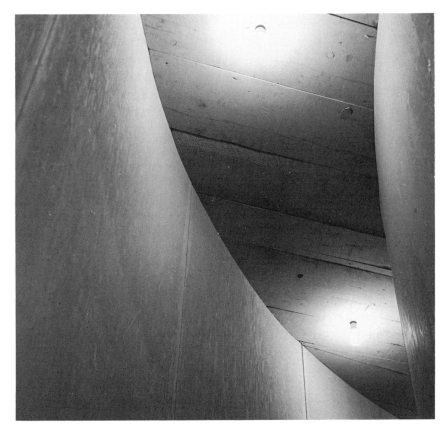

62
Robert Morris, *Passageway*, 1961. Ceiling detail.

63
Robert Morris, *Labyrinth*, 1974. Ink on paper. Collection of the artist.

ate and repressive demands of the real world. One thinks of Borges's words: "Often the labyrinth is a symbol for happiness . . . because we feel we are lost in the world, and the obvious symbol is that of losing yourself in the labyrinth . . . and the word labyrinth is so beautiful."[2]

The concept of the labyrinth as a vehicle for spiritual freedom is deeply ingrained in the history of ideas. The notion of the labyrinth as a refuge predates Romanticism, having existed as early as the mystery cults of Dionysus.[3] "The prisoner who survives incarceration or the rigors of the labyrinth," writes Stephen Eisenman, "transcends bodily cares and is initiated into a realm of spiritual redemption." Thus the labyrinth was seen as the setting for creative acts, a space "where time and the phenomenal world are placed in suspension."[4] As such, Morris's labyrinthine spaces serve as metaphors for the central and driving dialectic of his oeuvre: the idea of a desublimating, antirepressive art that deconstructs the institutional hierarchies of late capitalism.

The possibility of liberation from repression was a utopian goal for intellectuals such as Marcuse, who believed that repression represented the principal means by which society could control the individual. In the mid-1960s, a questioning of the logic of domination, an issue initially discussed by Marcuse a decade earlier, reemerged in the work of Michel Foucault. Foucault himself later described the philosophical/political character of those years:

> Then came the five brief, impassioned, jubilant, enigmatic years. At the gates of our world, there was Vietnam, of course, and the first major blows to the powers that be. But here, inside . . . [the walls of academia], what exactly was taking place? An amalgam of revolutionary and antirepressive politics? A war fought on two fronts: against social exploitation and psychic repression? A surge of libido modulated by the class struggle?[5]

What was taking place in Morris's work of this period was an exploration of the various intellectual trends mapped out by Foucault. Morris was searching for art forms that could mirror and critique the repressive space of late capitalism as well as experiences that were self-validating and recuperative. It was in the winding and circuitous paths of the labyrinth that he could explore both sides of these seemingly contradictory positions. "The problems

of solipsism and autism hang in the air," wrote Morris. "Here the labyrinth form is perhaps a metonym of the search for the self, for it demands a continuous wandering, a relinquishing of the knowledge of where one is."[6]

Morris's dialectic centered on the means by which the repressive conditions of the institutions of industrial society robbed the individual of control over his or her actions and movements. Because the real mechanisms of control in urban and industrialized spaces existed outside the person, the notion of a psychologically centered individual was for Morris a fiction. Rather than "relinquishing the knowledge of where one is," Morris felt the individual must instead be acutely aware of a priori rules, regulations, and conditions in order to survive. The aesthetic realm, as Marcuse had reasoned, recapitulated these repressive conditions: the space of the museum—a maze of pedestals, framed images, and elegant chambers as well as economic and representational hierarchies—was a microcosm of the institutional structure of late capitalism. From his earliest dances and sculptures to his major installations and earth pieces of the 1970s, Morris sought to examine the basis of this repression and to realign his aesthetics toward a new social order. Some of these works functioned rhetorically or critically (*Site* or the Peripatetic Artists Guild), while others (like the Tate installation) actually attempted to put into effect this new, Marcusean aesthetic order—an order that replaced the oppression of the museum with a freer interaction between the viewer and art.

Morris's environments of the early 1970s, the labyrinthine units, mazes, and sound chambers, went to the core of his ideological program: they explored society's repression of the individual. It was not uncoincidental, for example, that *Untitled* (1967, Fig. 64), a series of nine cubicles made of steel, resembled the claustrophobic spatial dividers found in business offices. The organization of such structures is neither innocent nor randomly determined. Like the pedestals of the art gallery or museum, they act as instruments or signs of behavioral modification—partitions meant to offer employees "privacy," at the same time allowing their supervisors to observe them easily.

In 1972, Morris pushed this critique of repression to its extreme in a large-scale installation entitled *Hearing* (Fig. 65). Installed at the Leo Castelli Gallery in New York, *Hearing* consisted of a tableau of recognizable objects accompanied by the continu-

ous blare of recorded dialogue. *Hearing*'s arrangement was deceptively simple: an equilateral cruciform platform filled with casting sand served as the base for three pieces of furniture—a oversized copper chair, a galvanized steel table, and a lead cot and pillow. The unit was flanked by two arcs of chairs provided for the spectators. From the audiotape—a three-and-a-half-hour mock courtroom inquisition involving an "investigator," a "council," and a "witness"—issued a "drama of ideas," as Morris referred to it.[7] Echoing in this maniacal courtroom were English-language texts by Noam Chomsky, Marcel Duchamp, Michel Foucault, Gabriel García Márquez, Jean Piaget, Claude Lévi-Strauss, Ludwig Wittgenstein, and others.[8] The dialogues and monologues of the taped interrogation—essentially a juxtaposition of opinions on art history, aesthetic theory, Marxism, and structuralist analysis—were interrupted periodically by a raucous buzzer and by a gavel striking pronouncement of "recess," a pause meant to release the seated spectators to approach the haunting objects before them.

Hearing's subdued ambient lighting partially disguised its most shocking detail: buried in a trench in the sand was a group of wet-cell batteries. Carefully worded signs placed on the floor

64
Robert Morris, *Untitled*, 1967. Steel. Solomon R. Guggenheim Museum, New York.

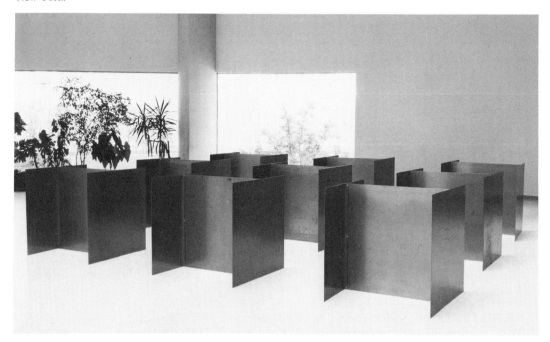

read: "CAUTION. Injurious heat and amperage. Do not touch the objects or step on the platform." This admonition—which on one level served as a parody of the mechanisms of authority under question—signaled the fact that the table and bed were electrically charged and the chair was filled with circulating water heated to the point that its copper glowed. The experience of moving around the installation was frustrating, for the sensuous and tactile demands of the sculpture were in conflict with its mechanisms of fear. In the end, *Hearing* established an analogy between the space of exhibition and the carceral realm of courtrooms and prisons. The trial represented in this work reads as a metaphor for Morris's own indictment of modernist culture. The claustrophobic and unnerving experience of *Hearing* represents a microcosm of late capitalist society.

The triallike ambience of *Hearing* was extended later in the decade to an exploration of prisons as a metaphor for industrial spaces. Under the influence of Michel Foucault's *Discipline and Punish,* a study of how penal institutions and the power to punish became a part of our lives,[9] Morris executed a suite of twelve drawings in 1978 that explicitly examined the repressive order of

65
Robert Morris, *Hearing,* 1972. Installation for the Leo Castelli Gallery, New York, April 1972. Stereo tape of 3½ hours, stereo tape recorder, amplifier, 2 speakers, wooden platform with bronze molding and covered with casting sand, copper chair filled with water heated with immersion heater, galvanized aluminum table and lead bed linked by wet-cell batteries. Leo Castelli Gallery, New York.

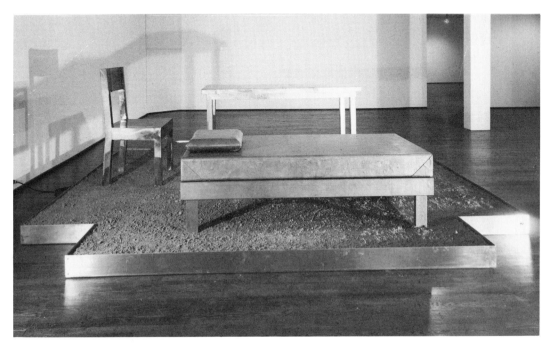

industrial society. The drawings—collectively entitled *In the Realm of the Carceral*—represent the way hierarchies of power insist that space be organized to monitor people and control their actions. The *Carceral* drawings (Figs. 66, 67), images of labyrinthine prisons and other spaces of confinement, have several sources in the history of art and architecture: the visionary architecture of Etienne Boullée and Claude-Nicolas Ledoux and the *Carceri inven-*

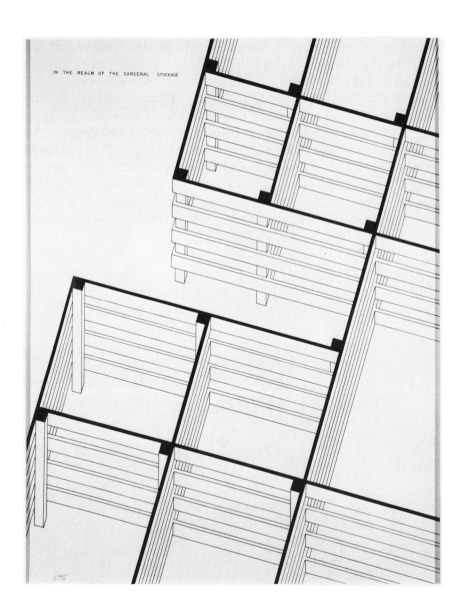

IN THE REALM OF THE CARCERAL STOCKADE

66
Robert Morris, *In the Realm of the Carceral: Stockade*, 1978. Ink on paper.

zione of Giovanni Battista Piranesi (Morris had visited the Piranesi exhibition at the National Gallery in Washington in the spring of 1978). The enclosing spaces depicted in the *Carceral* series—*Towers of Silence, Security Walls, Stockade, Places for the Solitary,* and *Observation Yards*—resemble, as well, Morris's earlier cagelike sculptures constructed in steel mesh and aluminum grating, beginning in 1967 (Fig. 68).[10]

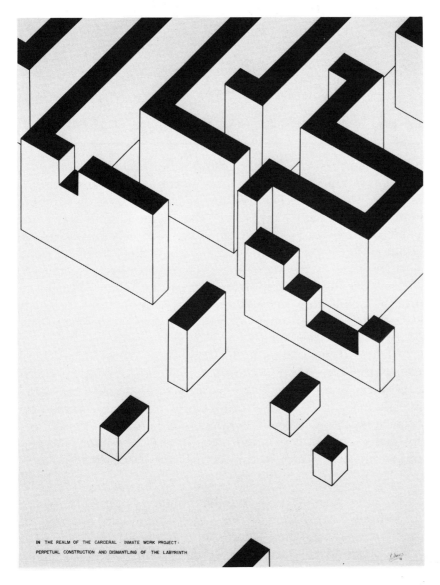

IN THE REALM OF THE CARCERAL · INMATE WORK PROJECT ·
PERPETUAL CONSTRUCTION AND DISMANTLING OF THE LABYRINTH

67
Robert Morris, *In the Realm of the Carceral: Inmate Work Project— Perpetual Construction and Dismantling of the Labyrinth,* 1978. Ink on paper.

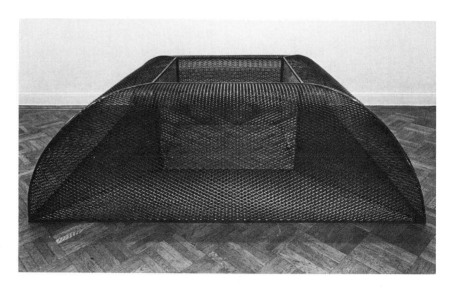

68
Robert Morris, *Un-titled*, 1967. Steel.
Private collection.

"Is it surprising," asks Foucault in *Discipline and Punish,* "that prisons resemble factories, schools, barracks, hospitals, which all resemble prisons?"[11] Even before the ascendance of computer simulation and media repetition, the hierarchies of power demanded that space be organized so that people's movement and actions could be both monitored and controlled. Foucault points to society's pervasive alienating geometries, to the existence of repressive political technologies that can be integrated into any social function—into the realm of education, medical treatment, production, and punishment—in order to determine the interaction of docile bodies.

Central to Foucault's understanding of the industrial social order is the "invention" of the panopticon, essentially a central observation point surrounded by a maze of discrete cubicles.[12] The schema, rooted in nineteenth-century systems of prison surveillance such as Jeremy Bentham's penitentiary panopticon, represents an ideal paradigm of the modern mechanism of power—invisible power in the service of subtle coercion:

> [The panopticon] makes it possible to draw upon differences: among patients, to observe the symptoms of each individual, without the proximity of beds, the circulation of miasmas, the effects of contagion confusing the clinical tables; among school children, it makes it possible to observe performances

(without there being any imitation or copying), to map attitudes, to assess characters, to draw up rigorous classifications and, in relation to normal development, to distinguish "laziness and stubbornness" from "incurable imbecility"; among workers, it makes it possible to note the aptitudes of each worker, compare the time it takes to perform a task, and if they are paid by the day, to calculate their wages.[13]

What carceral structure attempts to restore to society in its techniques of surveillance and correction is not so much the "juridical subject, who is caught up in the fundamental interests of the social pact, but the *obedient subject, the individual subjected to habits, rules, orders*" (emphasis added).[14] The systems of corrective penalty established in the nineteenth century, as opposed to the ruined prisons lined with torture chambers depicted in Piranesi's dark and frightening engravings, were destined to reorder silently and efficiently social and political interaction. "Without any physical instrument other than architecture and geometry, [panoptic order] acts directly on individuals; it gives 'power of mind over mind.' "[15]

Ultimately, it was this panoptic, repressive world that Morris wished to transcend in his art. Marcuse had long advocated just such a role for the artist, as he reasoned that art could play a substantial role in "revolutionizing a stunted sensuality and repressive structure of the drives and instincts."[16] In the early 1970s, following his experiences with the Art Strike and other challenges to the sanctity of art institutions, Morris became increasingly interested in the idea of resuscitating the self—the private, psychological center that gives each of us a sense of control of our lives—from the oppressive, ego-confiscating world of late capitalism. As such, he temporarily distanced himself from the oppressive space of the city and looked to nature and the land.

By relocating art from the museum to the landscape, Morris's earth projects dramatically transcended the art world's institutional demands. Often assuming a labyrinthine structure and scale that would not allow the viewer to apprehend the entire work at once,[17] such projects were neither earthworks nor sculptures; instead they existed somewhere between landscape and architecture, establishing a connection to the geological and temporal conditions of their setting. Works like the *Ottawa Project* (Fig. 69, a structure in earth and sod commissioned by the National Gallery

of Canada in 1969 but, like most of Morris's proposals for land projects, never realized due to lack of public or private funding) and the *Evanston, Illinois, Earth Project* (1968–69, Fig. 70)[18] radically negated the spatial and ideological demands of the museum while at the same time celebrating the expansiveness and beauty of the land.[19] It was this beauty that Morris first turned to in search of our collective past, a past he hoped would more deeply and spiritually connect us to our problematic present.

Morris's conception of history as a window onto the present was most dramatically played out in *Observatory,* a large earthwork built on a plain near Santpoort-Velsen in the Netherlands. The artist's contribution to Sonsbeek '71, an international sculpture exhibition organized by the town of Arnhem in 1971 (Figs. 71, 72), *Observatory* had a total diameter of 230 feet and consisted of two concentric, circular mounds of earth marked by one steel-lined and two granite notches that aligned with the two equinox and two solstice sunrises. The work established a complex connection between history and contemporary ideas about reorienting the experience and perception of art. The overall appearance of *Observatory* derived from Neolithic and Oriental architectural complexes that provided "a kind of 'time frame' or ever present context for the physical experience of the work."[20]

69
Robert Morris, *Ottawa Project,* 1970. Pencil on graph paper. Collection of the artist.

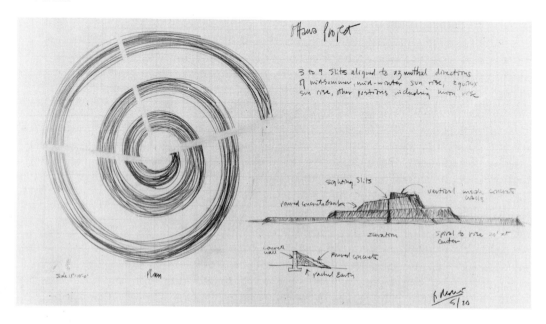

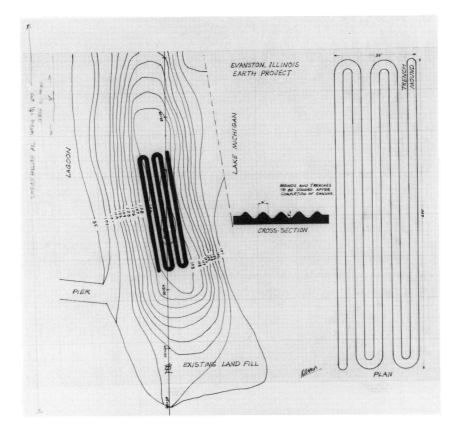

70
Robert Morris,
*Evanston, Illinois,
Earth Project,* 1968.
Ink on graph
paper. Collection
of the artist.

One Neolithic source for *Observatory* was Stonehenge—the circular arrangement of prehistoric monoliths on Salisbury Plain, England. The mysterious structure, oriented toward the exact point at which the sun rises on the day of the summer solstice, probably served a sun-worshiping ritual. The historical implications of *Observatory* arose from the geological history of the Netherlands and of Santpoort-Velsen, where much of the land had been reclaimed after being submerged by periodic flooding. *Observatory* appeared to emerge naturally out of the ground, constructed mostly of material belonging to the site, such as bulldozed earth and large, roughly cut granite blocks.[21]

The relationship Morris established between prehistory and the present recalls the work and ideas of his friend Robert Smithson.[22] Like Morris, Smithson's interest in prehistory functioned simultaneously as a "symptom of political pessimism amid the

ruins of the 'new world' " and as an "act of faith in new roles and powers for artists in this ruined world."[23] Smithson was fascinated by the idea of chaos, seeing in it a constant confusion between man and nature. *Entropy* was the word he used for the energy drain toward which the world was inexorably headed—a kind of "evolution in reverse." By failing to produce closed and static objects, the temporal dynamic of the phenomenological art of the 1960s seemed appropriate to Smithson. It paralleled the entropic direction toward which he saw art and culture moving:

> [The new art] celebrate[s] . . . "inactive history" or what the physicist calls "entropy" or "energy drain"—they bring to mind the Ice Age rather than the Golden Age, and would most likely confirm Vladimir Nabokov's observation that "the future is but the obsolete in reverse." In a rather round-about way, many of the artists have provided a visible analog for the Second Law of Thermodynamics, which extrapolates the range of entropy telling us energy is more easily lost than

71
Robert Morris, *Observatory*, 1971. Under construction at Santpoort-Velsen, the Netherlands, 1971. Earth, timber, granite blocks, steel. Destroyed.

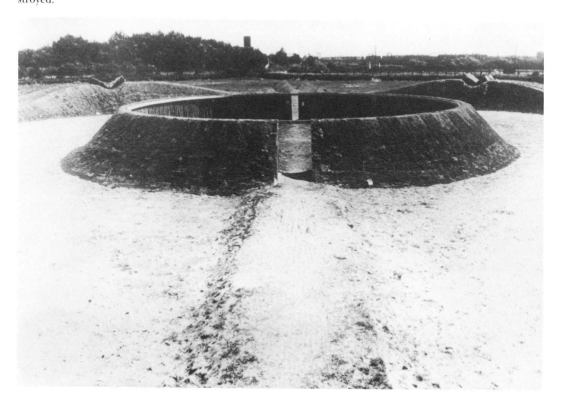

obtained, and that in the ultimate future the whole universe will burn out and be transformed into an all encompassing sameness. The "blackout" that covered the Northeastern States recently may be seen as a preview of such a future. Far from creating a mood of dread, the power failure created a mood of euphoria. An almost cosmic joy swept over all the darkened cities. . . .[24]

Morris himself had thought of his Minimal structures as entropic. As early as 1961, in his unpublished contribution to *An Anthology,* Morris wrote that Blank Form sculpture "slowly waves a large gray flag and laughs about how close it got to the second law of thermodynamics."[25] Smithson, like Morris, believed that the critical boundaries of formalism tended to isolate the art object into "a metaphysical void, independent from external relationships such as land, labor, and class."[26] Smithson recognized the relevance of Marxist principles of alienation to land use. Citing abstractions like spirituality and idealism as enemies of social responsibility, he

72
Robert Morris, *Observatory,* 1971. Ink on paper. Collection of Gillman Paper Company, New York.

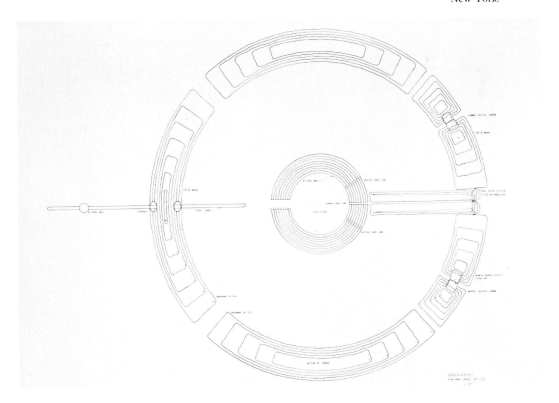

called on land artists to cultivate the ecological situation rather than impose abstract structures on the site.

Smithson's site-specific projects were based on a rigorous examination of the prehistory and the socioeconomic history of the area under consideration. The temporal and mythological setting that shaped the *Spiral Jetty*—Smithson's extraordinary monument to the Great Salt Lake in Utah—was the lake itself. "The occurrence of a huge interior salt lake," writes Rosalind Krauss, "had for centuries seemed to be a freak of nature, and the early inhabitants of the region sought its explanation in myth. One such myth was that the lake had originally been connected to the Pacific Ocean through a huge underground waterway, the presence of which caused treacherous whirlpools to form at the lake's center."[27] Such references to prehistory also mediated a central political consideration: the jetty was adjacent to an abandoned oil drilling operation that rendered the entire northern section of the lake useless. "I'm interested in bringing a landscape with a low profile up," Smithson remarked, "rather than bring one with a high profile down."[28]

It was this kind of historical context that Morris brought to his work. Each of his major land pieces, from the *Field Planting* in Puerto Rico (1969) to the *Observatory* projects,[29] considered the historical contexts of the site as the basic material—the archive—from which the monument would emerge. This concept of land reclamation rests on an archaeological understanding of art and history, speaking to the way history is conceived and the means by which the artist—who often reclaims history—goes about constituting the past and present. Such an archaeological understanding of history, of course, opposes the modernist model, where the "document," the "archive," and the "oeuvre" are diligently recomposed into logical, diachronic narratives.[30]

Morris's approach to the land as historical archive was rooted in the work of Foucault, in particular *The Order of Things: An Archaeology of the Human Sciences* and *The Archaeology of Knowledge* (published in English translations in 1970 and 1971, respectively). Foucault's arguments fundamentally undermined the linear organization of history.[31] For Foucault, the historian was charged with a new responsibility: to constitute events synchronically in relation to the monuments and issues that defined them in their own time. His was a discourse liberated from traditions that imposed an often artificial causality on a given period's disparate meanings. The new

history, Foucault wrote in *The Archaeology of Knowledge,* would establish a network of discontinuous events rather than a linear narrative based on historical convention:

> History, in its traditional form, undertook to "memorize" the *monuments* of the past, transform them into *documents,* and lend speech to those traces which, in themselves, are often not verbal, or which say in silence something other than what they actually say; in our time, history is that which transforms *documents* into *monuments*. . . . Where, in the past, history deciphered the traces left by men, it now deploys a mass of elements that have to be grouped, made relevant, placed in relation to one another to form totalities. There was a time when archaeology, as a discipline devoted to silent monuments, inert traces, objects without context, and things left by the past, aspired to the condition of history, and attained meaning only through the restitution of a historical discourse; it might be said, to play on words a little, that in our time history aspires to the condition of archaeology, to the intrinsic description of the monument.[32]

In a similar way, Smithson and Morris's land-reclamation projects achieved meaning not by a standard relationship to art history but by recovering the past through a disinterring of its individual monuments and myths. Edward Fry has observed that in Morris's oeuvre reference to the past through memory was permitted "only if limited to the past actions and thoughts of the isolated individual. What is astonishingly absent is any acknowledgment of the cumulative record of history, of the collective written record of the human race."[33] In works such as *Spiral Jetty* or *Observatory,* the role of history is recuperative rather than antiquarian; history now facilitates the "discovering or constituting meaning in the inertia of the past and in the unfinished totality of the present."[34] In other words, these epistemological mutations of history—by reconstituting the ruins of our past to suggest the depth of our ruined present—alert us to unmistakable signs of collapse that mark the institutions of late capitalism.

At the root of Morris's attraction to the ruin, to the idea of history as an inevitable process of dissolution and decay, was a desire to warn of impending social collapse. Allegory, in the form of a work like *Observatory,* gives speech to what is only mutely implied in Morris's more orthodox work: that the metaphysical

pretensions of much modern art (including the generation of Abstract Expressionism)—those principles of illusion and belief that disguised a growing sense of alienation and disenfranchisement—are as ruined as the social structures that created them. The idea of the ruin as allegory did not, of course, originate with Morris or the concept of land reclamation. As early as the 1930s, Walter Benjamin had suggested that in the ruin history merged physically with its environment: "And in this guise history does not assume the form of the process of an eternal life so much as that of irresistible decay. Allegory thereby declares itself to be beyond beauty. Allegories are, in the realm of thoughts, what ruins are in the realm of things. . . . In the process of decay, and in it alone, the events of history shrivel up and become absorbed in the setting."[35] Just as Benjamin understood the ruin as an allegory for the exhaustion of the capitalist vision, Morris rooted his simulated ruins in specific historical settings, charging them with allegorical implications about the limitations of our world and its resources.[36]

If allegory is "the projection of the . . . static axis of language onto its metonymic or temporal dimension,"[37] we might say that the experience of passing through the *Observatory* functions outside a linear historical narrative. Rather than imposing contemporary meanings onto past events and monuments, the allegorical object allows archaeological form to unfold and lend meaning to the present. The spiraling metaphors of birth and decay that mark one's journey through *Observatory* (or Smithson's *Spiral Jetty*) are manifested without prior knowledge of a specific historical narrative; through a union of nature, history, and direct experience, Morris infuses the work's decentering passage with allegorical implications.

Morris's reclamations of prehistorical and present-day ruins extended beyond mere historical recuperation to a consideration of the individual's psychological relationship to the site. When Morris went to Peru to observe the Nazca lines, he did so not as an artist but as a kind of archaeologist. The first section of his essay "Aligned with Nazca" is what Foucault would call a "description of the monument," a lengthy, meticulous record of his journey, his process investigation, and his own temporal relationship to the site as spectator. Significantly, Morris's description of Nazca is based on a continual dialectic between the repressive, overpowering verticality of urban spaces and the more expansive, liberating realm of the Peruvian plain.[38] Morris's description also acknowledged

the connection between the spatial relationships themselves and their specific setting. He felt that the Nazca lines could be re-thought as large-scale public art, whose claim to monumentality was based on its unique integration with its site.[39] But what most impressed Morris about Nazca was neither its large scale nor its publicness; instead, he saw in these lines "something intimate and unimposing,"[40] something that could compensate for the sense of loss that permeated late-industrial urban society. For Morris, this loss was not just the lack of care, economy, and insight in a world of overproduction and overconsumption but the absence of an even more valuable entity: the self. At Nazca a possibility existed for rethinking the way our bodies relate to the world; there one's position is located inwardly (by realizing the expansive patterns established by the lines) through a private temporal accumulation of visual and visceral information.

For Morris, such a phenomenological passage could serve as the foundation for experiences that return to the individual those processes of perception and cognition lost through a priori meth-ods of thinking. The public scale of the new sculpture of the 1960s, Morris came to believe, was "informed by a logic in its structure . . . [and] sustained by a faith in the significance of abstract art." The art of that decade "was one of dialogue: the power of the individual artist to contribute to public, relatively stable formats which critical strategies, until late in the decade, did not crum-ble."[41] What Morris saw at Nazca was exactly the opposite of these stable formats and critical strategies; he realized in his outer-directed, temporal passage a means for continuing the project of deconstruction begun by anti-form. If the crumbling intellectual architecture of modern society could offer no access to that pri-vate, individual space of the self, the shift away from the Minimalist *object* that began in the late 1960s did offer a possibility of greater access. "Deeply skeptical of experiences beyond the reach of the body, the more formal aspect of the work in question provides a place in which the perceiving self might take measure of certain aspects of its own physical existence," Morris wrote. "Equally skeptical of participating in any public art enterprise, its other side exposes a single individual's limit in examining, testing, and ulti-mately shaping the interior space of the self."[42]

In the end, Morris's land works were limited by their transcen-dental aims and their inaccessibility. Such works remained ideo-logically unresolved as they retreated from Morris's aggressive

73
Robert Morris, *Philadelphia Labyrinth,* 1974. Installation for the Institute of Contemporary Art, Philadelphia, March 1974. Plywood and Masonite painted gray. Destroyed. Certificate to refabricate in the Panza Collection, Milan.

social activism of the early 1970s. If a search for a self lost in the morass of late-industrial culture was a preeminent goal of Morris's work of this period, the earth pieces could offer little more than an insightful journey into our ruined past. The expansive landscape of Holland or Nazca offered no ideological resistance for Morris to work against; he would have to return to the world of repressive institutions in order to critique them more convincingly. As such, the abstract concept of the self that governed the earth pieces would yield to a more ideologically grounded notion of the individual's place in the world. Morris's return to the museum and gallery after his work on *Observatory* demanded a conceptual realignment of the self as ideologically bound and defined.

Thus, in 1973, Morris began work on three projects—the *Philadelphia Labyrinth,* the *Blind Time* drawings, and *Voice*—that collectively explored the space of the self through autistic or decen-

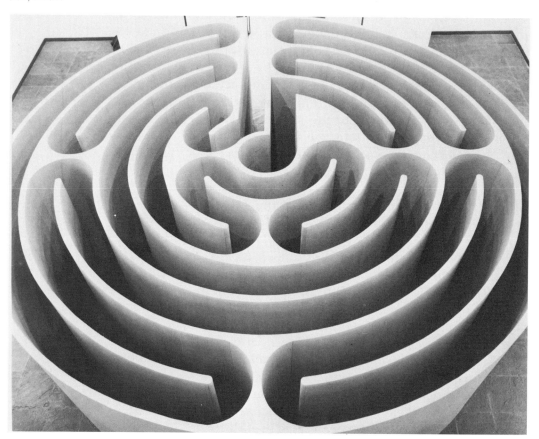

tering states. Bringing his work back into the context of the gallery and museum, Morris in these works presents the culmination of two decades of thinking about art as a vehicle of desublimation and recovery from repression. In Morris's *Philadelphia Labyrinth*, installed at the Institute of Contemporary Art in Philadelphia in 1974 (Figs. 73, 74), the viewer was asked to traverse a claustrophobic 500-foot circular maze, too narrow even for two people to pass each other comfortably. The walls were eight feet high and were painted the usual Morris gray. In contrast to a true labyrinth, there were no dead ends; instead the focus was on "the circuitous transit to the center and out again, and on the physical and psychological aspects of transit."[43] The vertiginous path of the *Philadelphia Labyrinth* acted much like the collapsed shifters of Morris's

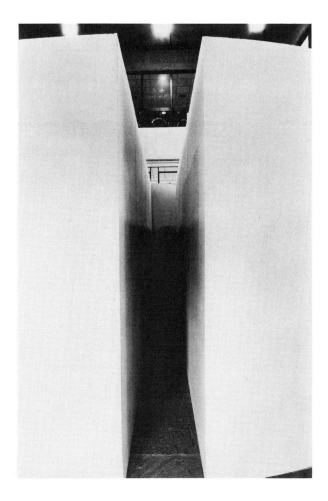

74
Robert Morris,
Philadelphia Labyrinth, 1974, detail.

work of the early 1960s; the autisticlike state effected by the claustrophobic, dizzying passage temporarily disoriented the participating viewer. (Morris built the labyrinth, in part, in response to his own severe claustrophobia.) Yet, the experience of the *Philadelphia Labyrinth*—in its winding paths and misdirections—was unlike that of a traditional museum exhibition. As in the Tate installation, viewers were invited to play in the corridors of Morris's labyrinth. And through the work's phenomenological dynamic, viewers became increasingly aware of their own sense of place and direction.

While Morris was designing the *Philadelphia Labyrinth,* he began work on *Blind Time I* (1973, Fig. 75), a series of ninety-eight drawings executed with his eyes closed. His working method for these drawings was consistent: he would define a particular drawing task (related to such conditions as pressure, distance, location, and shape), estimate the length of time needed for its completion, and finally close his eyes and draw on paper with his fingers using graphite mixed with plate oil.[44] Despite the specificity of the assigned tasks, the sense of being lost in darkness intensified his

75
Robert Morris, *Blind Time I (No. 51),* 1973. Ink and graphite on paper. Private collection.

reliance on lived experience, for the very condition of blindness mandated that spatial orientation occur only by an accumulation of information in *time,* as other operative senses compensated for the loss of vision. Like being lost in a labyrinth, such drawing processes radically altered the artist's sense of control over his own actions. By undoing the compositional claims of the artist over his work, the *Blind Time* series distanced the artist from the modernist conceits of ego and temperament. Because the artist's masterful control of his process was now rendered irrelevant, such works travestied the obsession of formalist abstraction with compositional balance and harmony.

Further distancing himself from the mythologies of the ego in *Blind Time II* (1976, Fig. 76, 77), Morris asked a woman who had been blind since birth to act as his surrogate. "For many of my

76
Robert Morris, *Blind Time II (No. 13),* 1976. Etching ink on paper. Collection of the artist.

projects I've always had assistants," he remarked, "and I somehow thought why not extend this *Blind Time* series, only have someone else do it."[45] Consistent with the neutral plinths and permutation pieces of the 1960s, these drawings continued to question the obsession of artists with expressive and egocentric interpretations of their labor. Contacted through the American Association for the Blind, the woman—known to us only as A.A.—remains as anonymous as the impersonal fabricators of Morris's sculptures. Uncomfortable with the inherently visual discipline of drawing and unaware of predetermined methods for depicting depth, the blind woman approached her task with skepticism and confusion:

77
Robert Morris, *Blind Time II (No. 41)*, 1976. Etching ink on paper. Collection of the artist.

She had no idea of illusionistic drawing. I described perspective to her and she thought that was absolutely ridiculous, that things got smaller in the distance. She had no conception of that. She kept asking me about criteria, got very involved in

what is the right criteria for a thing. And there was no way that she could find any and finally that sort of conflict became very dramatic. She was operating in a way that she wouldn't have to invoke [these criteria]. And at the same time she was aghast that she was not able to.[46]

To enter into the realm of darkness—into a labyrinthine space where clear and articulate objects are abolished, where our perceptual being establishes a spatiality without things, where there are no outlines—is to redefine the way our bodies relate to the logic of the world. "[It's] sort of weird, what I'm questioning, what I'm asking in all this. . . . Is that just the nature of it?" asks the blind woman in a moment of frustration. "Is there no analogue in the world that I can experience that is as intense?"[47]

Morris's understanding of the recuperative aspects of this dismantling of the ego and the fiction of a centered self also informed an elaborate sound chamber that was installed at the Leo Castelli Gallery in New York in 1974. In a number of ways, *Voice* (1973–74, Fig. 78) was Morris's most striking and self-critical attempt at an antirepressive aesthetic for art. The work summed up the founding principles of his art and thinking: antiobject, language-oriented,

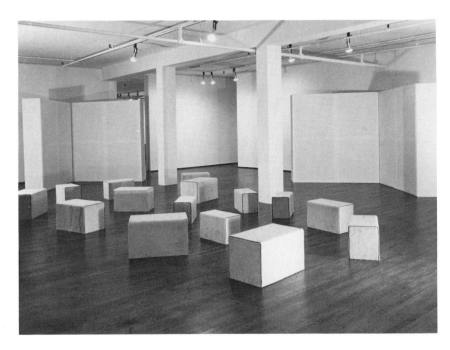

78
Robert Morris, *Voice*, 1974. Installation for the Leo Castelli Gallery, New York, April 1974. Eight high-resolution loudspeakers, 4 wall panels, 14 wood boxes covered in white felt, 3½-hour audio tape, 2 four-channel tape recorders.

and theatrical, *Voice*—unlike the earth pieces—existed in ideological opposition to its institutional setting. The work reached beyond anti-form in its desire to liberate the art object from what Marcuse had called, "the repressive familiarity with the given world of objects."[48] In *Voice,* Morris dissolved the very architecture of the art object and its institutions: rather than approaching physical objects that were tokens of beauty or exchange, spectators were now at the center of a mesmerizing experience as sounds whirled around their heads.

The organization of the installation was relatively simple: four large amplification units, each fitted into a corner of the room, defined a rectangular space in the gallery. Within this 50-foot-square area, viewers were invited to sit on randomly arranged boxes laminated with white felt. Differing from Morris's orthodox Minimalist plinths only in their cloth covers, these boxes reiterated the ordinariness of the earlier work; what had once been art objects were now utilitarian devices for making the auditor/spectator comfortable. The demystification of the art object extended even to the three-and-a-half-hour sound track. As in the earlier sound track for *Hearing,* many of the texts were appropriated from a range of published sources. For *Voice,* Morris recorded eight actors reading from a painstakingly organized 256-page manuscript he had prepared.[49] The text was divided into four sections. The first section, "The Four," was written by Morris and involved four actors, each identifying an amplification unit with a point of the compass (NE, SE, NW, SW). The second section, "They," was made up of amplified passages from Emil Kraepelin's *Dementia Praecox* (1919) and *Manic Depressive Insanity and Paranoia* (1921).[50] Section three was divided into three parts; the first two—"Cold/Oracle," "He/She"—were written by Morris, while the third—"Scar/Records"—was a list of entries from the *Guinness Book of World Records.* The final section, also by Morris and narrated by the poet Mark Strand, was called "Monologue."

The sound track was both discursive and complex. Morris drew up elaborate charts to mix the eight-track tape for *Voice,* arriving at 546 random combinations of words and sounds that could issue from the four speakers (Fig. 79).[51] "As with the interplay between seats and the disposition of the amplifiers," wrote Jeremy Gilbert-Rolfe, "Morris . . . initiates one's experience of *Voice* with a series of references to spatial positioning and temporal order that reflexively identify the two through what are puns or

almost puns—of specific location with generalized orientation on the compass, of a speaker system with a narration that's sometimes suggestive of a person moving around the room (when a single voice comes first from one speaker and then from another) and at others suggests a space of speaking (when more than one voice speaks simultaneously on more than one speaker)."[52] The dizzying circularity of speech resulted in a disorienting array of voices and information: the listener, never permitted to concentrate on any single area of discourse, was drawn into a temporal passage of words so unpredictable and disruptive that both narrative and extended meaning were denied.

The gender confusion in "They" is an example of this denial (Fig. 80). The four-track tape was read by an actor and an actress. Each of two speakers diagonally opposite one another was reserved for passages read exclusively by the man or the woman. The other two were used for both voices together. Sentences read by either the man or the woman were often interrupted by both voices reading at once. Some sentences were repeated as many as four times. Significantly, when the two actors were reading together they transposed the personal pronoun for the opposite sex whenever it came up: he became "she," she became "he."

The circuitous, confusing paths of these texts was self-consciously reiterated by the very presence of Kraepelin's writings on mental illness. Kraepelin, the originator of a classification system

79
Robert Morris,
*Text—Voice Distribu-
tions—Monologue,*
1974. Ink on graph
paper. Collection
of the artist.

80
Robert Morris,
Monologue (Manuscript Drawing for Voice: "They"),
1973. Ink and colored pencil on typewritten bond paper. Collection of the artist.

of psychopathology on which all subsequent classifications were based, differentiated between varying degrees of insanity: dementia praecox (schizophrenia), manic-depressive disorders, paranoia. In *Voice,* Morris asserted the conditions of ego loss that constituted these mental illnesses. The complex sound track, which took Morris more than three months to create, often shattered into an

incoherent field of sentence fragments and sounds where men identified themselves as women; women as men, where the word "I" was almost never invoked.[53]

Morris's allusions to mental pathology in *Voice*—his construction of a schizo-effective environment—suggest a central paradox. Like the labyrinth itself, the psychotic world that Morris envisioned was as much a duplication of our own degraded world as it was a space of desublimation and recovery, a space where established patterns and habits could be questioned. As a realm removed from the social constraints of logic and reason imposed by an industrial social order, *Voice* represents the ultimate labyrinthine space in Morris's oeuvre—a world of repetitive and circuitous verbal turns that ultimately drives the auditor into his or her own private center.[54] Stranded in the midst of Morris's confusing space of verbal operations, the auditor eventually succumbs to its hypnotic effects: what began as confusing and disturbing ends as calming and self-reflective.

The concept of autistic or psychotic states as recuperative experiences was central to those aspects of New Leftist thinking in the 1960s and early 1970s that sought to disavow the standards of normalcy that govern late-industrial society. An important intellectual source for Morris was the writing of the British psychiatrist R. D. Laing.[55] Laing's texts (*The Divided Self* [1959], *Self and Others* [1961], *Reason and Violence* [1964], and *The Politics of Experience* [1967]) offered a humanistic rethinking of our attitudes toward a principal condition of social aberrance: mental illness. Laing reasoned that society's impulse to incarcerate and tranquilize the schizophrenic, to silence the mumblings of disaffection and confusion that characterize psychotic speech, parallels a greater need to establish order in a society conditioned by violence and repression. "What we call 'normal,' " wrote Laing, "is a product of repression, denial, splitting, projection, introjection and other forms of destructive action on experience. . . . It is radically estranged from the structure of being."[56] If schizophrenia was construed by Laing as a "social fact . . . a political event," then *experience* itself was also seen as hostage to an entire subset of ideologies and demands. Citing a description by Emil Kraepelin of his interaction with a schizophrenic woman (a study similar to those used by Morris for the sound track of *Voice*), Laing revealed Kraepelin's hidden semantics of coercion, a discourse built on cruel and violent attempts at behavioral modification.[57] Ultimately, Laing asked

one of the most compelling questions about the nature of mental illness: Can schizophrenic or, more inclusively, psychotic states be seen as intervals of healing? Can we accept the passage into psychosis as a transcendental, albeit desperate, search for recovery from the conditions of alienation that haunt us all?

Gilles Deleuze and Félix Guattari asked a similar question in *Anti-Oedipus,* their challenge to the social order of Freud and Marx. Published in 1972 in French (and subsequently translated into English in 1977),[58] *Anti-Oedipus* questioned the conditions and assumptions on which psychoanalysis was built. Specifically, Deleuze and Guattari dismantled what they considered to be the mythological status of oedipal desire. In their antioedipal thinking, the ego had to be undone as a major repressive force that validates reality and logic over sensuality as it fashions docile and obedient subjects. "Everybody has been oedipalized and neuroticized at home, at school, at work," writes Mark Seem in his introduction to *Anti-Oedipus.* "Everybody wants to be a fascist. Deleuze and Guattari want to know how these beliefs succeed in taking hold of a body, thereby silencing the productive machines of the libido."[59]

In *Anti-Oedipus,* the psychotic holds the key to liberation. Whereas the neurotic responds to oedipalization, the psychotic is most often incapable of yielding to the logic of oedipal desire. The fundamental task of the revolutionary, Deleuze and Guattari suggested, is to dismantle the oedipal complex in order to dissolve the mystifications of power and "initiate a radical politics of desire freed from all beliefs."[60] Exemplars are made of those marginal figures who, at least hypothetically, resist oedipal drives: orphans (no parents as the object of desire), atheists (no beliefs), and nomads (no habits, no territories). Thus, Deleuze and Guattari advocated the replacement of psychoanalysis based on Oedipus and the ego with *schizoanalysis*—a therapy that attempts to denormalize and deindividualize through a decentering and transformation of human relationships in a struggle against power. To distance ourselves from our egos is to make possible a nonneurotic politics, they reasoned, a politics that fights against subjugation. The object of this distancing ultimately is not madness as a way of life (for psychosis would result in an extreme disconnection from power), but rather a politics of the here and now—a kind of materialist psychiatry. The space of the *Anti-Oedipus* oscillates between the worlds of Nietzsche and Marx, a construct of intense experi-

ences tied to revolutionary political causes, where process and experience are favored over a repressive social order.[61]

One can see reflected in Morris's labyrinths, in their winding paths of experience and process, what was to become the anxious dialectic of the *Anti-Oedipus*—a discourse that in Morris's case was grounded in both the radical psychiatry of Laing and such Marcusean texts as *Eros and Civilization, An Essay on Liberation,* and *One-Dimensional Man.* From the very beginning—from the *Passageway* in 1961 or the *I-Box* in 1962—Morris has charted a journey wherein the ego is temporarily suspended, where the logic of "reality" yields to the visceral and the sensual.[62]

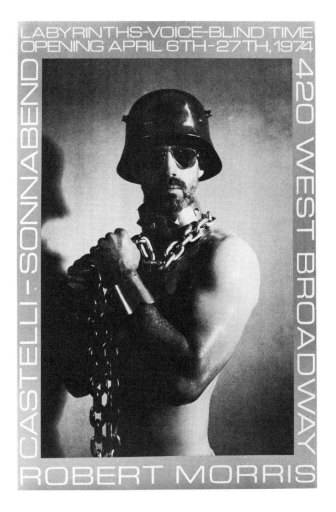

81
Robert Morris, poster for Castelli/ Sonnabend Gallery exhibition, April 6–27, 1974. Offset on paper. Leo Castelli Gallery, New York.

The aggressive sensuality of Morris's project is reflected in the exhibition poster he designed for *Voice,* an exhibition that also included drawings for the *Philadelphia Labyrinth* and the *Blind Time* series. That poster boldly presents a photograph of Morris in a helmet and sadomasochistic drag—dark glasses, chains, spiked neck band (Fig. 81). The image at first suggests a Foucaultian explanation in its apparent assertion of the artist as master, the viewer as slave: an effigy of the architect at the center of the labyrinth, a metaphor for a panoptic society at its entrance. But the image, like those of *Site* or *Waterman Switch,* exhibits a depersonalized eroticism where the artist and spectator are permitted to indulge in their private fantasies. A parody of pornography, Morris's ironic and even playful display of sexuality contradicts the repressive chasteness and modesty demanded by our puritanical culture. (A year later, Morris proposed a series of nondescript *Sex Chambers* as gallery installations to be constructed in straw and copper wire [Fig. 82].) While this poster would at first appear to

82
Robert Morris, *Sex Chamber,* 1975. Pencil on paper. Collection of the artist.

have little relationship to the triad of projects it commemorates, it stands as a metaphor for their unlocking of the mechanisms of bourgeois repression. Like the Marcusean dialectic on which it is based, this poster—perhaps more than any other work in Morris's complex oeuvre—self-consciously announces a "new political praxis that integrates sensuality, fantasy, and desire."[63]

Ultimately, the unbounded, experiential world envisioned by Morris and proposed by *Eros and Civilization, Anti-Oedipus,* or *The Politics of Experience*—the space of recuperative psychosis, schizo-analysis, and polymorphous sexuality—did not materialize. As the problems and contradictions of such ideologies of presence emerged, conviction collapsed into hopeless mythologies divorced from reality. For to observe a schizophrenic person descend into an abyss of delusions, paranoia, and self-destruction is, of course, to witness a tragic dismantling of control, a loss rendered more dangerous by society's relentless intolerance, even hatred, of the mentally ill. While the epiphanic tone of the 1960s sustained belief in the mythic transcendence of such psychological states, the more conservative spirit that arose in America after the oil crisis of 1973 shattered that belief. Although such utopianisms as the ideological programs of Gilles Deleuze and Félix Guattari or R. D. Laing—positions designed to transgress the boundaries of normalcy and acceptability—were problematic and perhaps even impossible to achieve in practice, they contributed to a discourse of liberation already established in the 1950s by such social theoreticians as Herbert Marcuse. Reconciling these ideas with phenomenology, Robert Morris constructed a correlative cultural discourse, deploying art objects, dances, installations, and environments that intentionally decentered the spectator as they continually asked questions about the nature of our confinement and the possibility of our freedom.

As such, Morris's explorations of phenomenal and psychosexual conditions attempted to actually effect what Laing and others concluded was impossible in the space of late capitalism: a truly *self-validating* experience without concessions to dominant ideologies and patterns of human behavior. Predominant throughout the artist's oeuvre is a dialectic between the modernist will to celebrate the ego through a cult of the personality (Morris as performer) and the 1960s impulse toward difference, deindividualization, and a decentering of linear logic and reason (the altered gestalts of the orthodox Minimalist plinths, the drive toward temporality rather

than formal closure, the sensual impulses, the labyrinthine space of his work). Oscillating between philosophical and social themes, Morris refused to adopt a fixed stylistic or intellectual identity. If alienation and repression were the subjects of Morris's social criticism, his vision nevertheless balanced a tacit acknowledgment of the continual disruption of our egos with the belief that such conditions of alienation could be transcended.

Robert Morris continually reiterated the structure and symbolism of the labyrinth, compulsively returning to it in search of an escape from the preconceptions of the past. As such, the impact of his vehicles for dismantling the ego—"desiring machines," as Deleuze and Guattari might have named them—was often felt by Morris himself. Whether naked in the *I-Box* or *Waterman Switch* or donning work clothes in *Site,* Morris helped reshape the role of the artist *and* the viewer in an age of radical social and cultural deconstruction. Moving around and around in circles, like one of Samuel Beckett's absurd heroes, he ground away at the desexualized persona of the elegant dandy or of the obedient worker. Gliding between the realms of personal expression and social commentary, Morris served as an important conduit for reconciling the interests of the avant-garde with those of the New Left. Throughout his insistent, exploratory journey, Morris sought to illuminate the social paradox of Beckett's words: "I seem to speak, it is not I, about me, it is not about me."

NOTES

1. From 1961 to 1974, the literal use of labyrinthine passages or mazelike organization occurs in the following works: *Passageway* (1961); *Pharmacy* (1962); *Arizona* (1963); *Waterman Switch* (1965); *Untitled* (four mirrored cubes) (1965); *Untitled* (four sloped cubes) (1965); *Untitled (L-Beams)* (1965–67); *Evanston, Illinois, Project* (1968–69); *Ottawa Project* (1969), *2″ Steel Plate Suite* (1970); *Blind Time* (1973, 1976, 1985); *Mirror* (1969); *Finch Project* (1969); *Earth Projects* (1969–70); *Whitney Museum Installation* (1970); *War Memorials* (1970); *Neo-Classic* (1971); *Observatory* (1971); drawings for imagined architectural complexes, walkways, observatories, and courts—e.g., *Bath House Observatory, Section of an Elevated Platform* (1971); *Tate Gallery Installation* (1971); *Sophie Krauss Memorial Project* (1971–72); *Untitled* (installation of mirrors and steel apertures) (1973); *Drawings for Labyrinths* (1973–74); *Voice* (1973–74); and *Philadelphia Labyrinth* (1974). In addition to these literal labyrinths, Morris often employed decentering devices in works that were not specifically mazelike.

2. Achille Bonito Oliva, "Dialogue in the Form of an Introduction" (interview with Jorge Luis Borges), in *Dialoghi d'artista* (Milan: Electa, 1984), pp. 9–11.

3. See, for example, Stephen Eisenman's discussion of Morris's carceral imagery and its relationship to the history of the prison in "The Space of the Self: Robert Morris in the Realm of the Carceral," *Arts Magazine* 55 (September 1980), pp. 104–09.

4. Ibid., p. 104.

5. "Preface," in Gilles Deleuze and Félix Guattari, *Anti-Oedipus: Capitalism and Schizophrenia,* trans. Robert Hurley, Mark Seem, and Helen Lane (Minneapolis: University of Minnesota Press, 1983), pp. xi–xii.

6. Robert Morris, "Aligned with Nazca," *Artforum* 14 (October 1975), p. 36.

7. The text was spoken by four actors: Jose Ferrer, Norma Fire, Hollis Frampton, and Steven Koch.

8. The following people were quoted or paraphrased: David Antin, Manfred Bierwisch, Noam Chomsky, David Crystal, Marcel Duchamp, W. Brounder Firth, Janet Dean Fodor, Michel Foucault, E. C. Goossen, Clement Greenberg, Roger Harrison, Max Kozloff, M. Lemon, E. H. Lenneberg, John Lyons, Gabriel García Márquez, Jacques Monod, Frank Palmer, David Pears, Jean Piaget, Seth Siegelaub, Robert Smithson, Albert Speer, Claude Lévi-Strauss, Andrew Stein, Liza Thomas, Immanuel Velikovsky, Mary Warnock, Lynn White, and Ludwig Wittgenstein. According to Morris, other writers, not identified in the Xeroxed program, were also included in the tape.

9. Michel Foucault, *Discipline and Punish: The Birth of the Prison,* trans. Alan Sheridan (New York: Vintage Books, 1979). Morris read the English translation of the work in the late 1970s.

10. These mazelike pieces with central enclosures or cubiclelike compartments resemble laboratory cages.

11. *Discipline and Punish,* p. 228.

12. For a discussion of panoptic structure in society see Foucault, *Discipline and Punish,* pp. 195–230.

13. Ibid., p. 203.

14. Ibid., p. 128.

15. Ibid., p. 202.

16. Jürgen Habermas, "Herbert Marcuse: On Art and Revolution," in *Philosophical-Political Profiles*, trans. Frederick Lawrence (Cambridge, Mass., and London: M.I.T. Press, 1983), p. 166.

17. Robert Morris discussed these scale relationships in his notes for a brochure announcing a portfolio of 10 lithographs of proposals for *Earth Projects* published in 1969.

18. For more on the projects, see Krens, *The Drawings of Robert Morris,* n.p.

19. For a critique of the earthwork's aestheticizing, high-art context, see John Beardsley, "Art and Authoritarianism: Walter De Maria's *Lightning Field,"* *October,* no. 16 (Spring 1981), pp. 35–38.

20. Unpublished statement on the *Observatory* project, undated (1971?) (Morris archives, Gardiner, New York).

21. Vulnerable to wind and rain, the structure was completely eroded in 1971. (Money was raised for its reconstruction on a larger scale and continual maintenance in Oostelijk-Flevoland in 1977.) For photographic documentation (with text by Morris) of the construction of the *Observatory,* see Robert Morris, "Observatory," *Avalanche,* Fall 1971, pp. 30–35. The photographs were taken by Peter Schuit from early June to mid-July 1971.

22. Morris often participated in field trips and excursions initiated by Smithson. In December 1966, Smithson, Morris, and Nancy Holt went to Great Notch Quarry, near Paterson, New Jersey. In April 1967, a two-day "site selection trip" to the Pine Barrens and Atlantic City was undertaken by Smithson, Holt, Morris, Virginia Dwan, and Carl Andre.

23. Lucy Lippard, "Breaking Circles: The Politics of Prehistory," in Robert Hobbs, *Robert Smithson: Sculpture* (Ithaca, N.Y., and London: Cornell University Press, 1981), p. 31.

24. Robert Smithson, "Entropy and the New Monuments," *Artforum* 4 (June 1966), p. 26.

25. For a reprint of Morris's statement, see Barbara Haskell, *Blam! The Explosion of Pop, Minimalism, and Performance, 1958–1964* (New York: Whitney Museum of American Art, 1984), p. 101.

26. Smithson as quoted in Lippard, p. 32.

27. Rosalind Krauss, *Passages in Modern Sculpture* (New York: Viking Press, 1977), p. 282.

28. As quoted in Lippard, p. 40. For the definitive collection of Smithson's writings, see *The Writings of Robert Smithson: Essays with Illustrations,* ed. Nancy Holt (New York: New York University Press, 1979).

29. In addition to discussing the historical concept of land reclamation in an area of Holland that had been ravaged by flooding, Morris also acknowledged the socioeconomic conditions of the area. In an interview with Lucy Lippard, he talked about the response of the middle-class farmers who lived around the *Observatory.* See Lippard, unpublished interview with Robert Morris, December 1971, pp. 17–20 (Morris archives, Gardiner, New York).

30. See Michael Foucault, *The Archaeology of Knowledge* (New York: Pantheon, 1972). For an important discussion of the emphasis on causality in the writing of history and of the distinction between general and special history, see Maurice Mandelbaum, *The Anatomy of Historical Knowledge* (Baltimore: Johns Hopkins University Press, 1977).

31. This archaeological understanding of history was first postulated by Foucault in his influential *Les Mots et les choses* (Paris: Editions Gallimard, 1966), later translated into English as *The Order of Things: An Archaeology of the Human Sciences* (New York: Pantheon, 1970). Robert Morris read *The Order of Things* as early as 1970 and was fully versed in its arguments by the time he began thinking about the *Observatory* project. Several years later, Foucault's *The Archaeology of Knowledge* was published in America (1972), a work that more fully developed the author's concept of a new historical process based on archaeological considerations of the events and monuments of history. See especially Foucault's "Introduction," in *The Archaeology of Knowledge,* pp. 3–17.

32. Foucault, *The Archaeology of Knowledge,* p. 7.

33. Edward Fry, "Robert Morris: The Dialectic," *Arts Magazine* 49 (September 1974), p. 22.

34. Ibid., p. 11. Morris's concept of the collapse of the economic order of late capitalism is based on Barry Commoner, "Capital Crisis," in *The Poverty of Power* (New York: Knopf, 1976), pp. 221–49.

35. Walter Benjamin, *The Origin of German Tragic Drama,* trans. John Osborne (London: NLB, 1977); as quoted in Craig Owens, "Earthwords," *October,* no. 10 (Fall 1979), p. 129.

36. My argument on the ruin as a function of allegorical desire is indebted to Craig Owens's impressive argument about Robert Smithson in ibid., pp. 121–30.

37. Ibid., p. 129.

38. Robert Morris, "Aligned with Nazca," *Artforum* 14 (October 1975), p. 31.

39. Ibid., p. 39.

40. Ibid.

41. Ibid.

42. Ibid.

43. Fry, p. 23.

44. This process was discussed in conversation with the author. For more on the *Blind Time* series, see Museum of Contemporary Art, Chicago, *Robert Morris: Works of the Eighties* (1986), pp. 34–38. Morris executed a third *Blind Time* series in 1985.

45. Transcript of Thomas Krens interview with Robert Morris, tape 3/side 10, p. 8 (Morris archives, Gardiner, New York).

46. Ibid., pp. 9–10.

47. Diary notes for the 1976 *Blind Time* series (Leo Castelli Gallery archives).

48. Marcuse, as quoted in Habermas, p. 166.

49. The eight actors were Jack Firestone, Richard Dunham, William Pritz, Mike Zelenko, Cathryn Walker, Gene Galusha, Charles Randall, and Mark Strand.

50. For a discussion on Morris's use of these texts, see Jeremy Gilbert-Rolfe, "Robert Morris: The Complication of Exhaustion," *Artforum* 13 (September 1974) pp. 46–47.

51. For a discussion of these charts, see Krens, *The Drawings of Robert Morris,* n.p.

52. Gilbert-Rolfe, p. 46.

53. Of the schizophrenic's refusal to speak in the first person, Gilles Deleuze and Félix Guattari write: "There are those who will maintain that the schizo is incapable of uttering the word *I,* and that we must restore his ability to pronounce this hallowed word. All of this the schizo sums up by saying: they're fucking me over again. 'I won't say *I* anymore, I'll never utter the word again; it's just too damn stupid. Every time I hear it, I'll use the third person instead, if I happen to remember to. If it amuses them. And it won't make one bit of difference.' And if he does chance to utter the word *I* again, that won't make any difference either. He is too far removed from these problems, too far past them" (Deleuze and Guattari, p. 23). The quotation within their statement is taken from Samuel Beckett's *The Unnamable.*

Morris's dislocation of language relates, as well, to strategies common to the writings of the Minimalists. This interchangeability of writing and sculpture, as Craig Owens observes, results in the dislocation of language that matches the decentering conditions of the sculpture. Owens quotes Robert Smithson's observations of the poetry of Carl Andre: "Thoughts are crushed into a rubble of syncopated syllables," writes Smithson. "Reason becomes a powder of vowels and consonants. His words hold together without any sonority. . . . The apparent sameness and toneless ordering of Andre's poems conceals a radical dislocation of grammar." Owens's conclusion is indeed relevant to Morris: "In demonstrating that Andre deploys linguistic signifiers as he would the cinderblocks, logs, or metal plates of his sculpture, writing and work are made to confront each other like parallel mirrors mounted in series, opening onto an infinite play of reflections in which the distinctions between writing and sculpture are, in effect, dissolved." See Owens, p. 125. Also see Robert Smithson, "A Museum of Language," in *The Writings of Robert Smithson: Essays*

with Illustrations, ed. Nancy Holt (New York: New York University Press, 1979), p. 67.

54. Herbert Marcuse writes: "In the equation Reason=Truth=Reality, which joins the subjective and objective world into one antagonistic unity, Reason is the subversive power, the 'power of the negative' that establishes, as theoretical and practical Reason, the truth for men and things—that is, the conditions in which men and things become what they really are. The attempt to demonstrate that this truth of theory and practice is not a subjective but an objective condition was the original concern of Western thought and the origin of its logic—logic not in the sense of a special discipline of philosophy but as the mode of thought appropriate for comprehending the real as rational. . . . The totalitarian universe of technological rationality is the latest transmutation of the idea of Reason." *One-Dimensional Man* (Boston: Beacon Press, 1964), p. 123.

55. Morris began reading Laing in the early 1960s. In Morris's library are well-annotated copies of *The Divided Self, The Politics of Experience, Reason and Violence* and *Self and Others.*

56. See R. D. Laing, "The Schizophrenic Experience," in *The Politics of Experience* (New York: Ballantine, 1967), pp. 27–28.

57. Ibid., pp. 106–30.

58. The following discussion of the *Anti-Oedipus* attempts to establish a theoretical model for thinking about Morris's interests in schizophrenia and other psychotic states, interests that stem from the writings of R. D. Laing rather than Deleuze and Guattari. Since Morris has not read *Anti-Oedipus,* my argument does not attempt to establish this work as a source for his thinking.

59. Mark Seem, "Introduction," in Deleuze and Guattari, p. xx.

60. Ibid.

61. The above paragraphs on the *Anti-Oedipus* are indebted to Mark Seem's excellent introduction.

62. "The person going through ego-loss or transcendental experiences," writes Laing, "may or may not become in different ways confused. Then he might legitimately be regarded as mad. But to be mad is not necessarily to be ill, notwithstanding that in our culture the two categories have become confused." See *The Politics of Experience,* p. 138.

63. Habermas, p. 169.

INDEX

Numbers in *italics* refer to illustrations.